Contagious Imagination

David Ball, Series Editor

CONTAGIOUS IMAGINATION

The Work and Art of

LYNDA BARRY

Edited by Jane Tolmie

University Press of Mississippi / Jackson

The University Press of Mississippi is the scholarly publishing agency of
the Mississippi Institutions of Higher Learning: Alcorn State University,
Delta State University, Jackson State University, Mississippi State University,
Mississippi University for Women, Mississippi Valley State University,
University of Mississippi, and University of Southern Mississippi.

www.upress.state.ms.us

The University Press of Mississippi is a member
of the Association of University Presses.

First printing 2022

∞

Library of Congress Cataloging-in-Publication Data

Names: Tolmie, Jane, editor.
Title: Contagious imagination : the work and art of Lynda Barry / edited by
Jane Tolmie.
Other titles: Critical approaches to comics artists.
Description: Jackson : University Press of Mississippi, 2022. | Series:
Critical approaches to comics artists series | Includes bibliographical
references and index.
Identifiers: LCCN 2022005481 (print) | LCCN 2022005482 (ebook) | ISBN
9781496839794 (hardback) | ISBN 9781496839800 (trade paperback) | ISBN
9781496839824 (epub) | ISBN 9781496839817 (epub) | ISBN 9781496839848
(pdf) | ISBN 9781496839831 (pdf)
Subjects: LCSH: Barry, Lynda, 1956—Criticism and interpretation. | Comic
books, strips, etc.—History and criticism. | Cartoonists—United
States—History and criticism. | Women cartoonists.
Classification: LCC PN6727.B36 Z64 2022 (print) | LCC PN6727.B36 (ebook)
| DDC 741.5/973—dc23/eng/20220509
LC record available at https://lccn.loc.gov/2022005481
LC ebook record available at https://lccn.loc.gov/2022005482

British Library Cataloging-in-Publication Data available

Contents

Welcome to Lynda Barry's Wondrous Word-Drawing Imaginarium: A Foreword

—Frederick Luis Aldama

The year 2000 proved a watershed moment in my comic book education. This was the year I discovered Lynda Barry. Salon.com was publishing her serialized strip *One Hundred Demons*, and I was mesmerized. I met all sorts of Brown, Black, and mixed-race freckled kids; nerdy, grimy, and gritty, they looked and acted like my ragtag group of childhood friends and me. Each vignette (or demon) pummeled my senses with art and words so labyrinthinely textured that my senses popped, and in all different directions. Barry delivered this crazy meat-grinder blend of *Mad* magazine, *Archie*, Picasso, Fielding, Kafka, and Dr. Seuss. Somehow I was back in the deep end of the multisensorial and edgy imaginarium of childhood. I was swimming among the familiar and the strange, vulnerable and joyful, savage and blissful—all seamlessly and simultaneously. Barry had served up a comic book eight ball, and I couldn't get enough. I feverishly scurried and scrounged for more.

Just because I arrived late to Barry did not mean, however, that she appeared ex nihilo on the comic book scene in 2000. As it turns out, she had been creating comics her whole life, as a child and then more professionally for the Evergreen State College newspaper, the *Cooper Point Journal*. While studying for a fine arts degree in the mid- to late 1970s, she published her strip *Ernie Pook's Comeek* in this newspaper, which was then steered by none other than the aspiring cartoonist Matt Groening, who would go on to create *The Simpsons*. Her minimalist "words with drawings" (her preferred term for comics) vignettes brought to life the everyday preoccupations and ins and outs of all variety of anthropomorphic cactus characters and the eponymous

Ernie Pook. And while Barry's stick figure and line art might seem simple, she knew just how to draw a line and write a word that would take readers to surprising new places, psychologically and physically. On one occasion, for instance, we are asked to ponder the significance of Ernie's foot morphing into a cactus. *Ernie Pook's Comeek* caught the attention of the *Chicago Reader*. From there, Barry went on to have a long, healthy run in dozens of nationally syndicated newspapers.

Barry was not creating in a vacuum, of course. As a child she had already discovered underground comix. At the time she knew well that they were not intended for children, but she notes that "kids found them anyway" (*Blabber Blabber Blabber Everything*). Not surprisingly, the work of Crumb and his fellow underground creators at once scared her and enticed her. More than anything, they made her "brave" (*Blabber Blabber Blabber Everything*). They showed her that she too could use words and drawings to talk about anything and everything that was going on around her. Underground comix became her training ground, both in her diligent copying of the artwork of artists like Crumb and Spain Rodriguez but also in training her to watch attentively "the people around me and listen to how they talk and to write down what they say" (*Blabber Blabber Blabber Everything*).

It is not just that in this period Barry's generation was liberated by the underground from the draconian rule of the Comics Code. It was also a period when women comic book creators were pushing open doors so that they too could dip into inkwells to draw their own stories. It was a time when women claimed visual-verbal storytelling art as their own, and not the coveted and protected domain of a cadre of men like Crumb. While these women saw the underground as liberating comic book creativity in general terms, they also saw the creations of males in the new generation as masturbatory ejaculate that only ever objectified and sexualized women.

In response, when Barry was in her late teens and her early twenties, creators like Trina Robbins, Sharon Rudahl, Terry Richards, Lee Marrs, Pat Moodian, Diane Noomin, and Aline Kominsky were clearing room for their gender-affirming stories. One-dimensional female characters no longer functioned as sexualized objects to be *acted on* by men in their self-centered liberation of libido. Rather, female visual-verbal storytelling artists created female characters with a full array of dazzling corporeal and intellectual complexity. Barry was coming of age as a young artist during this great burgeoning of comic book creation by women, with the appearance of significant titles such as *It Ain't Me, Babe* (1970), *Wimmen's Comix* (1972), *Twisted Sisters* (1976), and *Tits & Clits* (1972). In story content and form (lettering, layout, and geometrizing of figures), these female creators sought to inscribe themselves on the page as

"legible, visual drawn" bodies that embodied at once the individual as well as the collective experience of women (Chute, *Graphic Women* 3).

Like these groundbreaking pioneers, Barry was also driven to give voice and shape to the gendered margins. Barry, however, chose to focus more on creating young girls and teen characters; adult women appear, but mostly as aunts, mothers, and schoolteachers who make up a larger, jaded, and censorial adult world. And in this way, Barry became a key shaper of the postunderground, *alternative* comics scene. As Barry remarks on this transitional moment in comics, "It went: underground, then funk, then punk, then new wave, then alternative, and then, then, then . . . art" (Chute, *Outside the Box* 69). Indeed, that Barry was published in the high-production, full-color *Raw* (known for serializing Spiegelman's Pulitzer Prize–winning *Maus*) says much about her rootedness in this next phase of comics—the *alternative* phase that focused less on drugs, sex, and revolution and more on the mundane everyday. Barry was an active shaper of this comic book scene, but in ways that differed from her male peers like Chris Ware and Charles Burns. Where they tended to go for a highbrow readership like that of the *New Republic*, Barry was more interested in reaching readers who relished the albumen of everyday existence. She created with an eye toward the protoplasmic and vulnerable: young girls and teens very much anchored in their bodies and very much caught up in the viscera of life.

At every stage of her evolution as a creator of "words with drawings," Barry's girls and teens also grow, in both variety and complexity. After deciding she wanted to "make comics with trouble in them" and with drawings that were less controlled and where the line would feel "alive again" (*Blabber Blabber Blabber Everything*), in 1981 she began to make her photocopied and stapled-together *Girls and Boys* series. Gone was the more rigid, stick figure drawing style of *Ernie Pook*; here instead was a four-square layout with dense, multidirectional, multiperspective (cubist) artwork that conveyed a full range of rebellion and anxiety-filled youthful emotions and actions, including the fear of being swallowed alive by parents. She went on to enrich this landscape with the various young girls and teens who populate both DIY and book-published collections such as *Naked Ladies! Naked Ladies! Naked Ladies!: Coloring Book* (1984), *Down the Street* (1988), *Come Over, Come Over* (1990), *It's So Magic* (1994), *Freddie Stories* (1999), and *The Greatest of Marlys!* (2000). In the latter two, using a four-square panel layout and an episodic structure, Barry introduced readers to the freckled, hair-banded, bespectacled first-person narrator/character whose poignant insights into everyday family life refused to dumb childhood down to vapid adult-constructed artifice. Barry's youngsters struggle with pimples, bullying, and an oft-irrational adult world, but their experiences are compounded by life at the socioeconomic margins. Barry richly textured the

everyday life of youth at the social margins in its encounter with, in Chute's words, "the hidden and the traumatic" (*Graphic Women* 114). Barry's carefully chosen (and drawn) words and her multiperspectival artwork shaped readers' perceptions, thoughts, and feelings about young people as they learn to navigate social and physical maps of everyday life. They cleared a safe space for young, vulnerable readers of comics, especially young girls, where they could find verbal and visual refuge from the jaded, unimaginative, and sometimes violent adult world.

Here I return once again to Barry's mind-, genre-, and form-bending *One Hundred Demons* strip (notably collected and published in book form by Sasquatch in 2002). Her "Fruit Loops and sparkle paint" artwork (as she calls it) gives shape to—geometrizes—fact-fictional flashes (gestalts) of insight into life as a girl and as mixed Anglo-Filipina, opening up many opportunities for interventions from critical race studies—as do many of her other works. In her self-identified "autobifictionalographic" series of seventeen episodic word-drawings, her character/narrator self opens a window into her smart and often comical take on everyday encounters with boyfriends, friends, and grumpy older people. To this end, Barry creates a "vital feminist work, resignifying the detritus of girlhood as productive collage by aesthetically revisioning it" (Chute, *Graphic Women* 125). At the same time, she offers us one of the first comics to explore the richness of life growing up mixed-race within a matriarchal Filipino family. That is, this and others of her girl-centered word-drawing stories significantly expand the alternative comics scene, because Barry creates word-drawing stories that open readers' perceptions, thoughts, and feelings to issues of growing up a girl who identifies as mixed-race in the United States. With the deft use of visual and verbal shaping devices at play in *One Hundred Demons*, Barry distills and reconstructs in fictional-factual form the experiences of a mixed-race girl firmly anchored in time and place.

Barry draws from her own experiences growing up with her mother's extended "tangle" of a Filipino family in Seattle; her mother could not live in Wisconsin with her Anglo father, as he ran off with another woman early during her grade school experiences. In an interview with Hillary Chute, Barry describes how she grew up in a bilingual family in a "poor area where there were all sorts of mixes like Japanese and Mexican" and where she "heard a big range of how language was spoken" (*Outside the Box* 74). Barry's re-creation of race and gender does not put whiteness on a pedestal. Indeed, in her re-creation of her own experiences as a young girl growing up loving the beautiful brown skin and smarts of her Filipino cousins, her fictional re-creation of a younger self is one who is transfixed by the beauty, smarts, and physical agility (evidenced in their mastery of hula, for instance) of her Filipino family members. In her

word-drawing reconstruction of her matriarchal clan, she chooses to give shape (layout, perspective, and shape and dimension of character within the panel) and color (brown) to her Filipina mama and grandma in ways that celebrate their Filipinaness. And yet Barry is careful not to use her word-drawing skills to sentimentalize Filipinaness; there is nothing exotic about the way she portrays her cranky mama chain-smoking and reprimanding Barry's younger self, all while code-switching between English and Tagalog words and phrases (*n'ako* and *pu-it* come up often).

Into this distillation and reconstruction that becomes something like *One Hundred Demons*, Barry actively adds the Filipina American experience to the word-drawing, comic book landscape. Melinda L. de Jesús argues that Barry's creation of an in-between racial and ethnic character *with a voice* pushes against a larger American mainstream culture that seeks to disempower and erase such subjectivities. According to Jesús, Barry's refusal to reproduce tired stereotypes of Asian women and girls as passive, submissive sexual objects clears a space for envisioning "alternative conceptions of being that contribute greatly to Filipina American visibility, agency, and decolonization" (74). For Jesús, Barry's center staging of a complex, smart, mixed-race Filipina and Anglo character, along with her complex Filipina family matrix, prevents the erasure of Filipinas as Asians in America—and complicates what Filipinaness is: it can be and is brown and Tagalog speaking, as well as red-haired, fair-skinned mestiza, and English speaking.

Barry is more than an artist working in words and drawings to call attention to girlhood and teen trauma, as many scholars have articulated. She is this, and much more. If we take her body of work as a whole, Barry creates, as Susan Kirtley so nicely phrases it, a "polyscopic ontology of girlhood" (187). In so doing, Barry frustrates our impulse to label her. At the same time, Barry's work is that of a mixed-race Filipina who seeks to blow the lid off word-drawing stories by center staging the reconstruction of young lives that exist in the liminal spaces of identity categories and experiences.

Barry chose a hard path. After the publication of *One Hundred Demons*, Barry could not make a living with her work and resorted to selling items on eBay. Fortunately, her significant body of work not only survives but *thrives* today. Under Chris Oliveros's direction, Drawn & Quarterly has made sure the public knows Barry and her work. After adding her to their steady stable of writers, Drawn & Quarterly published *What It Is* (2008), *Picture This: The Near-Sighted Monkey Book* (2010), *Blabber Blabber Blabber, Everything: Vol. 1* (2011), *Syllabus: Notes from an Accidental Professor* (2014), and *The Greatest of Marlys* (2016). There is much more to come. It is fortunate that this is the case. I say this selfishly, but also because I have seen firsthand Barry's impact

on new generations of Latinx comic book creators such as Liz Mayorga, Cristy C. Road, Crystal Gonzalez, and Serenity Sersecion. One way or another, Barry's work makes these creators brave and confident in creating word-drawing stories that give resplendent shape to memories of places and bodies, gender and race, in new and affirming ways. Barry's word-drawing creations—built out of what many others might consider waste—are the kind of DIY *rasquache* aesthetic that so many Latinx creators identify with. This *rasquache* aesthetic and worldview open minds *and* bodies to the wondrous splendors of this vital, ever-expansive word-drawing imaginarium.

WORKS CITED

Chute, Hillary L. *Graphic Women: Life Narrative and Contemporary Comics.* Columbia University Press, 2010.

Chute, Hillary L. *Outside the Box: Interviews with Contemporary Cartoonists.* University of Chicago Press, 2014.

De Jesús, Melinda L. "Liminality and Mestiza Consciousness in Lynda Barry's *One Hundred Demons.*" *Multicultural Comics: From Zap to Blue Beetle*, edited by Frederick Luis Aldama, University of Texas Press, 2010, pp. 73–92.

Kirtley, Susan E. *Lynda Barry: Girlhood through the Looking Glass.* University Press of Mississippi, 2012.

Contagious Imagination

Brief Introduction:
Contagious Imagination

—Jane Tolmie

When I decided to call this book *Contagious Imagination*, it was prepandemic, and I was thinking of contagion in different ways. Since then I have learned what a privilege as well as a pleasure it is to focus on imagination as contagious and shareable in a very dangerous world. It is with this privilege that this book seeks to reorient our attention to the work and art created by comics producers and professors such as Lynda Barry in particular. The recipient of a MacArthur Fellowship in 2019, Barry continues to attract our attention as someone who both teaches and researches, and who also creates. Her work with children and students is something that makes me think also of Glenn Willmott's afterword for us, on access to and reinvigoration of childlike imagination. The title of a *Washington Post* article says it all: "How MacArthur 'Genius' Lynda Barry Is Exploring Brain Creativity with True Artists: Preschoolers." The MacArthur Foundation describes Barry as a cartoonist, graphic novelist, and educator. In other words, she is the embodiment of research-creation. Natalie Loveless's *How to Make Art at the End of the World: A Manifesto for Research-Creation* draws our attention to "the status of art as itself a form of research" (6). Loveless observes that in the context of the university, the real potential for research-creation "rests in its demands for an inter- or trans-disciplinary perspective that, while marshaling the insights of emerging and developing fine arts research methodologies, exceeds the fine arts proper" (6, 7). The offerings in this book reflect that transdisciplinary approach.

In "The Highs and Lows of Black Feminist Criticism," Barbara Christian speaks to the importance of "rememorying," or the deliberate reconstruction

of memory to void fixed categories (48). Barry is a master of rememorying, whether in her patented autobifictionalography or in her constructions of the memories of her created characters. She is also a master of reshaping participant memory via her workshops and her pedagogical practices, with several of her numerous publications being how-to guidelines for the classroom and for personal use alike. In the classroom and in the process of editing this volume, I have considered and continue to consider some aspects of Barry's pedagogical practice and how they constitute radical critiques of academia and the so-called art world alike. Effectively I, together with the authors and artists in this volume, am framing Barry as both an innovative and a dissenting presence within an increasingly neoliberal academy, and indeed economy.

I have used Lynda Barry's work, especially *One Hundred Demons*, in the classroom for many years now. At first I taught the text lecture style, as I myself was trained, focusing on technique, on memory and trauma, and on Barry's attention to the processes of remembering and forgetting. Over time, however, I found myself shifting to a more practical, hands-on introduction to the work, in which students are encouraged to draw and contextualize a demon from their own past, working quietly and independently but then sharing their work. In making this shift, I was moving away from traditional teaching models that were deeply ingrained in my highly traditional literary training, and moving toward a more affective and interactive classroom style. I too participated in the exercises. The book changed me, and the resulting classroom discourses were startlingly different in their personal and connective tones, and in the processes of learning and unlearning that attended them. Since then, I have been very much influenced by texts such as *What It Is* and especially 2014's *Syllabus: Notes from an Accidental Professor*. I have been trying new things and indeed seeing new things.

In *Syllabus* Barry asks: "Is creative concentration contagious?" (2). Passing on creativity is a constant theme in Barry's work, but I realize now that part of her pedagogical practice is to combat neoliberal environments of competition, perfectionism, individualism, and, in fact, maturity. Her work is precisely designed to break down assumptions about good and bad art, about good and bad writing, about self-doubt, self-hatred, and anxiety. She encourages participants to do the same, resisting and rejecting a world of pressures that drive students toward success, wealth, achievement, and, of course, stress and misery. Barry's work invites readers to reclaim art, childhood, self-care, and self-esteem, and to bypass institutional and commercial structures that restrict access to self-knowledge as well as to comics and art. Also in *Syllabus*, Barry observes: "In grade school we didn't listen critically to stories the teacher read to us. Somehow," she urges, we must "restore that state of mind" (46).

The word "accidental," as in *Notes from an Accidental Professor*, is key to understanding Barry's approach: it is an approach that embraces doodles, questions high art, and resists intentionality. Susan Kirtley's excellent book *Lynda Barry: Girlhood through the Looking Glass* (2012) got us all thinking about childhood and the many and mighty ways in which Barry invites us backward in time, offering us the chance to explore the seriousness, beauty, and, of course, profound dangers of childhood. By integrating childhood and adulthood, however, Barry avoids a retrospective and nostalgic overdose: one is invited back not to *be* a child but to regain and rebuild *some* of what is lost in childhood. Kirtley's detailed study of girlhood throughout Barry's work leads her to the insight that "action is required of Barry's girls, but simply engaging with the world is not enough to flourish. The girls must also act in such a way as to lead themselves away from the corruption and disillusionment of adulthood and back toward the hope and magic of childhood" (190). Turning here to Barry's heroine, or perhaps her antiheroine, from her novel *Cruddy*, Kirtley observes of Roberta Rohbeson that "action in and of itself is not enough" (190). Roberta adapts to the warped adult world and ends up dead. Kirtley points out that "Barry's heroines are most successful when they pursue their childlike exuberance and return to a state of imaginative play. For Barry's girls, crossing the border into adulthood brings inescapable angst and anxiety; and to return to, or continue to dwell in, a younger, more hopeful and imaginative place brings fulfillment" (190).

This brings me back to the opening question of *Syllabus*: "Is creative imagination contagious?" (2). What I realize from teaching or adapting some elements of *Syllabus*, in particular, however, is that we are not merely being welcomed back into childish pursuits but being invited to reconsider and critique the value of some of our academic notions of maturity and progress. Glenn Willmott's afterword is suggestively titled "My Kid Could Do That: Lynda Barry and Subversive Writing for Everyone." He goes on to observe that Barry's "practice of a *writable imagism*, which Barry finds rooted in shameless childhood capacities and pursuits . . . struggles to escape the commodity form of writing and, more profoundly, to subvert an impoverished ideology of maturity in consumerist forms of desire and wealth."

Barry's work frequently highlights the energy flow between classmates and instructor. Paulo Freire, in his seminal work *Pedagogy of the Oppressed*, emphasizes the importance of praxis, of doing with, not for or to. Freire advocates a pedagogy that is liberatory, and it is interesting to note that he refers to this liberation as a "childbirth" (49). This language of returning to childhood is striking. In several key senses, Barry's pedagogy is one that seeks this doing *with* rather than for or to; and as such it is a liberatory praxis, in the dialogic sense.

It is also critical of the pedagogy of the oppressed and of certain aspects of the academy. Freire talks about the first step of unveiling or revealing oppression. Let us consider that for a moment.

In one of my classes, I now use an exercise inspired by *Syllabus*. Early in the term, before I have lectured on Barry or exposed my students to her work in any form, I hand out pencils and crayons and paper and ask everyone to draw a self-portrait. This is a change from the demon or monster I sometimes give them in another set of circumstances. I give them a half hour or so. Then we all exchange drawings—I do it too—and talk about them. I ask the class: Who thinks their drawing is good? Without exception, they all think their drawings are bad, that they cannot draw, and that I should not have asked them to; their tension is much higher than when they are asked to draw a demon or monster. I can legitimately format that as a form of oppression. They are so stressed by this first exercise that they cannot take any pleasure, dare I say childish pleasure, in the praxis of drawing. In many interviews and in her classes, Barry urges people just to draw, to forget about good art versus bad art. She has often highlighted the extent to which asking yourself "does this suck?" hinders creativity and contributes to a culture of shame and anticreativity, as it were. In a 2014 interview with *ARTnews*, Barry stresses the importance of having fun, reengaging with childish creativity. She says in this interview that art is there to save us just as our livers are there to "keep us alive." In the same interview, discussing *Syllabus*, she describes her goal for the book: "I try to attract people who are confident drawing and those who gave up when they were 9. What's fascinating about the people who gave up at 9 is that their drawing style is intact from then. And these people don't realize how valuable that is. It's like watching a baby walking around with a vase, hoping it doesn't break. That's what this book is really about. It's not, 'everybody can draw like Michelangelo!' with rainbows around it. It's about this other astonishing ability that lays dormant in people's untrained hands" (Casamento).

After doing the self-portrait exercise, I show the class a selection of drawings, and we talk about creativity and preconceptions. In *Syllabus*, Barry asks, "What is a bad drawing?" and "How old do you have to be to make a bad drawing?" (16), and these are some of the questions we pursue collaboratively, alongside the many excellent questions that the students provide themselves. In phase two of Freire's pedagogy of the oppressed, which follows on the uncovering or revelation of oppression, "this pedagogy ceases to belong to the oppressed and becomes a pedagogy of all people in the process of permanent liberation. In both phases, it is always through action in depth that the culture of domination is culturally confronted" (54). Every time we start working on portraits in class, I am deeply shocked by the depth to which students have internalized and are intimidated by a whole series of assumptions and assertions about art,

quality, self-worth, and the value of creativity. As with many important things in the classroom, it then becomes a series of processes of unlearning. All good teachers and indeed activists know that unlearning, as in decolonization or antiracism, is just as important as learning, in fact usually more so. The simplicity and accessibility of the physical materials are also key to emphasize here; no specialist equipment or expensive things are needed. No mobile classrooms or advanced technologies are necessary to bring these lessons to a group, though of course those can be useful under some circumstances.

It is important to acknowledge that *Syllabus* is accessible in other ways. Barry offers a self-reflexive critical and pedagogical praxis, showing a willingness to admit mistakes, reflecting here, for example, on overinstruction. This approach and style made me less afraid to try new things through a strategy of critical openness and creative generosity. It is an amazing offering of intellectual and creative property to other educators. As the daughter of a Canadian realist painter, I was raised with highly traditional ideas about art, and the work I do on comics continues to puzzle and alienate my family, who remain wedded to limited and narrow definitions of art and the "art world." But it has been a pleasure in the classroom to see the gradual unfolding of confidences and experiments and insights, into self and others, and very interestingly into politics, that are made possible through active engagement with Barry's work and her pedagogical philosophies. One of the comments that Barry makes in her interview with Hillary Chute in *Outside the Box* really became clear to me in the classroom, which is that memory and imagination are "absolutely entwined" (77). Barry observes: "I don't think they can exist without the other, absolutely not. Like that question, can you remember something you can't imagine?" (77).

Students in my class invariably pointed out how they were remembering new details with each creative exercise, so there was an actual visible connection being made between memory and imagination, right in front of me. Their final project is an extensive scrapbook with a range of creative assignments, moving around between traditional literary analysis, interdisciplinary work, and creative work. This ties in too with Barry's constant returning to childhood, to early memories, and using them to feed her imaginative projects. In terms of liberatory projects, telling one's own story in whatever format has always been key, as so many critics, feminist and antiracist critics in particular, have asserted many times. This too is an aspect of anti-oppressive pedagogy, restoring lost voices or giving shape to lost images. In the same interview with Chute, Barry also points out how much more you notice when you are in the habit of drawing things. You see more because you are looking harder and in more places. And her mastery of memory, especially childhood memory, is the sort that invites people in rather than shutting them out.

I regret that I have not taken one of Barry's workshops myself, though I have watched her online many times and would very much like to take one someday. So another aspect of her pedagogical practice that I have to stress here is her creative generosity, the way in which the theme of passing on imagination is so central to both her creative work—for example, when the art teacher helps her out in *One Hundred Demons*—and her how-to books such as *What It Is* and *Syllabus*. She is inviting you, and others, to pass it on too, just as she does in her invitation to join in the Demons project, inviting the audience in rather than expelling the demons. It is emblematic of her inclusive, expansive, and, I argue, anti-oppressive approach to creative concentration. As we all know, this is a difficult time in academia—and, of course, elsewhere. As we muddle through the increased corporatization and face sky-high rates of adjunctification in academia, coupled with crushing service loads for everyone; as our students increasingly apply a corporate model to their classrooms, to their teachers, and to their grades—they want value for their money—Barry's emancipatory creative model gives me hope. I have recently been following many related debates very closely, often with a sense of frustration and emotional drainage. Barry's work reinvigorates me when I am feeling and living these lows, both through her own approach and through the renewed energy I share with my students and colleagues. I will be continuing to research and theorize her various pedagogical models in my upcoming work and teaching, with gratitude and in the hope that, in the vein of *One Hundred Demons*, creative and intellectual generosity truly is something that no one can take away.

Frederick Luis Aldama provides the foreword for this volume, and Glenn Willmott the afterword. Both Aldama and Willmott focus on the synthetic mind-body impact of Barry's outputs. I have divided the book into four parts: "Teaching and Learning," which focuses on critical pedagogy; "Comics and Autobiography," which targets various practices of rememorying; "*Cruddy*," a self-explanatory category that offers two extraordinary critical interventions into Barry criticism around a challenging text; and "Research-Creation," which offers two creative, synthetic artistic pieces that embody and enact Barry's own mixed academic and creative investments.[1] As this volume goes to press, Barry's online workshop for *Graphic Medicine*, participated in by one of my graduate students, appeared this very day on my Facebook.[2] Such moments bring it all together for me: pop culture, artwork, and art *work*. Barry's investment in the by its nature interdisciplinary, transdisciplinary vision of *Graphic Medicine*, which juxtaposes comics and health care, her sharing of teaching and learning simultaneously, offers a snapshot of her in continued, continuous action, bringing my investment in her contagious imagination to a natural and fitting—and inspiring—end.

NOTES

1. I thank all the contributors for their patience during my long postaccident medical leave. Editing errors that remain are of course my own. I owe many thanks to Leah S. Misemer, who generously stepped in to help me out during my ongoing recovery.

2. Graphic Medicine's Facebook page, July 8, 2016, https://www.facebook.com/Graphic-Medicine1/photos/a.126487967401266/1315367795179938 (accessed March 19, 2021); see also https://www.graphicmedicine.org.

WORKS CITED

Barry, Lynda. *Syllabus: Notes from an Accidental Professor*. Drawn & Quarterly, 2014.

Casamento, Nicole. "How Non-artists Can Draw: Comics Great Lynda Barry on Teaching Creativity." *ARTnews*, June 5, 2014. http://www.artnews.com/2014/06/05/comics-artist-lynda-barry-on-teaching-non-artists-to-draw/.

Cavna, Michael. "How MacArthur 'Genius' Lynda Barry Is Exploring Brain Creativity with True Artists: Preschoolers." *Washington Post*, November 22, 2019.

Christian, Barbara. "The Highs and Lows of Black Feminist Criticism." *Reading Black, Reading Feminist*. Edited by Henry Louis Gates, Penguin, 1990.

Chute, Hillary L. *Outside the Box: Interviews with Contemporary Cartoonists*. University of Chicago Press, 2014.

Freire, Paulo. *Pedagogy of the Oppressed*. Continuum International Publishing Group 1970, 2012.

Kirtley, Susan E. *Lynda Barry: Girlhood through the Looking Glass*. University Press of Mississippi, 2012.

Loveless, Natalie. *How to Make Art at the End of the World: A Manifesto for Research-Creation*. Duke University Press, 2019.

TEACHING
AND
LEARNING

Chapter 1

Hand-Drawn Images and Playful Pedagogy: Experiencing Lynda Barry's "Writing the Unthinkable"

—Melissa Burgess

We drew monster after monster, some ten feet tall and covered in yellow fur, some covered in scales and spots. We read aloud stories written in nine minutes or less. We sketched sixty-second self-portraits every morning. We sang an Emily Dickinson poem, "There Is Another Loneliness," to be exact, to the tune of the Beach Boys' "California Girls" and morphed "Sheena Is a Punk Rocker" by the Ramones into a spiritual incantation. We had an impromptu late-night dance party after watching *Saturday Night Fever* and pretended we were John Travolta in the glow of the flashing overhead lights of the classroom. We listened to our teacher recite Rumi's "The Diver's Clothes Lying Empty" several times a day as we centered ourselves and prepared for another mind-opening writing or drawing exercise. We saw the beauty and power of creation as line after line came out of our hands every day, lines that merged together to create images to be shared with our teacher and with our classmates, images that made us laugh and some that made us cry. We contemplated the nature of images and examined their importance and function in our lives. We learned and grew as writers, as artists, and as people. We had fun.

This wide-ranging and seemingly unbelievable list encompasses only a fraction of my experiences during my time as a student in Lynda Barry's interac-

tive and ultimately life-changing writing and drawing workshop, "Writing the Unthinkable." I was extremely fortunate to have the opportunity to participate in a five-day incarnation of her long-running workshop at the Omega Institute in Rhinebeck, New York, in July 2015. During my time with Barry, I was given space to reflect on my own process of creation and saw it begin to shift and morph into a more energized and meaningful process. I saw myself becoming more fearless as a writer and as an artist because of Barry's fun, fast, and extremely effective writing and drawing lessons and exercises. "Writing the Unthinkable" succeeds because Barry, acting as a trusted, relatable mentor and caring guide, cultivates a nonjudgmental, playful environment where students are supported to become producers, composers, and creators of their own images.

For me as a student, Barry's impact as an engaged and connected teacher has been immeasurable. Before "Writing the Unthinkable," I was reluctant to refer to myself as a writer. I never thought of myself as particularly "good" at writing, despite years of positive feedback from my professors as a graduate student working on my doctorate in English, as a literature and composition instructor, and as a longtime consultant for my campus writing center. Although I wrote all the time and worked hard to teach others how to write with style, clarity, precision, and excitement, I nevertheless had felt like a fraud identifying myself as a writer. I believed that good writers did not struggle and were always confident in their abilities. Because I did struggle and almost always doubted my abilities, I assumed that thinking of myself as a "real" writer was an unattainable goal.

This harsh and ultimately incorrect perception of myself as a nonwriter has been stifling, sometimes paralyzing me for years at a stretch. As a child and adolescent, I wrote often and in many contexts: diaries or journals, letters to pen pals and friends, poems and short stories. But as I progressed up the academic ladder, I associated writing less and less with freedom, experimentation, and play, and more and more with grades, pressure, vulnerability, and doubt. As a first-generation college student, I had to navigate an unmapped terrain for years. I was the first person in my immediate and extended family to go to graduate school, much less to earn a doctoral degree, and this relative isolation from my traditional familial support system pushed me to seek out mentors, guides, and encouraging voices among the scholars and professors around me instead. Extending my support system to include a highly regarded author such as Barry seemed like an outrageous impossibility, to say the least.

When I learned that she would be offering a workshop that I could feasibly attend, I knew I had to jump at the chance to participate. Her writing has inspired me again and again, so much so that her 2002 graphic memoir, *One Hundred Demons*, became the subject of a chapter of my dissertation on twentieth- and

twenty-first-century women's life writing. In fact, my doubt and uncertainty surrounding my then still-in-progress dissertation was one of my biggest reasons for participating in the workshop in the first place. I sought a new kind of awakening in my own creative process, hoping to recapture the feeling that writing can be rewarding, rejuvenating, and healing, and not something to be dreaded and avoided. Furthermore, I wanted not only to experience "Writing the Unthinkable" as a student and as a writer but also as an autoethnographer.

Understanding "stories and storytelling as ways of knowing," I took copious notes during my time with Barry with the ultimate goal of eventually representing my experience through a narrative that could be shared with others (Adams, Jones, and Ellis 10). As Tony Adams, Stacy Holman Jones, and Carolyn Ellis argue, the autoethnographic approach allows researchers to "look *inward*— into our identities, thoughts, feelings, and experiences—and *outward*—into our relationships, communities, and cultures" (46). By examining and sharing our own "epiphanies" with others, "those remarkable and out of the ordinary life-changing experiences that transform us or call us to question our lives," we have the potential to bring about both individual and cultural change (26).

Experiencing "Writing the Unthinkable" has undeniably shifted my perception of myself as a writer, as a teacher, and as a human being. One hundred pages of handwritten stories and drawings flowed out of me over the span of those five days, all due to Barry's gentle guidance. I was asked to draw self-portraits, create original characters and comic strips, and hand copy photographs in less than a minute. I wrote dozens of autobiographical stories about my childhood and adolescence and fictional stories inspired by characters spontaneously created by my classmates only moments earlier. What I realized by the end of the workshop experience was that I had always had the power and ability to create, but I needed Barry's constant enthusiasm and encouragement and her well-crafted student-centered teaching strategies to believe again in my creative potential.

Graphic Teaching: Barry's Pedagogy in Action on the Page and in the Classroom

Barry's oeuvre has long revealed an interest in empowering her readers to trust in their own creative expression and to believe in and foster their own authentic voices. Through works such as *One Hundred Demons* (2002), *What It Is* (2008), *Picture This: The Near-Sighted Monkey Book* (2010), and *Syllabus* (2014), she has continually reached through her comic frames to persuade her readers to become authors and artists themselves.

Early evidence of Barry's eager encouragement of her readers appears in her four-panel comic strip "How to Draw Cartoons" from 1981. The strip opens her collection *Girls and Boys,* and her trademark enthusiasm shines through immediately in the luxurious excess of exclamation points scattered throughout the frames. Defining herself as "the famous artist teacher," she begins by exclaiming, "It's Fun! It's Easy! All you need to begin is a pencil, a pen, and a Human Brain!" ("How to Draw Cartoons" 6). Her tone in the strip is immediately inviting and even electrifying, illustrated by an emphatic "LET'S GO!!!!," composed with thick, bold lettering that almost leaps off the page through the use of depth-creating shadows (6). Small smiling faces peek in from the edges of the frame and happily shout through their speech bubbles, "When do we start!" and "Wada we waitin for!" (6). By turning questions into excited statements, Barry creates a warm, enthusiastic, and inviting atmosphere for this potentially intimidating creative journey.

The three subsequent frames playfully break down the art of cartooning. First, readers are given models to emulate as Barry exclaims, "Learn from others! Let's take a look at how others do it!" (6). She draws the heads of traditional comic strip characters like Spider-Man, Charlie Brown, and Little Orphan Annie, but she leaves their faces blank so that readers can see these iconic characters in a new way by focusing solely on the shapes of their heads. In the next frame, she focuses on facial features by breaking down the eyes, noses, and mouths in a handy graph. After offering her readers these visual tools, her pedagogical stance once again shines through. She writes, "Now! Mix 'n' match! Create your *own* character! Try to *flow* w/it! *You* give it a try! Have *fun* with it!" (7). She invites experimentation and highlights her readers' ownership of their finished products. They may begin by using the foundations provided by the artists who have come before them, but what they end up creating will be their "own" (7). Her jubilant tone makes it almost impossible for readers to resist trying out her playful strategies themselves.

Barry's encouragement of readers to learn from established authors while simultaneously trusting in their own innate capabilities continues in her 2002 graphic memoir, *One Hundred Demons.* It is primarily autobiographical, with Barry exploring "demons" from her past, using comics, collages, photographs, and written text; but what sets this graphic memoir apart is its profoundly pedagogical stance. After seventeen chapters of her own autobiographical explorations, Barry concludes by handing the paintbrush over to her readers, offering them a brief how-to guide for creating graphic memoirs of their own. Immediately following a photograph of herself at her desk with a paintbrush in her hand and drawing a picture of a demon, the "Paint Your Demon" outro begins.

Filled with photos of inkstones, ink sticks, and brushes and Barry's handwritten instructions, this short, six-page demon-painting primer is written from the perspective of a trusted friend. She includes personal tips from her own experiences and a series of photographs of her own hand holding a paintbrush and grinding ink. Almost every sentence is enhanced with an exclamation point, and her closing words are "Try it! You will dig it!" (224). As Yaël Schlick argues, the "Paint Your Demon" section serves as "a means of demystifying creativity itself as belonging not to a select elite but to anyone who might pick up a pen to doodle and to write" (42). Barry takes readers through the process step by step and convinces them that trying it out is well within their reach because she has already paved the way. Similarly, Hillary Chute observes that this section of the text "lays bare its own procedure" as a means "of inspiring others" to begin a similar project themselves (301). Barry effectively moves her readers into the author position by offering guidance and a low-pressure, low-stakes starting point.

In her subsequent publications, namely, *What It Is* (2008) and *Picture This: The Near-Sighted Monkey Book* (2010), her confidence-building call to action to readers to participate in their own creative ventures becomes even more pronounced and comprehensive. These mostly nonnarrative, nonlinear texts find Barry working through and oftentimes performing pedagogical practices she has developed through her work as an artist, a writer, a professor at the University of Wisconsin–Madison, and the leader of her "Writing the Unthinkable" workshop. Nathalie op de Beeck argues that the "creative writing and illustration exercises" found in these "scrapbook-style how-to book[s]" build on "free association and can generate active critical thinking" (170). Similarly, Susan Kirtley asserts that Barry uses her exercises "to develop a creative spark in the reader" and that her choice of a nonlinear formal structure gives her audience "the power to study the text in an order that makes sense to each individual, dipping into various sections randomly or following a more linear progression" (346). In both texts, readers are given control and choice as Barry presents a multitude of rigorous but also playful techniques, including ways to choose a subject to write about or draw, exercises to generate story details, and prompts that set helpful time limits to allow for greater productivity and fearlessness.

Andrea Lunsford calls *What It Is* "a dizzying, exhilarating, sometimes even maddening *performance* of teaching" (312), an apt description that can be applied equally to *Picture This: The Near-Sighted Monkey Book*, which is even more explicitly an activity book, meant to be taken apart, reworked, written in and drawn on, dismantled, and added to. It is a playground-in-a-book, quite literally filled with places and spaces to "copy, cut, trace, and color," easing readers into the long-lost childlike mind-set wherein they embraced the

creative process (Barry, *Picture This* 18). And, once again with distinctive and overflowing exuberance, Barry directly encourages the reader's participation by exclaiming, "Why not say, 'Heck Yes!' You can do it too!" (225).

Syllabus, published in 2014, provides the clearest depiction of Barry's pedagogy. The text itself is composed of actual teaching notes and assignments from her courses at the University of Wisconsin–Madison. Her teaching experiences and materials are presented through a traditional composition notebook, effectively letting the reader see her work through her teaching past. Here again, readers are privy to her reflections on what art and the act of creating by hand have done for her and her students biologically, mentally, intellectually, and emotionally. Her "Writing the Unthinkable" workshop, then, serves as a living embodiment and extension of these pedagogical texts.

As a workshop leader, Barry helps participants tap into their creative imaginations. She aims to "set the right conditions for insight" so that what she calls "the back of the mind" may come forward, allowing the stories and images that already exist the opportunity to be expressed (Barry, "Writing"). She helps the class not only to *produce* images but also to consider the *process* of creation itself. By sharing personal anecdotes, bringing in scientific research on the brain and the biological function of the arts, and taking her class through countless writing and drawing exercises geared toward helping students create without fear or hesitation, Barry explores the question of "what's going on in the brain when we're in a certain image-making/mark-making frame of mind" and examining how images move and transfer from person to person, across time and space (*Syllabus* 9).

Regarding the movement of images, she observes, "Something inside one person takes external form—contained by a poem, story, picture, melody, play, etc.—and through a certain kind of engagement, is transferred to the inside of someone else" (*Syllabus* 9). Art itself, then, is "a transit system for images" (9). And, in Barry's classroom, any kind of image is welcome to be shared. In her characteristically exuberant style, she describes her workshop with visual emphasis and an abundance of exclamation points: "Write STORIES as NATURALLY as You Dream Them!!! Use: Memory!!! Pictures!!! Ordinary Words!!! Laughing!!! NO IDEA IS TOO SMALL!!!!" (Barry, "Workshop Description"). She pushes her students to trust their own ideas and follow through with their own creative instincts to write, draw, and share any images they wish. She explains, "*All* stories are welcome in this classroom. Any subject, any mood: happy, dark, sad, weird, puzzling" (Barry, "Writing"). Students are encouraged to explore whatever direction their minds and hands take them, and with this openness, Barry dismantles a potentially detrimental obstacle to creative expression.

Using simple materials is also an instrumental part of Barry's teaching philosophy. Everything created within the workshop is made by hand, using only basic sheets of lined loose-leaf paper, 4 x 6 index cards, and basic pens or pencils. The choice of accessible materials is a conscious one for Barry, who argues that "simple thing[s]—our hands, a pen, and some paper—[can be used] as both a navigation and expedition device," as vehicles we can use to travel through "the image world" (*Syllabus* 4). Expensive materials and tools like laptops, iPads, smartphones, high-quality papers, inks, or writing utensils are not needed to travel there, only human hands, or as Barry calls them, "the original digital device[s]" (*Syllabus* 157). Similarly, Barry aims to "unhitch drawing [and writing] from the cart of Art with a capital *A*," to see creating instead as an experience that should not be limited only to those who were born with some kind of innate writing or drawing talent or those with advanced artistic training (Barry, "Writing"). For Barry, everyone can and *should* partake in the psychological, emotional, and sometimes even physical benefits of creative expression.

But, she argues, the chance to access the frame of mind that allows for artistic creation in the first place, the frame of mind wherein we use our hands to create something even if we do not know what its purpose will be and even if we think the final product will be "bad," is often stifled before it can surface. Upon beginning a creative experience, many adults encounter fear, anxiety, insecurity, and other all-too-familiar forms of self-doubt, which in turn leave us paralyzed, giving up on the creative process altogether because we are convinced that it is something best left to the so-called experts. Regarding these artistic endeavors, Barry explains, "Worrying about its worth and value to others before it exists can keep us immobilized forever" (*Syllabus* 163). To help overcome the threat of immobilization and silence, Barry gives her students tools to fight back against their own self-doubting inner critics.

The Workshop Begins: First Impressions, Ground Rules, and Personal Realizations

As I traveled from Missouri to New York on a hot day in July to attend "Writing the Unthinkable," all of Barry's works circled in my mind. As one of her devoted readers, I had already felt again and again the impact that creating without fear could have on my life and on my mental well-being, and knowing that I would soon be able to hear her speak in person filled me with more anticipation that I knew how to handle. After my long day of impatient travel, I woke up earlier than necessary on my first morning at the Omega Institute in the Hudson River Valley. I set out from my tiny cabin in the woods, feeling like a

nervous kid on her first day of school. I breathed in the fresh air and tried to prepare myself for what awaited me. Would Barry be everything I hoped she would be? Would I do well? How was I not only going to write but also share my writing with a group of strangers and Barry herself? And drawing? What was I getting myself into? These questions nearly overwhelmed me, but I willfully forced the doubts from my mind. As I neared the classroom, I told myself this would be a week of empowerment, adventurousness, and transformation.

Before I even set foot inside the classroom, I was greeted by a surprise welcome message that confirmed my newly established positive outlook. On a large easel outside the door, Barry had sketched herself as her well-known avatar, the near-sighted monkey, smiling and holding a heart with the greeting "I'm so glad you're here!" (Barry, "Writing"). She has used this avatar in several of her publications, most notably *Picture This: The Near-Sighted Monkey Book*. As a longtime reader, I immediately connected to the iconic image and felt this seemingly simple gesture began to establish the welcoming environment I had hoped for. I felt connected to her before even meeting her. It was a profound and much-needed reminder that images do indeed carry immense power.

As I crossed the threshold, I encountered a spacious room filled with long rows of tables. Barry was seated at a desk at the far end of the room, organizing her notes and readying herself for the day, her trademark bandanna tying up her hair. With a little sadness, I registered that there were many more students than I had expected: around seventy altogether, women and men of all ages. I wondered how I would have the chance to forge a personal connection with Barry when so many of us would be vying for her attention. Our large class size would not, however, be a problem because she would make a point to reach out to each of us personally. And, for me, her openness and willingness to connect was especially significant. As the week went on, I felt more willing to open myself up to her because I felt that she was genuinely interested in my growth as a human being.

The room was divided into two halves, with long rows of tables that faced each other. With such a large class, a circular structure was simply not feasible, and this setup was the closest we could get to a nonhierarchical, decentered space. As classmates, we faced each other and, simultaneously, the center of the room. I could see as well that Barry would further decenter the space by placing her seat not at the far end of the room by her desk but instead by the wall in the midst of our long rows of tables. With her seat on the sidelines of our as-close-as-could-be circle, we were a connected group. Somehow our group of seventy strangers immediately felt intimate and close.

This feeling of unexpected intimacy was amplified when Barry began the first day not with a simple and expected "Hello, class!" but instead with a song.

Her voice rang out, and our large group quieted as she sang a silly song about her love of the uni-ball pen. She next shared with us her camp name, Professor Squirrelhead, and asked us to decide on camp names for ourselves. The playfulness of such a gesture immediately set me at ease, and for the next five days, I became Clementine, a name I borrowed from my own wonderful cat. My new camp name brought with it a certain level of anonymity and fearlessness when we began the intensive writing and drawing exercises shortly thereafter, and it also brought back childhood memories of being at summer camp, a time I still connect with growth, exploration, and transformation.

And, of course, it is worth noting that this exercise of choosing a camp name or pseudonym aligned with the physical and mental environment in which our workshop was taking place. The Omega Institute, while not a summer camp exactly, is an organization focused on the spiritual, intellectual, mental, and physical growth and learning of thousands of students at its Rhinebeck campus in various workshops every year. Instead of working with Barry in a typical classroom setting, we were surrounded by the natural beauty of trees, lakes, and gardens, in a space where internet access is extremely limited, cell phones are frowned on, and mindfulness is key. The retreat-like environment makes the process of creation everyone's biggest priority, and living in a cabin for those five days allowed me to achieve a different and, I argue, substantially more profound depth of thought than if I had met Barry in a more traditional school environment. Spending the previous evening in a hammock beside a quiet lake before slowly walking back to my cabin in the dark meant that my first day with Barry began with an open, calm, and centered frame of mind.

She began by laying out the ground rules for our class. All our writing and drawing exercises would be timed. Sometimes we would be able to write for nine minutes, sometimes five or less, and our drawings could take as little as sixty seconds or over two minutes, but we would always be timed. The feeling of being timed was, of course, pressure filled, but it was also liberating. The speed at which I worked kept my deeply ingrained demons of self-doubt from surfacing and pressured me to produce more than I could have expected. Stories flowed out because I did not have a chance to stop them from emerging. I did not have time to deliberate over the right word or the right way of beginning or ending a train of thought.

In addition to the fast-paced timing, Barry insisted that our hands must always be in motion. If we found ourselves at a loss for what to write next, we could simply write "tick tick tick" or start writing the alphabet "until the story start[ed] again" (Barry, "Writing"). What was written was not as important as the very deliberate act of making sure to "keep your pen moving for the entire session" ("Writing"). We also were not allowed to read over, change, add to, or

delete anything we had written until the workshop was officially over. We had to resist the urge to edit the images we produced, not only in the moment of composing itself but also when we could see the finished products at the end of the session. Barry also insisted, "We NEVER talk about the stories we hear in this class—not to each other, not to people outside of class, and especially not to the reader" ("Writing"). Doing so helped us feel confident that what we chose to write would not be censored or judged, would not be torn apart and criticized, and most importantly would not be deemed unworthy or "bad." Barry reinforced this rule every time a student shared her or his work. As each story ended, her only response would be to look at the writer and say, "Good, good, good," and nothing more ("Writing").

Experiencing the Daily Writing Exercises
and Emerging with a New Writerly Identity

After describing the ground rules for the class, Barry asked us to open our binders to a fresh, blank page, and we jumped right in. We began each writing exercise by listening to Barry reciting Rumi while our hands made slow, tight spirals on our pages. I would look down and think only of the line emerging from my hand, not my worries or fears, not even about the people around me. The line was at the forefront of my mind, mingling with Barry's voice gently proclaiming, "You are in your body / like a plant is solid in the ground, / yet you are wind. / You are the diver's clothes lying empty on the beach" (Rumi 51). The process of creating spirals while immersed in Rumi's images inspired a feeling of quiet, calm focus and also, in a sense, a separateness from myself that helped me put aside my long-held insecurities for a moment as I readied my mind for the exercise to begin.

First, Barry would ask us to number a blank page from one to ten. Then she would give us a topic to work with, such as neighbors, walks from our pasts, other people's mothers, other people's fathers, and even accidents. Barry would provide us with no other details than these sparse prompts, and we would fill in our numbered lists with the first ten images that came to our minds. Then we had only a few seconds to choose one subject from our list to be the focus of this particular exercise. Sometimes I would immediately, and often instinctively, be drawn to one of my possible subjects; sometimes Barry chose for us, either by simply calling out a random number or even by rolling a ten-sided die.

Next we would turn to a blank page and draw an X. Barry called this our X-page, a space where we would gather our thoughts and bring forward the images connected to this subject from the back of our minds. She would pose

questions aimed at helping us visualize our chosen subject from every possible angle. These questions included "What's in front of you?," "What's behind you?," "What's below your feet?," "Where is the light coming from?," and "What's above your head?" (Barry, "Writing"). The diagonal lines of the X prevented us from writing our thoughts in any sort of linear fashion because we did not need to organize our thoughts but simply had to let them come. Her questions forced me to think about aspects of my subject I had not thought about in years and sometimes brought to the surface details I had forgotten. By the end of the X-page exercise, I could clearly see my subject and a potential story in my mind's eye.

Now we were ready to write. Barry would give us a time constraint, typically nine minutes of continuous writing, and we would begin. She would provide minimal direction, often just telling us to write from the present tense using "I am" or "You are." Using this point of view let me reexperience my story during the act of writing itself, and I found I was able to access a stronger level of detail than if I had written in the past tense. And as the clock ticked down, I simply wrote. My hand moved, the words came out, and I felt "that strange floating feeling of being there and not being there" as "a story slowly formed under my hands" (Barry, *What It Is* 135). Each writing experience further boosted my confidence and chipped away at the long-ingrained self-imposed barriers that had shattered my confidence for years.

Barry's playful and unconditionally supportive demeanor also had an impact on my shifting perception of myself as a writer. She began the first day by singing to us and making us laugh and smile, and her enthusiastic and inviting personality continued to shine throughout our week together. Her teaching style is one of intense energy and lively action. Always on the move, she would kneel next to our desks as we read our stories out loud, lean in to see the details in a self-portrait, sing and teach us songs, even dance and encourage us to dance as well. Always present, too, was her infectious laughter. Countless times each day, we had the pleasure of hearing her joyous, loud, and welcoming laugh, accompanied by supportive exclamations such as "These are beautiful!" and "I love this!" (Barry, "Writing"). Her laugh often caused a ripple effect throughout the class, further strengthening our already strong sense of community. This is not to say that we only connected through humor and fun. Several of us chose to write about past traumas or painful memories, and being able to share images and stories from the other side of the emotional spectrum also reinforced our connection to Barry and to each other in a different and equally important way.

The first two days of "Writing the Unthinkable" were filled with innumerable moments when a new understanding of myself as a writer would crystallize.

After every writing experience, Barry would request volunteers to share their creations. I surprised myself with my bravery, quickly raising my hand each time she opened up the floor for a reader, uncharacteristically ready to take the potentially terrifying leap of reading my story to seventy strangers. The supportive and encouraging atmosphere made it a safe space, and I never doubted my newfound impulse to share. I embraced it knowing that if I was chosen to read, my words would not be judged, and more importantly, I would not be judged either. But each day I left feeling a little disappointed because I had not yet been picked; someone else had enjoyed the privilege of having Barry sitting on the floor by their chair with her eyes closed, listening with rapt attention to the images they were conjuring with their words and with their voices. Reflecting back now, though, I see that if I had been called on then, I would not have had the same profoundly life-changing experience I had on the third workshop day. I left the classroom that day with my perception of myself as a writer irrevocably changed for the better when Barry finally chose me to share my story with the class.

The morning of the third day began like the previous two. We started by drawing our self-portraits, priming our minds and our hands for the work that was to come. Then, after two days of writing single-chapter stories, we used a new writing prompt that Barry had developed with the writer Dan Chaon. Inspired by Michael Ondaatje's poem "Seven or Eight Things I Know about Her," the "Character Exercise" required us to write about one character from eight angles or perspectives. We began by thinking of people we "haven't seen in a very long time—living or dead" (Barry, "Writing"). I chose as my subject a friend from my childhood, a girl who was my best friend from fourth to seventh grade, but whom I had not spoken to since we went to our separate high schools years ago. I still cannot fully explain why I felt the desire to make a childhood friend the subject of this exercise, but the back of my mind insisted that something meaningful might lie on the other side of the experience.

After choosing our subjects, we began writing. The process was more fast-paced than usual, as each writing segment was four or five minutes long, a frantic speed that again did not give me the opportunity to question myself. I just wrote. Barry's prompts forced me to dig into the back of my mind to flesh out the character of someone who had been incredibly important to me in my past but had decided one day in seventh grade that we were no longer friends. More than twenty years have passed, and I honestly did not think her mean words and bullying behavior were still affecting me. But as I sat in Barry's classroom writing eight snapshots of my old friend, the long-ago pain surfaced again, mingled with happy memories. It was a cathartic experience to create

her anew on the blank pages in front of me, seeing her character come to life in the images that were coming out of my pen.

After we finished the eighth vignette, Barry asked for volunteers to read. My hand shot up; she saw me from across the room, smiled, and said, "I see you," and started making her way toward my seat. As she approached, time slowed in my mind. I was chosen, and there was no time for fear to take hold. My classmates began drawing their slow, tight spirals as Barry knelt beside my chair, closed her eyes, and asked me to start. I took a deep breath and heard my voice, normally so quiet and reserved, ring out through our large classroom. Seventy people listened to my story, and Barry continually offered her own wordless encouragement by sighing, laughing, or shaking her head in sadness during the particularly painful moments. My words brought my old friend back to me. I could see her butterfly hair clips and blue eye shadow again, I could feel her hand in mine in the schoolyard, I could hear her and her new friend whispering about me after she told me I was no longer good enough to be her friend, and I could see her ignoring me and pretending I did not exist on the last day I saw her, when we were both seventeen. Barry's guidance allowed me to produce images that were incredibly authentic and powerful to me, and as I read, I started crying. Instead of feeling embarrassed or ashamed, I kept going as the tears flowed down my face. My voice cracked and wavered, but the words I had just written and Barry herself were my anchors. Knowing that she was near, truly hearing me, gave me the confidence to continue.

When my story was finished, I could hear others holding back tears as well. My words and images had affected my listeners; they had heard me. I had put my writing on display and opened myself up to a room full of people I had known for only two days, and I had arrived on the other side of my story with the realization that I *could* write. The experience of sharing it with an accepting group of people was crucial, as it helped me see not only how writing could help me access images from my past and from my imagination but also how my writing and my voice could translate and transfer the same images to my listeners. My identity as a writer shifted, and the deeply ingrained belief that my words were unimportant and unworthy began to be dismantled. As my story ended, I looked to Barry. Still kneeling beside me, she took a breath, looked into my eyes, and slowly and genuinely said, "Good. Good. Good." ("Writing"). She uttered one simple word three times, but I had never felt so supported by a teacher in my life.

I lingered behind after class, still trying to process what had just transpired. I wanted to thank Barry for her part in helping me have such an amazing learning experience, but I also did not want to bother her. I should not have worried. As I tentatively approached her, she excitedly exclaimed, "Whoa! That was an amaz-

ing class!" ("Writing"). I grinned when she happily said, "Do you have a minute to talk? Let's sit" ("Writing"). I then had the surreal and meaningful experience of chatting one-on-one with Barry. She helped me unpack and trace how writing and reading my story out loud had affected me. She listened with care and focus, and as our conversation ended, she hugged me and said, "I'm so happy we got to have this experience together. I'm so happy you're here" ("Writing"). I left the classroom that day not only feeling connected to Barry as a teacher and as a person but also enjoying a new sense of possibility and openness to the creative process and a new sense of the place I wanted it to have in my life.

Bringing "Writing the Unthinkable" Home

As our workshop came to an end, Barry advised us to remember the lessons we had learned during our five days together. Before we went our separate ways, leaving behind the comfort and security of Barry's classroom, she told us, "Hold this class together in your mind" ("Writing"). And in the years that have passed since I said goodbye to Barry and the Omega Institute, I have been trying to do just that. The demands of my daily life have inevitably made it difficult to put Barry's creative techniques and exercises into practice every day, but nevertheless I am still fiercely trying to hold on to the sense of confidence, freedom, and playfulness I gained at the "Writing the Unthinkable" workshop. In fact, I relied heavily on Barry's teachings during the process of writing this essay itself. I used her X-page brainstorming technique several times to develop my ideas, composed during short, quick, timed segments, and even wrote by hand during the initial drafting stages. Most importantly, when I became discouraged or overwhelmed, with the threat of writer's block looming over me, I heard Barry's excited voice in my mind, happily exclaiming, "Good! Good! Good!," and felt again the support and encouragement I was lucky enough to experience as her student.

Her pedagogical methods have had a profound and lasting impact, enabling me to feel not only capable and strong as a writer but also empowered and worthy of being heard as a person. Barry helped me realize my creative potential by connecting to me on a personal level and by prioritizing my voice and my lived experience. I plan to apply the lessons I learned from her as a student over those five powerful days to my own pedagogical praxis, letting my experience inform the ways in which I will interact with my own students in the future. I hope to encourage, empower, and support them as much as Barry encouraged, empowered, and supported me by helping them see the classroom as a space of freedom, experimentation, and excitement.

WORKS CITED

Adams, Tony E., Stacy Holman Jones, and Carolyn Ellis. *Autoethnography*. Oxford University Press, 2015.

Barry, Lynda. "How to Draw Cartoons." *Girls and Boys*. 1981. Harper Perennial, 1993.

Barry, Lynda. *One Hundred Demons*. Sasquatch Books, 2002.

Barry, Lynda. *Picture This: The Near-Sighted Monkey Book*. Drawn & Quarterly, 2010.

Barry, Lynda. *Syllabus: Notes from an Accidental Professor*. Drawn & Quarterly, 2014.

Barry, Lynda. *What It Is*. Drawn & Quarterly, 2008.

Barry, Lynda. "Workshop Description: Writing the Unthinkable." Omega Institute for Holistic Studies. https://www.eomega.org/workshops/writing-the-unthinkable.

Barry, Lynda. "Writing the Unthinkable." Omega Institute for Holistic Studies, Rhinebeck Campus, Rhinebeck, NY, July 19–24, 2015. Workshop.

Chute, Hillary. "Materializing Memory: Lynda Barry's *One Hundred Demons*." *Graphic Subjects: Critical Essays on Autobiography and Graphic Novels*, edited by Michael A. Chaney, University of Wisconsin Press, 2011, pp. 282–309.

Kirtley, Susan. "Considering the Alternative in Composition Pedagogy: Teaching Invitational Rhetoric with Lynda Barry's *What It Is*." *Women's Studies in Communication*, vol. 37, no. 3, 2014, pp. 339–59.

Lunsford, Andrea A. "Reflections on Lynda Barry." *Graphic Subjects: Critical Essays on Autobiography and Graphic Novels*, edited by Michael A. Chaney, University of Wisconsin Press, 2011, pp. 310–13.

op de Beeck, Nathalie. "Autobifictionalography: Making Do in Lynda Barry's *One Hundred Demons*." *Teaching the Graphic Novel*, edited by Stephen E. Tabachnick, MLA, 2009, pp. 163–71.

Rumi. "The Diver's Clothes Lying Empty." *The Essential Rumi*, translated by Coleman Barks, HarperCollins, 1995, p. 51.

Schlick, Yaël. "What Is an Experience? Selves and Texts in the Comic Autobiographies of Alison Bechdel and Lynda Barry." *Drawing from Life: Memory and Subjectivity in Comic Art*, edited by Jane Tolmie, University Press of Mississippi, 2013, pp. 26–43.

Chapter 2

Interventionist Teaching: (Re)Writing Trauma in the Work of Lynda Barry

—Mark O'Connor

Since the publication of her first collection of comic strips in 1981, Lynda Barry has been presenting a nearly three-decades-long tutorial about drawing and writing comics. Her earliest collections *Girls and Boys* (1981), *Everything in the World* (1986), and especially the ironically titled *Fun House* (1988), present a childhood populated by inept, sadistic teachers and lousy parents. The classroom, if these children are lucky, is merely a place of benign neglect. In the worst cases, it is a site of active abuse. At home, children fare no better, often subject to lackadaisical or abusive parenting. Barry's deployment of awful teachers acting on captive students and sometimes well-meaning but equally awful parents and other adults limns a traumatic landscape escapable only by finding agency in creative acts, like making comics.

Barry's slow inclination toward an overt pedagogy is enacted through a series of avatars over the years, until she claims her ground as an effective and compassionate teacher starting with *One Hundred Demons* (2002) through *What It is* (2008), *Picture This* (2010), *Syllabus* (2014), and most explicitly in her latest book, *Making Comics* (2019). The fully realized narrative persona of a confident pedagogue is only possible through her shift from fiction to autobiography in her writing and is concomitant with her professorship at the University of Wisconsin, previous tenure at the Omega Institute, and her barnstorming tours throughout the United States offering her creative writing

workshop "Writing the Unthinkable." In her most recent books, she extensively features student work, privileging a pedagogy counter to the prescriptive teaching she encountered as a child.

How to Draw Cartoons

The opening comic of Barry's first collection, *Girls and Boys*, is a self-referential four-panel sequence titled "How to Draw Cartoons." The first panel has the over-the-top enthusiasm of a new teacher on the first day of school, with a generous mix of cajoling and exclamation points. The cartoon begins with a self-portrait in a roundel, noting that the strip is by "the famous artist teacher Mrs. Lynda." Barry draws herself as a smiling baby with a gargantuan head. Just below, in quotation marks, is the promise "I can teach you to draw so anyone will want to be your partner," signed with her initials (fig. 1). The mocking self-portrait is interesting, particularly in light of highly accurate self-portraits in later books like *One Hundred Demons*. Even this early in her career, Barry's drafting skills are substantial (witness her spot-on replications of Little Orphan Annie and Ernie Bushmiller's Nancy). In spite of the implicit links between the author and narrator created by naming herself in the strip, this odd self-portrait opens up distance between Barry as author and Barry as the artist/narrator. By calling herself "Mrs. Lynda," the young, unmarried Barry is adopting the fictional persona of the many older female teachers she will deploy in later books.

This assumed confidence is emphasized by a series of imperatives, denoted by all-capital letters and wavy underlining, noting "its fun" and "its easy," among other encouragements.[1] A helpful materials list includes "a pencil, a pen, paper, and a human brain," this last item a funny but obviously crucial element in any creative act.[2] A helpful, smiling figure intrudes three times from the panel's border, asking, "When do we start," or offering encouragement, "This parts easy." The question "Wada we waiting for" leads readers to the largest words in the panel, the all-capitalized "LET'S GO" in the center, followed by four exclamation points. This intrusive figure operates as a second layer of narration, echoing the main point of this panel and the strip, the apparent ease of making comics. This figure will reappear crucially in panel 4.

However, the bottom half begins a counternarrative. All the initial energy and enthusiasm is undercut with "The *first* thing you'll want to think about is what you'll say in the *INTERVIEW* with *TIME MAGAZINE* after they select *YOU* as CARTOONIST of the YEAR!!!"[3] This self-aggrandizing seems out of place and operates ironically, evincing a discomfort with the pedagogical

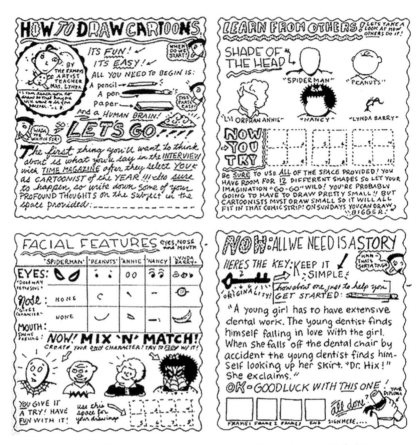

Figure 1. Lynda Barry, "How to Draw Cartoons." In *Girls and Boys*, pp. 6–7. © Lynda Barry.

project. As Linda Hutcheon explains, "Incongruities or seemingly inappropriate details are not interpreted as signaling deception or error—these are our normal 'default assumptions'—but as marking ironies to be inferred" (21). The irony to be inferred is about the project of drawing cartoons and sets up an interesting tension prevalent throughout much of Barry's early work, between the need for expressive creation and the seeming impossibility of such expression.

In the second panel, she offers a series of cartoon head outlines for practice, including Spider-Man, Charlie Brown, Little Orphan Annie, and Nancy. She also includes a fifth option—Lynda Barry, except there is nothing to complete. The outline she provides for Lynda Barry looks like a spider or perhaps a tuft of hair. Without knowing what the "real" Lynda Barry looks like, it is impossible for readers to successfully complete this assignment, as the young and anonymous artist has no signifiers. She cannot be drawn.

This contrasts starkly with the red-haired, freckled Lynda avatar who appears in various ages throughout *One Hundred Demons*, a book that includes black-and-white photographs of Barry herself at her drawing table. While *One Hundred Demons* overtly merges author, narrator, and protagonist textually and visually, it also foregrounds Barry's interest in the space between fiction and nonfiction, an idea she discusses in the introduction and the use of her neologism "autobifictionality." *One Hundred Demons* is the transitional book between these earlier fictions and the overtly autobiographical teaching methods displayed in *Syllabus* and *Making Comics*, where she confidently claims her ground as an instructor.

Even amid seemingly silly instructions like mixing and matching the facial features of famous cartoon characters (e.g., Charlie Brown with a pig nose and Nancy wearing a Spider-Man mask à la Joe Brainard), Barry announces a leitmotif of her work, the simplicity of drawing comics.[4] Barry offers an easy solution to readers who cannot draw: using "swipes" from other comic strips, as Chris Ware calls them.[5] Barry confessed to using swipes very early, starting in middle school: "The first person I wanted to draw like was Dr. Seuss, and I find myself coming back to him again and again, still copying. I think copying someone's work is the fastest way to learn certain things about drawing and line. It's funny how there is such a taboo against it. I learned everything from just copying other people's work" (Schappell). Her first effective teachers were outsider artists, many of whom, like Big Daddy Roth and Robert Crumb, she discovered beyond the classroom.[6]

In these instructions, Barry casually dispenses with the apparent difficulty of how to draw, and in comparison to her more recent work, these drawings seem rushed, though critics have long remarked on her "raw, funky, squiggly-lined style of drawing [that] has set her apart from other graphic artists" (Schappell).[7] The second and third panels contain empty practice boxes, hearkening to period draw-the-pirate advertisements for correspondence art schools that had long populated the backs of mainstream comic books,[8] and prefiguring explicit comics drawing instruction books like Ivan Brunetti's 2011 *Cartooning: Philosophy and Practice*,[9] an artist to whom Barry dedicated *Making Comics*. Barry's acknowledgment of her sources of visual inspiration here also shows a willingness to mix genres, creating mash-ups of various formal elements in her graphic novels as well as collapsing boundaries between canonical literature and everything else. Her privileging of everyday materials and "low" sources of inspiration (spectacularly demonstrated in the lush, textured *One Hundred Demons*) is an area of extensive critical work.[10] This mixing of genres, materials, and inspirations is suggestive of the path Barry will take in the ensuing decades for her art and pedagogy.

However, Barry's confidence about drawing comics is not matched by a confidence about how to write comics. In the fourth panel, she notes, "Here's the key" to writing well, accompanied by a drawing of a skeleton key, under which "originality" is written. The seemingly good writing advice "keep it simple" is difficult to read without irony, as originality is weighted in light of the previous panels that suggest using remixes from other comic artists as starting points. Adding to this instability, the formerly encouraging talking-head figure from panel 1 reappears, noting, "Hmm—that's sorta tough." At the same time Barry promises that making comics is "fun" and "easy," this figure suggests its difficulty where writing is concerned. Perhaps this is a just an aside to Pound's dictum to make it new or, more likely, a realization that writing well is extremely difficult, fraught with the "prohibitions, roads that may not be taken," to which Donald Barthelme refers.[11] Like the discouraging voices from *One Hundred Demons* who interrupt her work with criticisms like "This is pointless" and "What a waste of paper" (n.p.), this intruding voice undercuts the helpful instructions. By *One Hundred Demons*, Barry had found a way out of this cul-de-sac through her fusion of fiction and autobiography, but here she is struggling to find her way.

Barry does offer a narrative from which readers can draw inspiration: "A young girl has to have extensive dental work. The young dentist finds himself falling in love with the girl. When she falls off the dental chair by accident the young dentist finds himself looking up her skirt. 'Dr. Hix!' she exclaims." The moment is funny partly because of the pratfall and partly because of the young girl's response to the dentist's lechery, but it is not necessarily a simple story.

A countervailing narrative voice arrives via a coda in all caps, "OK—GOOD LUCK WITH *THIS* ONE!" Is the good luck needed because of the difficulty of writing a story with this prompt, for writing interesting comics in general, or for something else? Barry is unclear. The slipperiness of the narrative intention makes the four panels difficult to read without irony.

The comic ends with four small blank squares, helpfully labeled "frame one," "frame two," and so on, presumably spaces for budding comic artists to create their own work. However, these squares can also easily be read as the personal spaces for the young Lynda Barry to write her own life through making comics, empty panels that, at the time, had yet to be filled. In the decades after *Girls and Boys*, Barry will make her reputation through her distinctive DIY style, "crude but evocative line drawings surrounded by swaths of hand-written narration" (Casamento) that made its initial appearances in alternative newspapers like the *Chicago Reader* and the *Village Voice*, matched with her unflinching, laser-like focus on the traumas of childhood.

This self-reflexive, tutorial comic that opens her first published collection ends with a question, "all done?" and shows a hand holding "your diploma." It

seems unlikely that twenty-five-year-old Lynda Barry could imagine a time when she would be a highly regarded professor in a renowned graduate creative writing program, a MacArthur "genius" grant winner, or that an institution like the Center for Cartoon Studies would exist.[12] At this point in her career, the diploma has to be read as ironic, a discomfort with the project of making art, or at least this kind of art, one that would never be lauded, canonical, or taught in college classrooms.

Barry has yet to find her footing in these early works. Over time, how to write will come to displace the importance of how to draw, until she comfortably merges both instructional goals in her latest books. Her seeming discomfort with the pedagogy of making comics will take many books and years to erase.

Bad for You: Of Terrible Teachers and Lessons Learned

The list of foolish, terrible, or sadistic teachers in Barry's oeuvre is extensive. In *Girls and Boys*, Miss Parfet is easily deceived by Andy, a boy who is looking at "naked pictures" hidden inside his math book. When called on, he tells Miss Parfet his mother is "real sick" (12) and "probably dead by now" (15). She falls for this excuse. Amazed that his lie works, Andy is immediately wracked by guilt and a fear of discovery, asking "What have I done" (15). The readers, narrator, and other students know he is lying. This strip demonstrates the gullibility of teachers that often appears in Barry's work, partly as a way of indicting the enterprise of the classroom, which, with rare exception, is a site of repression that quashes any signs of creativity.

Her second and third collections, *Down the Street* and *The Fun House*, are cast with teachers who are physically odd, even repulsive in some cases, but always awful at their jobs. *Down the Street* features Miss Martles with the "shrimpy eyes," who sniffles constantly and whose hair "looks kind of like wig hair, no offense to her" (6). When Miss Parfet explains her "nose problem" to the class via an inappropriate and enormous chalk drawing, the students are understandably horrified. Yet the main characters Arna and Marlys (Barry's most significant early avatar) are sent to the principal's office after defending Miss Martles from mean comments by girls in the "beautiful" Miss Thompson's class (6–7). The narrator's scrutiny of her teacher's appearance is matched by a kindness, part of the complicated relationship Barry's characters always seem to have with their teachers. Students scrutinize their teachers (often to a teacher's detriment), but students are also intensely loyal. This is not unlike the unconditional love of pets for their owners, a subject Barry often examines.

Far worse than the always-sniffling Miss Martles, however, is the terrifying Miss Bevins from the opening comic of *The Fun House*. Miss Bevins, a substitute brought in to replace Miss Anasly, who was kicked by John Bailey, "our most rottenest person" (n.p.), has clacking false teeth and a "pointy bosom." An easy teacher-versus-student binary is absent in these works. Though the students are repulsed by Miss Bevins eating a chicken leg at her desk during class, on her last day the narrator asks, "If we hated her so much, how come a lot of us started crying?" (n.p.). In an interview with *ARTnews*, Barry explained, "Teachers played the biggest role in my life and to be a teacher is to continue a certain kind of family line for people who don't have families. It's my way of being a mom. No, not a mom—the crazy auntie that everybody needs. One of my students calls me 'Auntie Monkey Glasses'" (Casamento).[13] Perhaps the loyalty drawn by Barry in these strips is the same kind that one has for family, an idea Barry will address once she starts teaching.

Mr. File from *The Freddie Stories* is a rare male teacher in these pages and, like Miss Parfet, seems to suffer from olfactory dysostosis. The fumes from his near-addictive use of a menthol inhaler are so strong they cause Freddie to vomit on the first day of school (43), making Freddie the target of Glenn, the class bully. Glenn acts without consequences, because Mr. File, like Miss Parfet, is supremely gullible. Mr. File is duped by Glenn, who promises to introduce Mr. File to his father, the purported creator of "Milk Jaws" and "Jolly Jim's Peanut Wads" candies (52–53). Much of the book shows Freddie's suffering under Glenn's incessant bullying, an abuse ignored or missed by both teachers and parents. Only Freddie (and the reader) knows of Glenn's duplicity, but Glenn becomes a teacher's pet because of a lie easily swallowed by the naive Mr. File. Glenn's death-by-peanut-allergy exit from the strip is the precipitating event that drives Freddie into madness. Freddie is thrust into the role of grieving friend, while Glenn's ghost haunts Freddie for much of the book. Freddie's madness and great suffering are the direct result of a failure to recognize bullying by a teacher and lackadaisical parenting.

The teacher who dominates Barry's work, however, is the loud, easily angered, and delusional Mrs. Brogan. Mrs. Brogan appears in seven of the ten strips that make up the "School" section of *The Fun House*. Like the no-nonsense shoe her name recalls, Mrs. Brogan is stiff and eminently practical and does not tolerate the behavior of foolish children who waste valuable class time. Or paper plates. In "Art Project," the class is tasked with the hoary exercise of making Thanksgiving turkey drawings by tracing their hands on paper plates. The prescriptive nature of this "art" is upended, however, when Gary Deanes whips a paper plate across the room "like a Frisbee" (n.p.). In classic zero-tolerance pedagogy, the entire class is punished by having to write an essay

titled "Paper Plates—Why I Should Not Throw Them." The narrator is cagey enough to answer this writing prompt with a succinct but eminently acceptable "because you could put someone's eye out, waste earth's most valuable natural resources, and no consideration for others" (n.p.). This response, the narrator explains, "as far as Mrs. Brogan is concerned, is the correct answer to nearly any question" (n.p.). The narrator has learned to write for an audience, and Mrs. Brogan's pedagogy is easily subverted. Both the art project and the writing in this classroom are pallid. Teachable moments here only instruct children in the nature of power and the power of deception. Of course, this is not the kind of writing or art Barry will advocate in later books. Here Barry is teaching by counterexample, offering a demonstration of the worst kinds of instruction.[14]

The strip "Science" further demonstrates the abusive dynamic inherent in the teacher-student relationship. Here the innovative Ernie Barta brings in a grasshopper he trained to smoke a cigar for his science project. As an introduction to the project, Ernie uses a tried-and-true aphorism, "It took a long time but if at first you don't succeed, try try again" (n.p.).[15] Like a beginning writer in a freshman composition class, Ernie is feeling his way in language, speaking the language of success, albeit a clichéd language. Presumably he will be rewarded for his innovation and erudition. Mrs. Brogan, however, immediately crushes his efforts.

She forces Ernie to free the grasshopper, explaining that "teaching a grasshopper to smoke is cruelty to animals." The enthymeme is immediately countered by Ernie, who protests that it is "not a real cigar" (n.p.). Logically, if it is not a real cigar, then her syllogism collapses. And more to the point, a circumspect teacher would have inquired about where one could possibly procure a tiny cigar appropriately sized for a grasshopper's mouth (or praise Ernie for his ingenuity if he made it), but Mrs. Brogan does not seem to be concerned with such questions. Ernie's protests are to no avail.

In the third panel, a slump-shouldered, clearly distraught Ernie is being comforted by Mrs. Brogan, who, with a hand on his shoulder, offers, "I know you're upset now Ernest, but one day you'll thank me. You'll say, 'By golly, Mrs. Brogan was the best teacher I ever had!' And you'll want to send me flowers" (n.p.). Mrs. Brogan then asks the class to think about what they had learned. Here repressive pedagogy is emphasized in the last panel as Mrs. Brogan, drawn with horrific, gapped, oversize teeth and a melting neck, torments all of them, but especially Ernie, by singing "Born Free." The irony of the moment is not lost on the narrator, who answers the overhanging question, "what valuable lesson had we learned that day," with a thought she cannot express in writing or aloud, "whatever you do, never show nothing good to Mrs. Brogan" (n.p.). Double negatives aside, the answer is clear: teachers are never to be trusted.

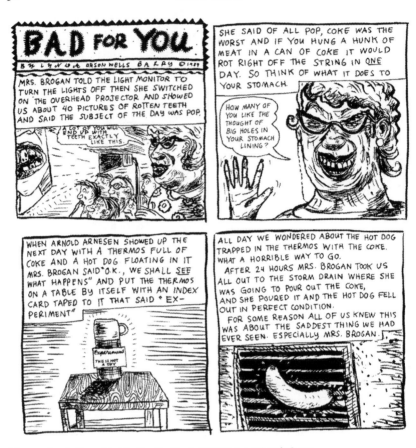

Figure 2. Lynda Barry, "Bad for You." In *The Fun House*, n.p. © Lynda Barry.

 The most profound undermining of Mrs. Brogan's pedagogy (and, by implication, that of all teachers) occurs in "Bad for You," another four-panel strip from *The Fun House*. This time a rare first-person plural voice narrates the action, which begins with a slideshow from Mrs. Brogan about the deleterious effect of soda, complete with a horrific image of rotting teeth (fig. 2). She warns the class that "Coke was the worst and if you hung a hunk of meat in a can of Coke, it would rot right off the string in *one* day." In the second panel, Barry shows a close-up of Mrs. Brogan, with her own imperfect smile, asking, "How many of you like the thought of big holes in your stomach lining?" To test her pedagogy, a student brings a hot dog floating in a thermos of Coca-Cola. Mrs. Brogan marks the thermos with an index card reading "experiment" and "this is not a toy," and a halo of amplification marks around the thermos indicates the class's excitement. The index card signifies the import of the moment,

entry by the young students into the adult world of science, objectivity, and earned knowledge.

The denouement occurs in the final panel, when, the next day, Mrs. Brogan empties the thermos down a storm drain and "the hot dog fell out in perfect condition" (n.p.). The hot dog is also haloed with amplification lines, but this time they do not indicate excitement but emphasize failure. As the narrator says, "For some reason all of us knew this was about the saddest thing we had ever seen. Especially Mrs. Brogan." The plural voice indicates a disappointment that is universal, marking the destruction of Mrs. Brogan's authority. The amplification lines around the perfect hot dog signify the naked revelation of her fraudulent pedagogy and the sadness it entails. If teachers cannot be relied on, who is left? At this point in her career, Barry has no answer.

The Reluctant and Accidental Professor: Embracing Teaching

The Greatest of Marlys (2002) is the transitional text leading to the full-on instruction manuals like *One Hundred Demons, What It Is, Picture This, Syllabus: Notes from an Accidental Professor,* and *Making Comics.* The necessity for making comics, as enunciated in these later books, stems from the belief that one can find refuge in a life of the imagination. Barry initially embraces this idea through her fictional avatar Marlys, who is Barry's ongoing proto-instructor, offering advice on everything from "how to groove on life" to creative writing lessons in "Poetry Corner." Marlys is ably assisted by the Beat poodle poet Fred Milton. The methodology hinted at by Marlys's enthusiasm for and embrace of everyday texts and subjects presages a way of writing oneself out of trauma in the subsequent books. Though rare, in these books there are teachers who can help.[16] Barry will eventually claim this space for herself through autobiography in her more recent books.

Marlys, however, was not always the inclusive, loving protagonist seen in *The Greatest of Marlys.* This collection gathers Barry's weekly alt-newspaper strip *Ernie Pook's Comeek* from the late 1980s onward.[17] Such a time span allows readers to track Marlys's transformation. A mid-1980s comic like "The Carnival," from *The Fun House,* shows Marlys as the outsider brat, a scold who "was making a hard time for everyone to think up things to do because no matter what you thought of, she said she'd tell on you. And she *would* too" (n.p.). About a year after *The Fun House,* Barry began to slowly transform Marlys from a tattletale into her most important avatar, until in *One Hundred Demons* Barry draws a red-haired, freckled character named "Lynda" and includes photographs of herself throughout the book. The utility of the fictional Marlys functions until Lynda Barry embraces autobiography and no longer needs Marlys to teach.

In *The Greatest of Marlys*, Marlys is both narrator and instructor. Intriguingly, Barry often presents book reports and instruction manuals in the "rough" drawing style of one of the characters, like Marlys's incredible instructions for learning the Funky Chicken dance. Maybonne's home economics report on hair contains simple drawings of women with different hairstyles, all far less sophisticated than Barry's usual drawings. Including strips drawn by a hand seemingly less skilled than Barry's creates a kind of democratization, suggesting a freedom for anyone who wants to write and draw comics. If these experiences are published, perhaps they open up a space for anyone's experiences to be published. These strips are visual antecedents to the overt instruction Barry will provide in books like *Making Comics*, where she admits, "I wondered if I could teach what I knew about the power of comics as a way of seeing and being in the world and transmitting our experience of it" (14). The emphasis here is not on a fine line or photorealistic representation but on getting the stories down on paper.

The freedom to create offers a crucial counternarrative to the fear of making Art, a topic Barry often discusses in interviews. "One of the things I've been really interested in is how we go from everything we call the arts—whether it's dancing or singing or drawing, all those things that, as a kid, helped me so much—and then at a certain point they turn into 'art' and they become less and less helpful, until we start to think that 'art' can only happen in a gallery or a museum" (Moore). Barry's poetics are aligned with her increasing confidence in embracing her role as a teacher, though she never attended school for creative writing.[18] Her means of inspiration are more eclectic than academic, more Big Daddy Roth than Philip Roth.

Barry's use of Marlys as the interlocutor for the Beat poodle poet Fred Milton suggests an open-source approach to creativity. The presence of a talking dog, albeit a slightly scatological one (he is overly fond of using "toilet" as an adjective), places Fred Milton in a long line of "humanized animals" in American comics.[19] Fred Milton is not an avatar for Barry so much as a source of inspiration, like the classified ads she discusses in *One Hundred Demons* or her love of Rat Fink.[20] The implication is that poetry, and by extension any kind of creative expression, can be sourced from anywhere, especially if one is lucky enough to have a talking poodle—or lucky enough to realize the imaginative creation of talking poodles.

Though Barry often draws and names herself in her recent books, she also instructs most prominently through another animal avatar, a beaming, serene monkey image. This is especially notable in *Syllabus: Notes from an Accidental Professor*. Reproduced in the book is a poster advertising her University of Wisconsin class "Making Comics: Art 448." The smiling monkey figure on the

poster holds a small sign that says "Instructor: Lynda Barry" (37). The figure is clearly a zoomorphic version of Barry, with its eyeglasses, wide smile, and bandanna. On the poster and throughout the book, the monkey figure provides a kind of visual feint, allowing Barry to offer readers and students (via college classes and cross-country workshops) an avenue for interrogating the past. A smiling monkey is nonthreatening. Her instruction creates linguistic and visual spaces as refuges from trauma, without the baggage of the abusive, ignorant, and "square" teachers whom Barry, and by extension her readers, may have experienced. These later pedagogical works provide agency for the voiceless, for the children we all once were, to write and rewrite what has already happened.

Autobiographical Pacts and Demonic Girls

Beginning with problematizing the self as construct in the introduction to *One Hundred Demons* (2002) through her use of the neologism "autobifictionalography," Barry's recent books *What It Is* (2008), *Picture This: The Near-Sighted Monkey Book* (2010), *Syllabus: Notes from an Accidental Professor* (2014), and *Making Comics* (2019) explicitly situate her in the role of a writing/art teacher, combining disciplines that have been crucial for her work over three decades of publishing. These later books offer readers a model for how to interrogate one's own history. Hutcheon's remark that "to re-write and to present the past in fiction and in history is to open it up to the present, to prevent it from being conclusive" (209) suggests that making comics is an accessible and safe kind of self-interrogation. The oscillation between genres inherent in Barry's autobifictionalography raises the question of whether Barry has to embrace a "pure" form of autobiography to be an effective teacher.

In defining the autobiographical novel from autobiography, Philippe Lejeune emphasizes how readers parse authenticity. In solely relying on textual evidence Lejeune argues, "there is *no difference*" (13) between the novel and autobiography. As soon as readers include elements outside the narrative like the title page, "with the name of the author, we make use of general textual criterion, the identity ('identicalness') of the *name* (author-narrator-protagonist). The autobiographical pact is the affirmation in the text of this identity, referring back in the final analysis to the name of the author on the cover" (13–14). This "identity of the name" concomitant with autobiography can be shown, Lejeune argues, in an obvious way "at the level of the name the narrator-protagonists is given in the narrative itself" (14). Barry's use of the character "Lynda" (with its unusual spelling that Barry adopted as an adolescent) suggests the work tends more toward autobiography. Supplementing this idea is the presence

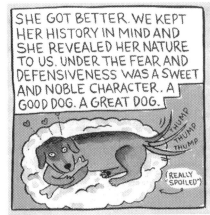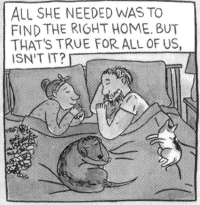

Figure 3. Lynda Barry, "Dogs." In *One Hundred Demons*, p. 118. The original is in color. © Lynda Barry.

of visual evidence, the numerous drawings of a red-haired, freckled Pinoy character named Lynda. In addition, there is a photo of an infant Lynda Barry and another of the adolescent Lynda Barry with her best friend Eve, whom she abandoned in a fit of adolescent angst. Metaphotographs of the adult Lynda Barry, the famous artist creating the text in readers' hands, bookend the text. She is presenting a visual minibiography through the photos.[21]

Whether Barry has fulfilled Lejeune's definition, her pedagogy about the necessity of writing continues unabated. In the "Dogs" chapter in *One Hundred Demons*, Barry relays the story of Ooola, a growling, snapping rescue dog she and her husband adopted. Once Barry and her husband gave the dog a "chance to start over again" (179), Ooola stopped growling. Barry reports, "We kept her history in mind and she revealed her nature to us. Under the fear and defensiveness was a sweet and noble character. A good dog. A great dog" (n.p.). She accompanies this description with a drawing of smiling Ooola thumping her tail at the viewer (presumably Barry and her readers), with hearts emanating from Ooola's head. The chapter's last panel is significant, a peaceful tableau of Ooola resting on the bed between a sleeping Lynda Barry and her husband, bracketed by two smaller dogs (fig. 3). The serenity of this image recalls Raphael's painting *The Holy Family with a Lamb*.[22] In the enunciation above Ooola, Barry notes, "All [Ooola] needed was to find the right home. But that's true for all of us, isn't it?" These elegant final images constitute Barry's declaration about the utter necessity of telling stories through making comics. Stories help us to understand angry rescue dogs, each other, and ourselves. For her and, by implication, for all of us, making art has crucial implications, as she argued in a 2012 interview:

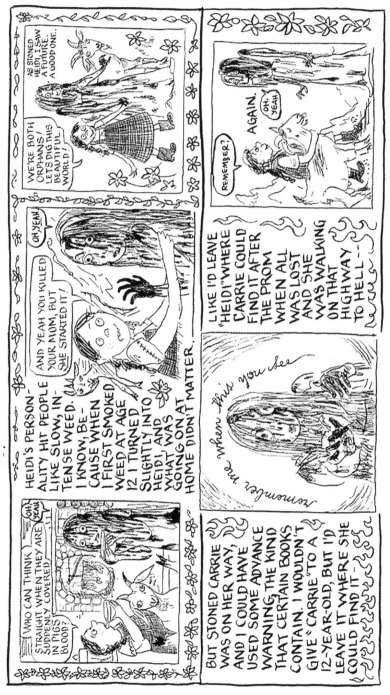

Figure 4. Lynda Barry, "When Heidi Met Carrie," n.p. © Lynda Barry.

We have this internal immune system that fights off bacteria and fungus, and comes to the site and prevents infection. I think that the image world—that's what I call the "art" now, because "art" is not the quite right word for it, since "art" is a pretty new word, and images have always been around for people— has the same sort of function. But instead of it providing stability for our body, I think it's for our emotional and mental health. And I think it's always been with us. (Moore)

Barry will likely return over and over to the necessary healing role creativity has for all of us. In 2016, in the sketchbook/graphic review section of the *New York Times*, Barry published a one-off comic, "When Heidi Met Carrie." The twelve-panel comic is a poignant illustration of Barry's outsider status as a kid, but also a demonstration of her mechanism for coping, writing her own stories via any and all means necessary. "When Heidi Met Carrie" is a mash-up of the acclaimed 1881 children's book *Heidi* and the 1976 R-rated film *Carrie*, whose bloodied protagonist appears in the second panel beside a smiling Heidi. Like a contemporary photobomb, a goat with a pentagram on its forehead sticks its tongue out in the background and somehow, despite a lack of fingers, throws the sign of the horns.[23]

There is something magical about the intersection of Heidi and Carrie, with Heidi's ineffable buoyancy acting as a corrective for Carrie's violence. Barry explains, "Heidi's personality hit people like slow, intense weed. I know, because when I first smoked weed at age 12 I turned slightly into Heidi, and what was going on at home didn't matter" (fig. 4). Though Barry expresses exasperation with Heidi, she understands her magnetic pull.

The mash-up offers tormented adolescents (and those recalling tormented adolescences) a specific avenue of escape in creative acts. Barry writes, "At 12 girls are too old for 'Heidi' and too young for 'Carrie.' But just the right age for both." The sixth panel of this twelve-panel comic has a bloody Carrie confessing, "I may have overreacted," to which Heidi replies, "Nonsense! I would have done the *same* thing," causing an exasperated Barry to ask in all capital letters, "What is it with Heidi?" the question surrounded by amplification lines. (Perhaps Heidi is the spiritual ancestor of the late-career Marlys.) In this panel, the photobombing goat reappears, but this time it is larger, and now it speaks, exclaiming, "Goat Grrls!," a winking reference to the 1990s feminist punk rock movement originating in Barry's home turf of the Pacific Northwest. That reference may be part of the answer, creating a feminist praxis in creative acts, like creating music or rewriting canonical young adult books for "girls" as comics.

Reading *Heidi* alone, of course, does not suffice. Barry's model here, the antidote to suffering, is something akin to a punk song, yoking the R-rated

movie and the hundred-year-old children's book. Barry rewrites the film's ending: "I'd leave 'Heidi' where Carrie could find it after the prom when all was lost and she was walking that highway to hell." This imaginative act, the creation of one's own identity through art, is infinitely renewable. In the final panel, poor Carrie reappears, again covered in blood, and the ever-forgiving Heidi, accompanied by her goat, asks "Remember?," to which Carrie answers, "Oh yeah." *Remember* is the key term, the exit from hell, the remembering of one's own creativity. This last panel is garlanded with flowers, like the comic itself and Barry's work, offering a respite for whatever terrible things the world throws at us, Barry's readers.

Barry's latest book, *Making Comics*, fully centers her pedagogy on the privileging of student work, the utility of everyday materials for making art, and a deep comfort with using her autobiography as a position from which to teach. The cover of *Making Comics* re-creates an inexpensive, mottled black-and-white composition book, a totemic childhood item that places Barry's pedagogy firmly in the realm of the accessible and the democratic. Upon opening *Making Comics*, the first thing readers encounter is not a title or copyright page (which appears on the last page of the book) but instead an endpaper filled with nine drawings on lined notebook paper, "copies of students work from the 'scribble monster' exercise" (n.p.). *Making Comics* is replete with Barry's immediate presentation of student work, a pointed rebuke to the awful teachers who populated her early comics with their canned exercises and judgments. The first page, also on lined notebook paper, is hand-lettered and directly addresses the reader, reminding us that "there was a time when drawing and writing were not separate for you" (1). This is almost a repeat of Benjamin Spock's famous introduction to *The Common Sense Book of Baby and Child Care* (1946), "Trust yourself. You know more than you think you do." Barry explains how even the act of writing our name, when we were young, was simply an act of drawing. Beneath this she draws a label with the words "This book belongs to," containing a space to be filled in with the reader's name, giving ownership to the project under way, creating our identities through making comics. Here and elsewhere, Barry has stated variants of the idea that "making comics saved me so many times" (14). This book and the arc of her work offer "the power of comics as a way of seeing and being in the world and transmitting our experience" (14). It has taken Barry's move from fiction to autobiography, from examples of bad teaching to an explicit pedagogy, for her to be able to state, "I believe anyone can make comics. . . . Everything good in my life came because I drew a picture" (197).

NOTES

1. Aside from the novel *Cruddy*, all of Barry's graphic novels and comics are hand-lettered, and she often plays with the forms of words, using italics or other kinds of graphical markers for emphasis. For example, the title of "How to Draw Cartoons" appears in all capital letters and is further distinguished by some letters being filled in, outlined (and sometimes tilted), with rough jagged edges, and one letter that is both filled in and jagged edged. Especially in her early books, she also uses underlining, bolded first letters, and italics all in the same line for emphasis. Misspellings are also occasionally present, and I have quoted Barry's original text without corrections.

2. The materials list Barry provides in *Making Comics* is far more detailed and is accompanied by explicit rationales, including discussions of cost ("for the first two weeks we will use a inexpensive black felt pen, a Paper Mate Flair") and utility ("Uniball pros: inexpensive, good waterproof black, you can get some variety with a single tip; Uniball cons: not hardly any!") (32). This is the voice of a confident art and writing instructor.

3. One irony Barry could not possibly have foreseen is how much the fortunes of *Time* have fallen with the decline of print media, while her status has risen in the intervening decades. Barry's success has been marked in various ways, including being selected by Chris Ware for inclusion in an all-comics issue of *McSweeney's Quarterly Concern* (2004), being named editor of *The Best American Comics* (2008), and winning two Eisner Awards (2003, 2009). Barry's original comics artwork was offered for sale from 2014 to 2015 at New York's prestigious Adam Baumgold Gallery, which lists blue-chip artists such as Picasso, Magritte, Warhol, and Richter on its roster. Barry's most recent award is a 2019 MacArthur Fellowship, and the foundation's web page notes Barry's roles as a "graphic novelist, cartoonist, and educator," https://www.macfound.org/fellows/1030/.

4. Brainard, a writer and painter, published *The Nancy Book* in 1988, containing over a hundred iterations of Nancy, ranging from imitations of other artists (*If Nancy Was a De Kooning*) to risqué portraits (*If Nancy Were a Boy*). Nancy is a point of fascination for many comics artists, a kind of ur-text that Bill Griffith, Scott McCloud, and Mark Newgarden have directly referenced. McCloud invented Five-Card Nancy, a game whose instructions are available on his website, http://scottmccloud.com/4-inventions/nancy/index.html. Newgarden's series *Love's Savage Fury* features a romantic relationship between Nancy and Bazooka Joe and was first published by Art Spiegelman in *Raw*.

5. Chris Ware, commenting on the cover of his first *Acme Novelty Library* (1999), noted, "This is probably the only one of my covers that doesn't have a swipe in it. . . . By 'swipe' I mean a visual inspiration or starting point" (Raeburn 54).

6. Barry reveals, "R. Crumb was another one I copied. His drawing style totally knocked me out, but it also totally freaked me out. The sex stuff was scary to me, but the drawing style was beautiful and I copied it and copied it. Once I was able to start wandering on my own and going to the library and to Skid Row head shops I was able to find more things to copy" (Schappell).

7. Barry's style has changed over the decades, especially with her finer command of line and use of shadow, undoubtedly due in part to her switching from pen and ink to calligraphy inks and brushes. On the last page of her 2002 masterwork, *One Hundred Demons*, a book entirely painted with calligraphy brush, Barry returns to her encouraging pedagogy, noting, "Discovering the painting brush, inkstone, and inkstick and resulting demons has been the most important thing to happen to me in years. TRY IT!" (n.p.).

8. These correspondence schools still exist, including Art Instruction Inc. in Minneapolis, the originator of the Draw Me advertisements. The school's website notes that its mission is "simple: provide quality artistic training to aspiring artists in the comfort of their own homes." Art Instruction Inc. counts Charles M. Schulz among its alumni.

9. In the appendix, Brunetti praises Barry's *What It Is* as "the best, mindblowingest book on tapping into one's own innate creativity" (76).

10. See, e.g., Hillary Chute's "Materializing Memory" for its discussion of the materiality of *One Hundred Demons*.

11. From Donald Barthelme's essay "Not Knowing," which argues, "Writing is a process of dealing with not-knowing, a forcing of what and how.... The anxiety attached to this situation is not inconsiderable.... The not-knowing is not simple, because it's hedged about with prohibitions, roads that may not be taken. The more serious the artist, the more problems he takes into account and the more considerations limit his possible initiatives" (12). In his review of *One Hundred Demons*, Nick Hornby neatly connects Barry and Barthelme, situating her among other postmodernists, writing that "Barry is, underneath the wonky handwriting and the quirky, naive drawings, a great memoirist, and 'One Hundred Demons' could happily sit on a shelf between Tobias Wolff's 'This Boy's Life' and Dave Eggers's first book—unless, of course, you arrange books alphabetically, in which case Barry belongs between Julian Barnes and Donald Barthelme, and that makes a kind of sense too."

12. Barry is currently listed as a faculty member in the University of Wisconsin–Madison creative writing program. Her official position is professor of interdisciplinary creativity / discovery fellow. The mission statement of the Center for Cartoon Studies explains, "The Center for Cartoon Studies (CCS) is dedicated to providing the highest quality of education to students interested in creating visual stories. CCS's curriculum of art, graphic design, and literature reflects the wide array of skills needed to create comics and graphic novels. CCS emphasizes self-publishing and prepares its students to publish, market, and disseminate their work." See https://www.cartoonstudies.org /index.php/about.

13. For the last decade or so, Barry has primarily drawn herself as a monkey. Among her more recent avatars, Barry has drawn herself as Chewbacca and a fedora-wearing robin (*Syllabus*), a devil, a skateboard-riding hot dog, Batman, and various monsters (*Making Comics*). All these versions wear glasses and a bandanna, like Lynda Barry.

14. The only kind teacher (before college) Barry writes about is Mrs. Lesene, from the "Dogs" chapter of *One Hundred Demons*. Mrs. Lesene lets the young Lynda skip recess, saying, "Why don't you stay in and make a picture for me?" (176). Barry notes, "Maybe it was my nature. Maybe it was my home life. But it was Mrs. Lesene's affection and interest that made all the difference." Alas, this kindness occupies only two panels, and soon a young Lynda Barry is told by another teacher, "Stay in and *draw*? *No*. Why do *you* need special treatment? I'm not Mrs. Lesene. I don't spoil *my* students. Get out there" (179).

15. The proverb is credited to W. E. Hickson, a British educator born in 1803. The full proverb reads, "'Tis a lesson you should heed: / Try, try, try again. / If at first you don't succeed, Try, try, try again." See https://en.wikipedia.org/wiki/William_Edward_Hickson.

16. Barry's model teacher, of course, is Marilyn Frasca, her instructor from Barry's time at Evergreen College in the 1970s. Of Frasca's pedagogy, she notes, "Her idea was that there is no difference between looking at a picture, making a picture, writing a story, that it's all about this state of mind, the serial state of mind" (qtd. in Thorn).

17. *Ernie Pook's Comeek* was originally published in 2000 by Sasquatch Books; Drawn & Quarterly republished the collection in 2016.

18. In a 2015 interview with Barry in *The Guardian*, the reporter Chris Randle argues, "Unsurprisingly, Barry is not a fan of MFA programs themselves. 'I'm sure not into the workshopping method,' she said. 'Obviously, teaching writing works, there are a lot of writers who come out of it, but it's not a process the way that it's approached, from the mind down to the hand.'"

19. The editors of *The Smithsonian Collection of Newspaper Comics* note, "The humanized animal, found in children's tales and cautionary parables as far back as Aesop, [was] most memorably captured in Charles Perrault's cocky and adventurous Puss in Boots" (Blackbeard and Williams 20). The list of talking animals in comics is extensive. Early newspaper comics featured Tige, Buster Brown's talking dog (1904), Krazy Kat (1913), and Felix the Cat (1923), all the way up to contemporary examples like the speaking tiger in *Calvin and Hobbes* (1995).

20. Barry said, "I loved drawing Rat Finks! Man, I loved Big Daddy Roth. There was something about his embrace of ugliness that made me feel freedom. He included flies in his drawings! Rat Fink became my idol. I kind of felt like a Rat Fink, I think" (Schappell).

21. For an interesting discussion of this idea, see Andrew Kunka's introduction in *Autobiographical Comics*, and for a specific discussion of the intersection of how photography interrogates authenticity in *One Hundred Demons*, see pp. 195–97.

22. The 1507 oil-on-canvas painting is currently on display at the Museo Nacional del Prado in Madrid. The holy family has been a favorite subject for artists for centuries.

23. Having the goat throwing horns, while very rock and roll à la Ronnie James Dio, is redundant. The pentagram already marks the beast as a Sabbatic goat.

WORKS CITED

Arnett, George. "A Woman Has Only Won *Time*'s Person of the Year Three Times." *The Guardian*, December 10, 2014. https://www.theguardian.com/news/datablog/2014/dec/10/woman-time-person-of-the-year-three-times-2014-ebola.

Barry, Lynda. *Down the Street*. HarperCollins, 1988.

Barry, Lynda. *Everything in the World*. HarperCollins, 1986.

Barry, Lynda. *The Freddie Stories*. Sasquatch Books, 1999.

Barry, Lynda. *The Fun House*. HarperCollins, 1988.

Barry, Lynda. *Girls and Boys*. Real Comet Press, 1981.

Barry, Lynda. *The Greatest of Marlys*. Sasquatch Books, 2000.

Barry, Lynda. *Making Comics*. Drawn & Quarterly, 2019.

Barry, Lynda. *One Hundred Demons*. Sasquatch Books, 2002.

Barry, Lynda. *Picture This: The Near-Sighted Monkey Book*. Drawn & Quarterly, 2010.

Barry, Lynda. *Syllabus: Notes from an Accidental Professor*. Drawn & Quarterly, 2014.

Barry, Lynda. "The 20 Stages of Reading." *Washington Post*, September 13, 2013.

Barry, Lynda. *What It Is*. Drawn & Quarterly, 2008.

Barry, Lynda. "When Heidi Met Carrie." *New York Times*, July 21, 2016.

Barthelme, Donald. *Not-Knowing: The Essays and Interviews*. Counterpoint Press, 2008.

Blackbeard, Bill, and Martin Williams, editors. *The Smithsonian Collection of Newspaper Comics*. Smithsonian Institution, 1977.

Brainard, Joe. *The Nancy Book*. Siglio, 2008.

Brunetti, Ivan. *Cartooning: Philosophy and Practice*. Yale University Press, 2011.

Casamento, Nicole. "How Non-artists Can Draw: Comics Great Lynda Barry on Teaching Creativity." *ARTnews*, June 5, 2014. https://www.artnews.com/art-news/news/comics -artist-lynda-barry-on-teaching-non-artists-to-draw-2451/.

Chute, Hillary. "Materializing Memory: Lynda Barry's *One Hundred Demons*." *Graphic Subjects: Critical Essays on Autobiography and Graphic Novels*, edited by Michael A. Chaney, University of Wisconsin Press, 2011, pp. 282–309.

Hornby, Nick. "Draw What You Know." *New York Times*, December 22, 2002.

Hutcheon, Linda. *Irony's Edge: The Theory and Politics of Irony*. Routledge, 1995.

Johnson, Ken. "Art in Review: Lynda Barry: 'Everything: Part I.'" *New York Times*, May 22, 2014. https://www.nytimes.com/2014/05/23/arts/design/lynda-barry-everything-part -i.html.

Kunka, Andrew J. *Autobiographical Comics*. Bloomsbury Academic, 2018.

Lejeune, Philippe. *On Autobiography*. Edited by Paul John Eakin, translated by Katherine Leary, University of Minnesota Press, 1989.

Macht, Joshua. "Running Out of TIME: The Slow, Sad Demise of a Great American Magazine." *The Atlantic*, April 5, 2013. https://www.theatlantic.com/business/ archive/2013/04/running-out-of-time-the-slow-sad-demise-of-a-great-american -magazine/274713/.

Moore, Anne Elizabeth. Interview with Lynda Barry. The Rumpus, April 22, 2012.

Newgarden, Mark. *We All Die Alone*. Fantagraphics Books, 2006.

Raeburn, Daniel. *Chris Ware* (Monographic Series). Yale University Press, 1994.

Randle, Chris. "Lynda Barry: 'What Is an Image? That Question Has Directed My Entire Life.'" *The Guardian*, May 14, 2015.

de Saint-Exupéry, Antoine. *The Little Prince*. Translated by Katherine Woods, Harvest/HBJ, 1971.

Schappell, Elissa. "The Open Bar: An Interview with Lynda Barry." Tin House, February 3, 2012.

Thorn, Jesse. "Lynda Barry, Author of *Picture This* and *What It Is*: Interview on the Sound of Young America." *Maximum Fun*, January 3, 2011.

Chapter 3

Lynda Barry's *Syllabus*, Neuroscience, and "the Thing We Call Creativity"

—Davida Pines

Lynda Barry's *Syllabus* cannot be read quickly. Each page encourages readers to notice, to linger, to meander, to reflect, to brainstorm, and to make connections. Rather than offering a clear path through her collage-like pages, Barry leaves readers to decide where to enter and how best to experience the material. If one rule governs *Syllabus*, it is that there is no right way to read it. The pencil, pen, and crayon drawings, the handmade page borders, the glued-on strips of typewritten text, the doodles and tight spirals, the poetry and prose, Barry's own teaching notes, the examples of her students' drawings, the actual assignments and syllabi that Barry developed for her students at the University of Wisconsin—all can catch the reader up for long periods of time. With each page, the reader enters a space that enacts what Barry's undergraduate teacher and mentor Marilyn Frasca called "being present and seeing what's there" (4).[1] The pages demand and create a certain kind of attention. Encountering them, we are offered the chance not only to witness what Barry's ideas look like "when they are taking physical shape" (2) but also to engage with Barry in her own creative process, to become her partner in making art. In *Syllabus*, then, Barry shares not only her pedagogy but also her process, enabling readers to achieve that "certain state of mind" (4) that leads to writing and image making.

Noticing and understanding what happens to the brain during creativity are of particular interest to Barry throughout *Syllabus*. She wonders about

the "electrical activities of the brain" (194) and asks that students who apply to take her class share her interest in exploring "what's going on in the brain when we're in a certain image-making / mark-making frame of mind" (9). Many of the works that Barry assigns to her students, whether poetry, prose, or film, explore the brain's dual hemispheres, for example, Emily Dickinson's "I felt a Cleaving in my Mind / As if my Brain had split," Iain McGilchrist's *Divided Brain*, the brain scientist Jill Bolte Taylor's *My Stroke of Insight*, and V. S. Ramachandran's *Phantoms in the Brain*. Despite encouraging her students to investigate the relationship between creativity and brain anatomy, what is perhaps of most interest to Barry is "how the brain works when we *refrain* from concentration, rumination, and intentional thinking" (194; italics mine). Indeed, Barry hypothesizes that creativity—the emergence of original images and ideas—depends on not thinking too much.

In this chapter, I take Barry up on her challenge to readers and students alike to consider the relationship between the brain and creativity. I look specifically at the ways recent studies in the neuroscience of creativity offer helpful context for Barry's pedagogy as seen in *Syllabus*. It is my contention that these recent studies lend direct and indirect support to Barry's approaches to teaching writing and drawing.

Barry's Methods and the Neuroscience of Creativity

Barry's strategies for promoting creativity, both those on display in her own work and those reflected in the assignments she gives her students, find support in the neuroscience of creativity. In their 2015 article "Enhancing Verbal Creativity," N. Mayseless and S. G. Shamay-Tsoory offer a definition of creativity that puts Barry's own writing, drawing, and teaching strategies into helpful context. "Creativity," the article begins, "has been defined as the ability to produce responses that are both novel (i.e., original, rare and unexpected) and suitable (i.e., adaptive and useful according to task constraints)" (167). The question, of course, is how to balance those mechanisms in the brain that produce "novel" responses with those that judge whether those responses are "suitable" given the task at hand. Referring to this definition of creativity as "the two-stage model," Mayseless and Shamay-Tsoory note that the two parts include "a free association process that involves generating ideas, and the monitoring and evaluation of these ideas" (167). Given these two processes, the authors go on to connect "convergent thinking" (which involves discovering "one correct and unique answer to a problem which has only one solution") with the *second* stage of creativity, and "divergent thinking" (which involves "producing many

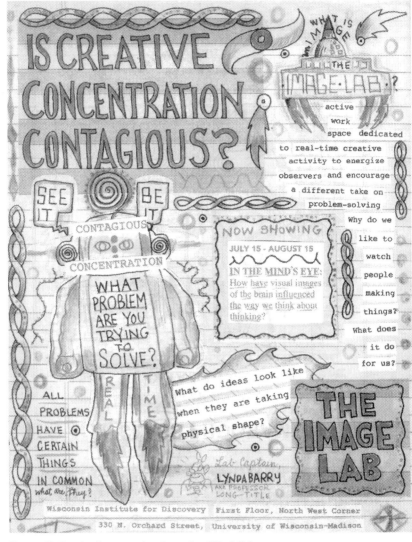

Figure 1. "Is Creative Concentration Contagious?" In *Syllabus*, p. 2.

ideas to a problem which has more than one solution") with the *first* stage. It is clear that Barry's strategies support divergent thinking.

One of the main ways that Barry facilitates the generation rather than the evaluation of ideas is by engaging the reader in open-ended thinking. It is telling that the first page of *Syllabus* presents readers with a question collage (fig. 1). The page appears to be a flyer that might have been posted on the door of what Barry calls her Image Lab at the University of Wisconsin, a space for

writing and drawing and making things by hand. One question explored on this page is the nature of a shared space for creativity: why come together to work separately? Barry's definition of the Image Lab appears in the upper right corner in a column of typewritten text that spills down the side of the page in the manner of refrigerator poetry: "active / work / space dedicated / to real-time creative / activity to energize / observers and encourage / a different take on / problem-solving" (2). In separating the words in space, Barry creates a vertical sentence rather than a horizontal or linear one, thus encouraging readers to pause briefly over each word in addition to considering the definition as a whole. In literally cutting up her sentence and arranging the words vertically, she taps into not only the verbal mechanisms of her readers' brains but their visual and spatial networks as well. Regarding the definition itself, what is perhaps unexpected about Barry's Image Lab is its stated goal of "energiz[ing] observers" of the creative process, not only participants. Rather than offering a work space only to those already engaged in making art, Barry hopes her lab will entice others to want to "get together to work intensely, using both drawing and writing to bring about the unthinkable" (10).

Barry's definition of the Image Lab leads (in the same typewriter font) to two related questions: "Why do we like to watch people making things? What does it do for us?" Panning left, the reader encounters the page's related and presiding question, announced in large, red block letters: "Is Creative Concentration Contagious?" That is, if we watch others in the process of creating, will we, too, become creative? Glancing down the left side of the page, scanning perhaps for the answer, one finds instead more questions. In the bottom left corner, an apparent riddle appears: "All problems have certain things in common. What are they?" If each student who comes to the Image Lab works on a different problem or project, Barry prompts, what connects this work? Looking up and to the right, we meet a cartoon character blasting off into space. On the figure's torso is the question "What problem are you trying to solve?" In the midst of the hand-drawn flames rocketing this figure upward, three thin strips of typewriter text shoot out, effectively mingling words and image: "What do ideas look like / when they are taking / physical shape?" As the reader works her way through the questions and images on the page, it becomes clear that Barry is leading an exercise in divergent (open-ended) thinking. Tracking upward to the center of the page, the eye lands on a postage-stamp-sized movie flyer: "Now Showing: In the mind's eye: How have visual images of the brain influenced the way we think about thinking?" Posing one exploratory question after another, each question transposed into a different font and color, Barry slows the thoughtful reader's progress through the page and encourages the creation of novel ideas. In addition to the questions, the doodles and designs

that decorate the page vie for the reader's attention. Even the paper itself—in this case, the yellow legal pad that serves as Barry's canvas—cannot be taken for granted, as it has been carefully set off in crayon-lined blue. Just as there is no clear starting point or path through this first page of *Syllabus*, there is also no clear end point. The longer one lingers, the more ideas bubble up, and the more associations one makes.

As strongly committed as Barry is to promoting the generative part of the creative process, it is the evaluative part that so much of her work seeks to stave off. Barry contends that, absent self-censoring, whenever anyone begins to draw, trained artist or not, "something starts to show up pretty quick: our own style. There is a way of making lines and shapes that is ours alone, and the more we draw, the clearer it becomes, not just to ourselves but to others: a style unique and recognizable" (70). In other words, unimpeded by self-criticism, our own distinctive voice will emerge. "The trick," Barry continues, "is to find a way to keep ourselves from rejecting [our line and our urge toward composition] before it can fully present itself" (70). Throughout *Syllabus*, Barry offers strategies designed to inhibit self-evaluation, and while she does not specifically refer readers to brain research, several recent studies in the neuroscience of creativity offer indirect support of her work.

In their paper "The Origins of Originality: The Neural Bases of Creative Thinking and Originality," Shamay-Tsoory et al. investigate the role of the different parts of the prefrontal region of the brain in the production of original ideas, defined specifically as that which "is statistically rare and represents an uncommon unique response" (178). By studying the impact of damage to different parts of the prefrontal region on a subject's ability to engage in divergent thinking (measured by creativity tests such as the Alternate Uses Task, or AUT, which asks subjects to name as many unconventional uses of an object as possible under a time constraint; and the Torrance test, which asks subjects to draw as many different objects as possible, incorporating an identical object in each), researchers observed that lesions on the left prefrontal regions of the brain were correlated with higher originality scores than lesions on the right prefrontal regions: "In particular, patients with lesions in the left temporoparietal region, including the inferior parietal lobule, and patients with left inferior frontal gyrus [IFG] lesions exhibited high originality scores. Furthermore, there was a significant correlation between lesions in the left posterior parietal and temporal cortex [PC] and originality scores, indicating that the greater the impairment in this region, the higher the originality score" (183). As the researchers note, the left IFG is involved in "a wide range of cognitive tasks demanding verbal information processing" (183), whereas the right IFG is connected to "creative cognition" (184). The left language centers of the brain

draw on neural networks that "store systematic, linear, logical, semantically similar, and automatic knowledge" (184). In other words, these left language centers coincide with ingrained ways of knowing and perceiving. As previous studies have suggested, "a release of the right PFC from language-dominant patterns of thinking ... is a key factor in the emergence of artistic skills" (184). In the current study, patients with *right* hemisphere lesions were more severely impaired in originality than patients with left hemisphere lesions, suggesting that the right side of the brain is more directly involved with creativity and originality than the left. Correspondingly, patients with left hemisphere lesions showed improved originality, suggesting that left-brain processes can impede divergent thinking. Particularly interesting is the observation that "a competition between the two hemispheres may diminish levels of originality" (184), and that higher originality emerges when the right hemisphere has been released from the competition, "thus facilitating the expression of the original response" (184). Left unchecked, then, the verbal processing centers of the brain are more likely to overshadow the networks that activate nonlinear, nonautomatic, visual-spatial thinking.

A glance at the composition notebook pages that make up *Syllabus* reveals a method of writing and drawing that veers away from "systematic, linear, logical, semantically similar, and automatic knowledge" (184). A repository for poetry, prose, sketches, doodles, notes, and ideas, the composition notebook represents the centerpiece of Barry's creativity strategies. As she tells her students, the notebook "is the heart of our class (Also the liver, spinal cord, and cerebral cortex)" (60). In explaining what students should collect in their notebooks, Barry offers, "You know, things like *everything*!" She elaborates: "Drawings! Tracings! Things you find and glue or tape into the book! Observations! Doodles! Lists of all kinds! Articles! Receipts! Photos! Ticket stubs! Quotes! Dreams! Things you wish you could say out loud! Things you regret saying out loud! ... Rants! Raves! Comics!" (60). In requiring her students to keep a composition notebook (and in offering *Syllabus* as a tangible example of what such a book might look like), Barry seeks to bypass the brain's built-in evaluation system, which sifts observations and experiences into ones that are "suitable"—worth noticing or collecting—and ones that are not. By encouraging new habits of openness and attention, she hopes to challenge ingrained patterns of thinking and experiencing the world. Given, as Shamay-Tsoory et al. assert, that "the right hemisphere is responsible for activating conceptual networks that have been only weakly activated or not activated at all" (184), and that competition between the left and right hemispheres typically results in lower levels of originality, Barry's composition notebook seems well positioned to strengthen those right-brain networks typically overshadowed by left-brain processes, and thus to produce greater originality.

Barry's focus on drawing, especially for students who have not drawn since they were children, similarly supports research that associates increased verbal creativity with balancing stimulation to the right and left hemispheres. As Mayseless and Shamay-Tsoory show in "Enhancing Verbal Creativity: Modulating Creativity by Altering the Balance between Right and Left Inferior Frontal Gyrus with tDCS," *decreasing* neural excitation to left brain regions while simultaneously *increasing* excitation to right brain regions improves verbal creativity. The suggestion is that focusing on visual-spatial activities has a "releasing effect" on the language-oriented left-brain activities, resulting in improved creativity. From Barry's perspective, the drawings of someone who has not been instructed, who is not following an ingrained set of teachings, are alive as no other work is. Explaining an assignment in which she sends her mostly non-art students out into the world to draw people, Barry offers, "I try to let them know that what I'm most interested in is what their hand naturally does while drawing. Some hands have been at it for a while but others are so new to the game that no particular style of drawing has had a chance to take root" (21). It is rootedness, then, that can interfere with the emergence of something unexpected. She continues, "I know if I can just keep them drawing without thinking about it too much, something quite original will appear ... (almost by itself)" (21). Describing a practice that approaches meditation, Barry explains, "The trick seems to be this: consider the drawing as a side effect of something else: a certain state of mind that comes about when we gaze with open attention; when we are in the groove, we are not thinking about liking or not liking what is taking shape, and it isn't thinking about us either" (22). The idea is to "keep our hand in motion and to stay open to the image it is leaving for us" (22). By focusing on the movement of the hand and following the line of the pen on the page, one bypasses not only the usual pathways and the ingrained expectations but also the evaluative network that governs the second part of the creative process.

In their 2014 article "Unleashing Creativity: The Role of Left Temporoparietal Regions in Evaluating and Inhibiting the Generation of Creative Ideas," Mayseless, Aharon-Peretz, and Shamay-Tsoory investigate this evaluative part of creativity. In particular, they offer two studies, each of which tests the potentially inhibiting role of the neural network responsible for judging the "suitability" of the ideas that emerge during the first part of the creative process. In the first study, a patient with no previous art training sustained a traumatic brain injury to his left frontal lobe, causing, among other deficits, significant damage to his verbal ability. At the same time, he experienced significantly enhanced artistic creativity: "His artwork evolved from two-dimensional line drawings into complex color paintings, which in his own words represented

'the development of a talent that wasn't there before'" (160). The researchers connect this enhanced drawing ability to the inhibition of the left-brain evaluation process. In other words, the dismantling of the patient's built-in neural system of evaluation released artistic abilities that had never before been permitted expression. After returning to normal, the patient noted, "Despite recurring attempts to paint, I have felt a striking reduction in my ability to paint since my language abilities have improved" (160). The case study shows the creativity-stifling effect of the critically thinking left brain.

To test their hypothesis that the patient's de novo artistic ability developed as a result of the damage to the part of the brain that evaluates rather than generates ideas, the researchers designed a study that compared the strength of an individual's creativity against the strength of that individual's evaluative network. Participants in the study were given a divergent thinking test (the Alternative Uses Task, or AUT) to measure their creativity relative to others taking the test. Then they underwent a functional magnetic resonance image (fMRI) of the brain to measure brain activation during an originality evaluation test. The originality evaluation test entailed judging the originality of the answers given in the first creativity test. For example, given "swing" as an alternative use for a car tire, the participant (while undergoing fMRI) deemed the answer original or not original. Researchers found that participants who had strong activations in the left temporoparietal regions during the evaluation activities were more likely to have earned lower creativity scores on the divergent thinking test administered before the scan. The results suggest that the individuals with lower creativity scores (relative to the other test takers) were not necessarily any less creative than the others; rather, their evaluation networks were stronger, thus impeding their creativity. The researchers concluded that the "evaluation process can be detrimental to creative production if it is too stringent or erroneous, such that, reducing the effect of the evaluation process may lead to more creative ideas" (165).

Even as Barry works to strengthen divergent thinking in her students by asking open-ended questions, requiring the keeping of a composition notebook, and insisting on a daily drawing practice, a number of her other teaching strategies focus directly on suppressing creativity evaluation. "Classroom Rules" (55), for example, playfully punning on the wonders and the necessities of the classroom for generating art, asserts the dos and don'ts for keeping the evaluation network at bay (fig. 2). As if intended to channel the verbal processing networks associated with the left hemisphere, Barry's rules page is almost entirely text based. In a table composed of two vertical columns with six panels in each, Barry issues what appear to be her twelve creativity course commandments. Limiting her color scheme to blue, black, and white, Barry permits one

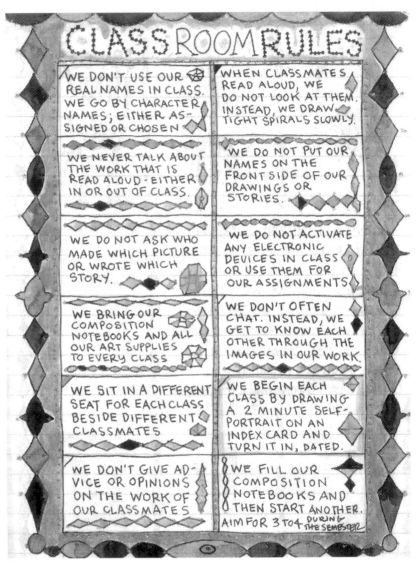

Figure 2. "Classroom Rules." In *Syllabus*, p. 55.

color breakthrough, outlining the panel mandating a daily drawing practice in bright orange pencil.

Most of the classroom rules seek to create an environment that limits the possibility of shame and self-consciousness in relation to creativity. The less vulnerable to judgment a student feels, the rules imply, the more willing that student will be to experiment. "We don't use our real names in class," the first

rule states, as playful as it is serious. "We go by character names; either assigned or chosen" (55). Thus, in Barry's spring 2013 course "The Unthinkable Mind," each student took the name of a brain part. Oliver Bendorf became known as "Amygdala," Mark Cayanan as "Basal Ganglia," Natalie DeCheck as "Brain Stem," and so on (49). As for Barry herself, for the duration of the course she was "Professor Old Skull." Taking a pseudonym frees students both from the perceived judgment of their peers and from the fear of revealing work that does not, at least in the student's mind, measure up. Barry's rule keeps attention focused on *what* rather than *who*, art rather than artist. Creating a judgment-free zone, however, does not preclude the creation of a listening community: "We never talk about the work that is read aloud—either in or out of class"; "When classmates read aloud, we do not look at them. Instead we draw tight spirals slowly." Communication takes place through the art itself, rather than through conversation about the art. Moreover, "We don't often chat. Instead, we get to know each other through the images in our work." To ensure that the focus remains on the images and not on the people who made them, "We do not put our names on the front side of our drawings or stories"; "We do not ask who made which picture or wrote which story"; "We don't give advice or opinions on the work of our classmates" (55). In sum, students shall not discuss, evaluate, compare, or otherwise verbally consider their own creative work or that of the other students in the class. "We fill our composition notebooks and then start another." The emphasis falls on continuous effort and persistence ("Aim for 3 to 4 [completed books] during the semester"): the making of a creativity habit.

In addition to creating her classroom rules, Barry seeks to help her students evade evaluative mechanisms through the use of time limits. What is important to Barry is that students not have too much time to think, as it is the thinking and the planning—those executive function skills associated with the evaluative networks in the brain—that impede creativity. Moreover, according to Barry, time limits reveal our own intuitive understanding of time and space: "If you had 10 minutes, five minutes, two minutes or 45 seconds to copy a photo, you'd somehow know how to fit it into the time allowed. But how are you doing it? (Hint: It's not thinking it all out first)" (97). As her course titles "Writing the Unthinkable" and "The Unthinkable Mind" suggest, Barry distinguishes between deliberate thought and creativity: "There is the drawing you are trying to make and the drawing that is actually being made—and you can't see it until you forget what you were trying to do" (16). Thus Barry's students practice two-minute self-portrait warm-up exercises (54, 56), Ivan Brunetti–inspired timed drawing activities (24–33), five-minute diary entries (62), twenty-minute X-page exercises (76), and "drawing jams," which entail timed collaborative comics (108). While it is certainly true that some kinds of creativity require strong executive

processing, for example, as Rémi Radel et al. note, "learning the context of the problem, analytic strategy of search, [and] checking the correctness of a solution," the creative processes that matter the most to Barry depend on what is known as "automatic associative processing (e.g., imagination, generation of ideas)" (111). Working under time limits, Barry suggests, taps those processes involved in "the generation of multiple ideas or solutions to a problem" (111).

In "The Role of (Dis)inhibition in Creativity: Decreased Inhibition Improves Idea Generation," Radel et al. test their hypothesis about the association of high levels of creativity with low inhibition. As defined by Radel et al., inhibition or inhibitory control "is the ability to suppress the processing or expression of information that would disrupt the efficient completion of the goal at hand" (111). In other words, they suggest that decreased powers of attention (impaired or exhausted executive function) correlate with increased performance of certain kinds of creativity. In their study, they deplete the cognitive resources of subjects by submitting the subjects to conflict tasks in which "participants are required to respond, as quickly and accurately as possible, by selecting the relevant feature of the stimulus and inhibiting the irrelevant feature which is associated with the incorrect response" (111). The greater and more prolonged the interference, the less cognitive control the subject demonstrates. Moreover, the researchers found that when cognitive resources associated with inhibition were depleted, the generation of ideas increased (119). While subjects' reaction time was measured in these experiments, and subjects were instructed to complete the tasks "as quickly and accurately as possible," the analysis did not specifically consider the role of time limits on creativity. Nonetheless, this research seems to support Barry's use of time limits as a strategy for releasing inhibitory control in her students. The less time the students have to complete a drawing or a story, the less likely they are to stop their own creative process to change, reject, or revise their original ideas. Paradoxically, excess time permits the thinking, planning, and strategizing that can "disrupt the efficient completion of the goal at hand" (111), namely, creative performance.

To quiet or distract the internal evaluative voice (effectively to decrease the level of excitation of the inhibitory aspects of the brain), Barry often suggests a dual focus. For example, she instructs students to draw tight spirals, paying close attention to the line they are making, getting "the lines as close together as possible without letting them touch" (76), while at the same time focusing on a relaxation exercise that demands putting "all of your attention on the tip-top of your head . . . then mov[ing] it to the center of your forehead, then the bridge of your nose [etc.]" (77). After this exercise, students continue drawing but move their attention to listening to a poem that Barry reads aloud. It is only after placing these simultaneous and consecutive demands on her students' attention

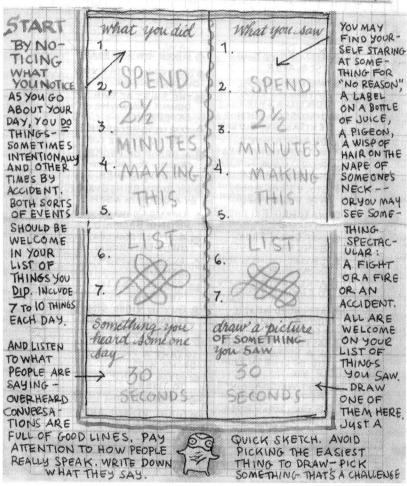

Figure 3. "Basic Quick Diary." In *Syllabus*, p. 63.

that Barry leads the students in a timed creativity exercise that ends in writing a story. By manipulating her students' attention in these various ways before having them turn to writing, Barry works to lower inhibitory control. In the language of Radel et al., she seeks "to suppress the processing or expression of information" that could interfere with the generation of their ideas.

It is perhaps for the sake of relaxing inhibitory control that Barry establishes a classroom routine of reading and drawing at the same time. "We need to

draw while listening to a story together," Barry writes in a notebook entry that
she pastes into *Syllabus* (46). "Read *Grimms' Tales* aloud. Practice just drawing
while listening. Let that be enough at first. No commentary. In grade school we
didn't listen critically to stories the teacher read us. Somehow restore that state
of mind" (46). Seeking to cultivate a creativity practice that keeps evaluation
to a minimum, Barry recognizes the productive relationship—the releasing
effect—that comes from mixing words and images, listening and drawing. She
suggests not only that diverting attention from creative evaluation increases idea
generation (in much the same way that depleting attention lowers inhibition)
but also that thinking verbally *and* visually, attending to sights and sounds and
sensations, works to activate neural pathways that increase creativity.

Barry's "Quick Diary" and "X-page" activities reflect her commitment to
multisensory (as well as time-limited) approaches to creativity. Both the diary
and the X-page exercises incorporate verbal, visual, and auditory practices that
encourage heightened engagement with the external world; they are Barry's
way of helping students shift the focus from self-evaluation (e.g., Is this idea
worth pursuing? Do I have anything to write about or draw?) to the self in
relation to the world. For the Quick Diary, students spend 2½ minutes listing
what they did that day, 2½ minutes listing what they saw, 30 seconds listing
what they heard, and 30 seconds drawing a picture of something they saw (63)
(fig. 3). As Barry explains, this kind of daily dairy "will teach you to hear, see,
+ remember the world all around you" (61). It is a way of paying attention, not
judging what is "worth" remembering, writing down, or depicting, but simply
collecting and recollecting verbal and visual experiences by hand. For the
X-page exercise, students begin with an image typically associated with nega-
tion and self-criticism—the X-ed out page—and use it as the starting point
for generating images and ideas for a story (fig. 4). Given a topic, say "car" (78),
students will have two minutes to produce ten memories associated with the
word. Then, instructed to X-out a whole composition notebook page, students
respond to a series of questions designed to help them hear, see, smell, taste,
and touch the world connected to the scene evoked by the word. Students jot
down the answers to these questions on the X-page. Before they have time to
consider what they have jotted down, Barry instructs them to "turn to a clean
sheet of paper and write this image up; stay in first person, present tense, write
for at least 8 minutes without stopping" (80). Using short time limits, leaving
no room for planning, considering, or reconsidering, the exercise leads to the
production of previously "unthinkable" stories.

In his review of recent studies in the cognitive neuroscience of creativity,
Keith Sawyer notes the connections that have been made between creative
insight and mind wandering. He explains that "mind wandering involves a

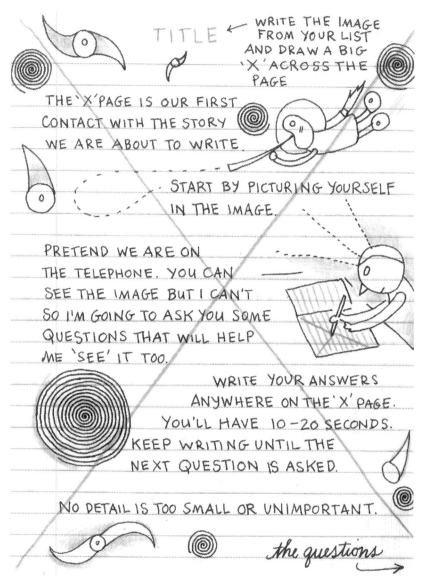

Figure 4. "X-Page Exercise." In *Syllabus*, p. 79.

shift away from the primary task to process some other, personal goal, but in a way that is not obviously goal-directed or intentional" (146). As we have seen, many of Barry's creativity strategies involve a deliberate turning away from the primary task at hand; as her doodling and coloring activities suggest, Barry promotes rather than punishes mind wandering. Indeed, her interest through-

out *Syllabus* continually comes back to the question of "how the brain works when we refrain from concentration, rumination, and intentional thinking" (194). Sawyer notes that mind wandering provides "mini-incubation" periods that have been found to precede creative ideas. He cites research that supports a connection between mind wandering and the brain's "default network," the part of the brain that is active during resting and less active during strenuous cognitive tasks (146). Barry's teaching strategies reflect Sawyer's observation that "by temporarily taking conscious attention away from the problem at hand and providing a brief opportunity for insight to occur," a certain kind of mind wandering can lead to insight. As Barry herself asserts, "I know if I can just keep them drawing without thinking about it too much, something quite original will appear" (21).

On Good and Bad, Liking and Not Liking, Worth It or Not Worth It: Barry's Problem-Solving Comics

In her approach to teaching, Barry recognizes that self-evaluation, in encouraging perfectionism, self-doubt, shame, and fear, impedes creativity. In particular, she homes in on the ways an internalized critical voice can keep us from writing and drawing, activities that were at one point natural to us. In addition to designing a course that deliberately seeks to keep those voices to a minimum, Barry models a problem-solving technique that calls on making comics. Specifically, she uses divergent thinking strategies (open-ended questions, brainstorming, drawing, and writing) in approaching familiar and ingrained roadblocks to creativity.

In one comics sequence titled "What Is a Bad Drawing?" (16), Barry interrogates the nature of "bad," applying divergent thinking practices (fig. 5). What is "bad"? Is it a matter of age? "How old do you have to be to make a bad drawing?" she wonders. Is "bad" mitigated by time limits or collaboration? Are we less responsible for "bad" if our creations are not entirely our own? What if the work is "drawn by one student in less than a minute and colored by another—Is it bad???" (16). What makes a drawing good? Is it "good" if someone else can recognize "what it is"? Is it bad if someone has to ask, "What is it?" Barry seeks to disconnect judgment from creation: "An image is not what anyone thinks it is." Rather, it simply is. Thus the title of her first book on creativity is not the disheartening question "What Is It?" but rather the affirmative statement "What It Is."

In a related sequence titled "On Liking and Not Liking," Barry explores another familiar statement that can interrupt the creative process (fig. 6). Once

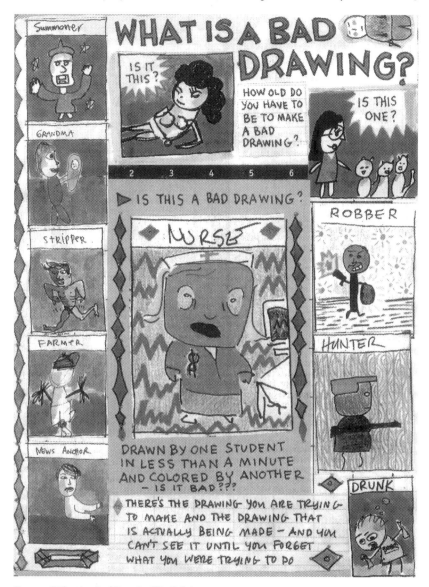

Figure 5. "What Is a Bad Drawing?" In *Syllabus*, p. 16.

again, asking probing, open-ended questions, she wonders aloud, "What happens to a drawing when we dislike it?" (19). What happens, that is, when we stop writing or drawing and start considering whether the work is "unique" or "appropriate"? Offering her own answer, Barry observes that evaluation disrupts and even distorts creation: "Liking and not liking can make us blind to what's

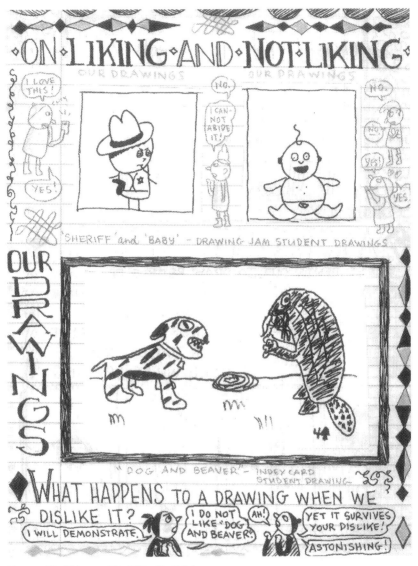

Figure 6. "On Liking and Not Liking." In *Syllabus*, p. 19.

there. In spite of how we feel about it, it is making its way, from the unseen to the visible world, one line after the next" (22–23). In addition to occupying the part of the brain that seeks to inhibit impulses with focused physical and visual activities like coloring and drawing spirals, Barry also encourages spontaneity: in asking students to fill out questionnaires about themselves, she advises: "First answers that come to mind are the ones I'm most interested in" (39).

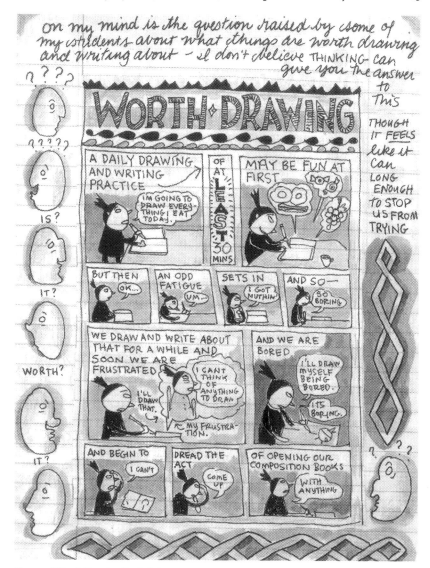

Figure 7. "Worth Drawing." In *Syllabus*, p. 162.

In another exploratory sequence in which Barry uses her composition pages to problem-solve, she begins, "On my mind is the question raised by some of my students about what things are worth drawing and writing about—I don't believe thinking can give you the answer to this though it feels like it can long enough to stop us from trying" (162). Stopping or avoiding or fending off the derailing question of the intrinsic or long-term value of a particular practice is

critical to the creative process. Putting the creative muscles into action, Barry suggests, is what leads to the generation of ideas: "The physical act of writing or drawing is what brings that inspiration about. Worry about its worth and value to others before it exists can keep us immobilized forever" (163). As always, Barry's work is both how-to guide and model. Her two-page comics sequence titled "Worth Drawing" shows and tells the story of someone engaged in creative activity: "A daily drawing and writing practice" (162–63) (fig. 7). Over the course of the comics sequence, the writing and drawing character sets off with hope and enthusiasm, slows to a near stop as a result of self-questioning, only to be saved by noticing the world around her, attending to what is there instead of to the evaluating voice—looking outward rather than listening internally: "Nothing in our lives is worth drawing a comic about or at least it feels this way UNTIL the moment when we realize there are mites in our eyebrows laying eggs in the follicles. . . . And we are awakened again to what is there and ever—there" (163).

Finally, in Barry's "Hate Crayon" sequence (88–89), she models another method of approaching a roadblock (fig. 8). When an assignment goes wrong in her class, Barry goes to her composition notebook, creating a two-page exploration of "what happened?" The problem she targets is the noticeable shift in her students from enjoying a certain coloring assignment to finding it frustrating—"a short-cut to dragsville" (89). A comics representation of Barry herself shows her turning over the problem in her mind: "This semester they hate it. They are pissed off about it. What *happened*? What changed this assignment into drudgery?" (88). What we notice is that the two pages in which Barry explores the problem are anything but joyless or dead. Barry brings her students' outrage alive in the hilarious scene of Professor Chewbacca wielding a huge crayon and roaring "HATE CRAYON!" (88). Patches of multicolored crayon appear throughout the two-page sequence, breaking through as though the paper is multilayered and three-dimensional. Barry shows her comics character surrounded by crayon colors, brainstorming for possible solutions. Through the process of thinking and exploring in words and images on the page, she realizes that telling her students what and how to do the activity robbed them of the exploratory part of the process—the play. "I told them to color hard in order to do it right" (89). The introduction of a standard of "right," and by implication "wrong," stopped the exploration, inhibited the creativity. "This took away the way of coloring they would have found on their own. By telling them just how to do it, I took the playing around away, the gradual figuring out that brings something alive to the activity, makes it worthwhile, and is transferrable to other activities" (89). By maintaining a form of "cognitive control," Barry short-circuited the process. In exploring the problem for herself, she comes to her own "ah-ha" moment: "Wait! I see" (89).

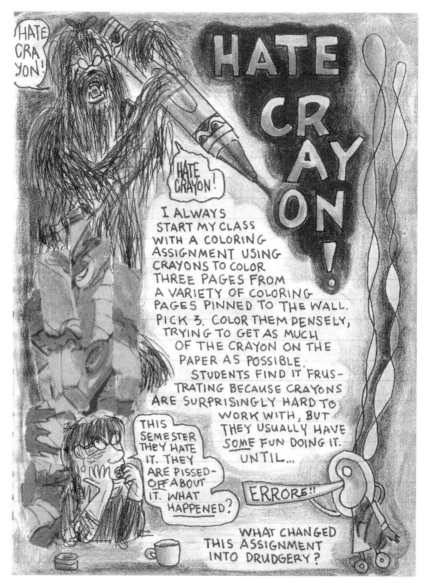

Figure 8. "Hate Crayon." In *Syllabus*, p. 88.

In one of her most personal reflections on the creative process, Barry enacts her own two-stage creative process (144–45). As usual, she begins a two-page sequence with an open-ended question: "Where do cartoon characters come from?" (144) (fig. 9). The answer, not surprisingly, is not from thinking about them: "In over 30 years of drawing I've never thought one up. I just draw and

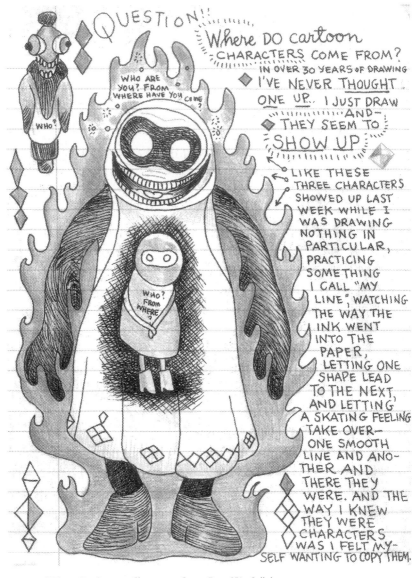

Figure 9. "Where Do Cartoon Characters Come From?" In *Syllabus*, p. 144.

they seem to show up" (144). Explaining a process in which she stays in the present moment, "watching the way the ink [goes] into the paper, letting one shape lead to the next, and letting a skating feeling take over" (144), Barry describes a generative process uninflected by planning, evaluation, or preconceived ideas. Eventually, however, "expectation" enters. "Try[ing] not to push things in

any particular direction for as long as I can stand to stay out of things," Barry ultimately finds intention taking over: "Eventually that open way changes and I start wanting from them. I want them to be really good right away and this stops the natural pace of discovery and replaces it with an objective" (145). At this point, after all the methods and suggestions, Barry finally observes that the second stage of the creative process necessarily has a place. The move from open-ended discovery to a more deliberate shaping and controlling of the images and ideas is inevitable. Ultimately confirming the need for balancing neuronal networks, verbal and visual stimuli, generative and evaluative modes, she ends without apology: "This can't be helped" (145).

Barry's Creativity Strategies and the College Composition Classroom

Is it possible to incorporate Barry's creativity strategies into the college composition classroom? In my own experience as a composition instructor, many undergraduates arrive in freshman writing seminars having already decided that they are not "good writers." "Writing was my worst subject in high school," many of them announce on the first day of the required course. "I could never figure out what my teacher wanted." Yet, if one of the goals of college composition courses is for students to develop not only their own voice but also the confidence to express their points of view in writing, then surely Barry's strategies for helping students discover their own "unique and recognizable" style (70) would be important. Moreover, if, as Mayseless and Shamay-Tsoory assert, verbal creativity is enhanced by altering the balance between brain networks, then incorporating a drawing practice into a writing course would be beneficial.

What is hard to know how to address is the focus in college composition classes on critical reading, writing, and thinking. Is there a role for Barry's composition book method or her quick diary and X-pages in freshman writing classes? What happens to Barry's "Classroom Rules" in a course that requires students to engage in "peer review" and to offer "constructive feedback" on each other's rough drafts? How can instructors ensure that the emphasis on the evaluation of writing does not impede the generation of ideas and the willingness to experiment? Peter Elbow and other composition scholars have long embraced the separation of writing and editing. Susan Kirtley has pointed to Barry's *What It Is* as an example of an alternative approach to invitational rhetoric, in which students practice a less adversarial approach to persuasive writing. In my own courses, I have come to incorporate a drawing and listening practice as well as an approach to college writing that relies on divergent, as much as or perhaps even more than convergent, thinking. I engage students in

open-ended questioning and suggest that they turn one of their essays into a hand-drawn comic. In consciously shifting from an exclusively verbal register to one that also includes visual, spatial, and auditory aspects, I seek to release students from the belief that there is only one right way of approaching writing and encourage them to think deeply about the relationship between college composition and "the thing we call creativity" (10).

NOTES

1. In citing material from Barry's *Syllabus*, one realizes immediately how much is missed when only the words themselves are reproduced. Without also duplicating the colors, textures, and other handmade elements of the quotations, it is impossible to do justice to the tone, message, and meanings of the original. I thus request the reader's forbearance in this regard.

WORKS CITED

Barry, Lynda. *Syllabus: Notes from an Accidental Professor.* Drawn & Quarterly, 2014.

Barry, Lynda. *What It Is.* Drawn & Quarterly, 2008.

Kirtley, Susan. "Considering the Alternative in Composition Pedagogy: Teaching Invitational Rhetoric with Lynda Barry's *What It Is.*" *Women's Studies in Communication*, vol. 37, no. 3, 2014, 339–59.

Mayseless, Naama, Judith Aharon-Peretz, and Simone Shamay-Tsoory. "Unleashing Creativity: The Role of Left Temporoparietal Regions in Evaluating and Inhibiting the Generation of Creative Ideas." *Neuropsychologia*, vol. 64, November 2014, 157–68. http://dx.doi.org/10.1016/j.neuropsychologia.2014.09.022.

Mayseless, Naama, and S. G. Shamay-Tsoory. "Enhancing Verbal Creativity: Modulating Creativity by Altering the Balance between Right and Left Inferior Frontal Gyrus with tDCS." *Neuroscience*, vol. 291, April 2015, 167–76. https://doi.org/10.1016/j.neuroscience.2015.01.061.

Radel, Rémi, et al. "The Role of (Dis)inhibition in Creativity: Decreased Inhibition Improves Idea Generation." *Cognition*, vol. 134, no. 1, January 2015, 110–20. http://dx.doi.org/10.1016/j.cognition.2014.09.001.

Sawyer, Keith. "The Cognitive Neuroscience of Creativity: A Critical Review." *Creativity Research Journal*, vol. 23, no. 2, 2011, 137–54. https://doi.org/10.1080/10400419.2011.571191.

Shamay-Tsoory, S. G., N. Adler, J. Aharon-Peretz, D. Perry, and N. Mayseless. "The Origins of Originality: The Neural Bases of Creative Thinking and Originality." *Neuropsychologia*, vol. 49, 2011, 178–85.

Chapter 4

Syllabus on the Syllabus: Teaching Lynda Barry in the College Writing Classroom

—Tara Lynn Prescott-Johnson

In the comic "Two Questions," the cartoonist, author, professor, and MacArthur "genius" grant recipient Lynda Barry succinctly captures two fears that haunt and paralyze most college first years: "Is this good?" and "Does this suck?"[1] Implied both in Barry's art and in her text are the fears lying just beneath: "Am I good?" and "Do I suck?" Barry's take on the pressures of internal and external criticism is part of a growing body of women artists' examinations of the pressures in artistic and literary creation. In *Bird by Bird*, the writer Anne Lamott dubs these inner voices "Radio Station KFKD," an endless stream of criticism that a writer must learn to tune out (116). She likens the voices of critics and "parental units," both real and imagined, to mental mice that the writer can silence by dropping them into an imaginary mason jar and closing the lid (21). The creative personification of writer's block and self-doubt that Barry visually depicts as octopus-monster-ghosts and Lamott describes as belligerent mouse people takes on a different form in the imagination of the performance artist Amanda Palmer. In her 2011 commencement speech for the New England Institute of Art, Palmer names these inner voices "the Fraud Police." They are "an imaginary, terrifying force of experts and real grownups" who have "evidence that you have no idea what you are doing" and will arrest you for "the crime of completely making shit up" (Palmer).

The issues that Barry, Lamott, and Palmer describe go much deeper than everyday writer's block or the "imposter syndrome" that strikes graduate students. It is revealing that these three talented women creators—a cartoonist, a writer, and a musician—all tackle a common menace and address college students in particular. This is because perfectionism and self-doubt cripple many of today's students, who are the product of high-stakes testing, dismal economic prospects, skyrocketing tuition and student loan debt, and increasing competition for rapidly diminishing resources. Many college students, especially high performers, are paralyzed, fearful to try anything new for risk of failure. This is particularly true for students who were successful in high school; many valedictorians go on to high-ranking colleges where they suddenly shift from being at the top of their class to just being like everyone else.

These feelings are compounded in the first-year writing classroom, which is usually filled with non–English majors who are required to take the course, "hate writing," and believe that they have never been and will never be good at it. This is partly a result of the devaluing of the humanities in general, and partly because many students do not feel connected to writing or see how it could be valuable to them. Writing involves a lot of risk: it is personal, subjective, and makes us vulnerable to judgment and a kind of failure that cuts so much more deeply than getting a low score on a math exam. With the pressures of No Child Left Behind, Common Core, and standardized testing, students have been drilled in reproducing "safe" cookie-cutter five-paragraph essays but cannot make the dangerous—and ultimately more satisfying—leap into creatively written essays that are deeply their own.[2]

But writing was not always this painful. In fact, Barry argues, creative activity was not only something we all did quite naturally at one point in our lives, but also something we reveled in. In her comics and books, Barry delves into her childhood, where coloring pictures and making up stories were natural and fun, where "making lines on paper gave [her] a certain floating feeling" ("Two Questions" 60). This magical zone rescued young Barry, who was a sensitive and distraught outsider as a child. "Making comics saved me so many times," Barry writes (*Making Comics* 14). But though she later became a famous cartoonist, this power was not unique to her: "Every kid [she] knew could do it" ("Two Questions" 60). The act of creation—drawing, writing, singing, or dancing—came naturally, and Barry was not fraught with anxiety over whether or not whatever she created was "good." We all had these skills as children, Barry argues, and they are innate aspects of being human rather than gifts bestowed only on the lucky few. But somewhere along the way, most adults lose the free "floating feeling" that comes from drawing and writing and instead only experience fear of failure, anxiety over judgment, and paralyzing

doubt. It is no wonder many adults have stopped drawing and writing for pleasure, even by college.

Barry has made it her mission to help people of all backgrounds and ages reclaim that "floating feeling" and the childlike joy of creation they once had. It is a topic that surfaces in her semi-autobiographical comics such as "Two Questions" and her illustrated collections such as *What It Is, One Hundred Demons,* and *Making Comics,* and reclaiming the "floating feeling" is the goal of the classes and workshops she leads. In these artistic endeavors, Barry has sought to find new ways to reach more people and help them fight the two questions that hold them "hostage": "Is this good?" and "Does this suck?" ("Two Questions" 63). But her most direct challenge to those questions—and perhaps the most ambitious in its scope, in that it gives readers instructions that help them to teach others as well—is *Syllabus.* Because *Syllabus* promotes self-reflexive writing as a path toward knowledge, this essay will use methods from autoethnography studies as a framework to analyze the text. I examine how one professor used *Syllabus* in the college writing classroom and what that reveals not only about Barry's work but also in terms of possibilities for other instructors to use this multifaceted, multidisciplinary text in their courses. *Syllabus* is the kind of text that can liberate students from the high-stakes model of writing solidified by SAT prep courses and can instead set them on the path toward becoming confident college writers.

What Is *Syllabus*?

The trickiness in defining Barry's self-referential "autobifictionalographic" work, and *Syllabus* in particular, is part of what makes teaching it so much fun (*One Hundred Demons*). It pushes students to think carefully about genres and their expectations as readers. Like *What It Is, Syllabus* "interlaces three different visual-verbal registers, all of which directly address the reader: narrative, collage, and 'instruction'" (Chute 127). It encourages students to think "on the *Inception* level" rather than take texts at face value. And it forces developing writers to question genres and sources and be extremely specific in their own analysis and description.

Syllabus is a collection of syllabi, lesson plans, exercises, student examples, diary entries, and ruminations Barry created over three years of teaching in the art department at the University of Wisconsin–Madison (*Syllabus* 3). Her courses included "What It Is," "The Unthinkable Mind," "Making Comics," and "Write What You See" and ranged from nine to twenty-six students each (*Syllabus* back endpaper). Barry has made many of these materials publicly

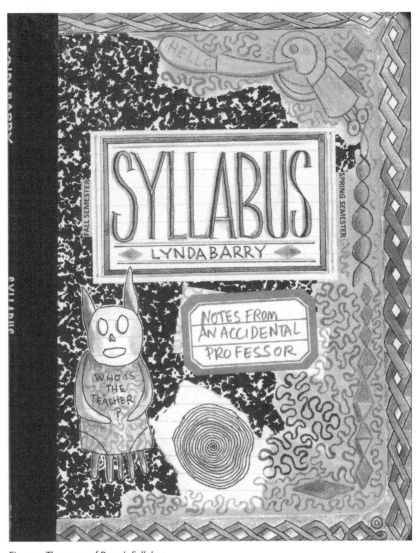

Figure 1. The cover of Barry's *Syllabus*.

available, posting them on her Tumblr page (thenearsightedmonkey) as well as in her workshops. But *Syllabus* gathers them and re-presents them as artworks in themselves, offering readers a chance to step into Barry's classroom not only as instructors but also as students. To quote one *Syllabus* fan: "It's like a paper MOOC!" (Halliday).

Syllabus is more than just a collection of syllabi. The physicality of the text is the first aspect people tend to notice when picking it up. In describing Barry's

earlier text *One Hundred Demons*, Hillary Chute notes, "The book demands to be understood in its entirety as a physical, aesthetic object" (112). The same is clearly true for *Syllabus* (and its companion text, *Making Comics*). In trompe l'oeil fashion, the book looks like a student's black-and-white marbled composition book, complete with doodles. With its cardboard covers, rounded corners, cloth-like black binding, and size, *Syllabus* is a near-perfect reproduction of the ubiquitous composition book (fig. 1). It is such a faithful reproduction, in fact, that one of my students said, "My roommate saw me reading it and thought the drawings in it were mine."[3]

The benign title on the cover belies the radically inventive text inside. Most college students do not think much about the syllabus, a standard document that routinely appears at the start of every class. Many instructors view the syllabus as a futile but necessary evil, since they know the students will ignore it. This no doubt has fueled the market for T-shirts that read, "It's on the f***ing syllabus." From the pedestrian ("Keep Calm, It's on the Syllabus") to the nerdy (Morpheus from *The Matrix*: "What if I told you the information you seek is in the syllabus?") there are multiple memes about students neglecting to read the syllabus. There are equally many stories of the tricks professors use to figure out which students actually read the syllabus, including the Columbia University classics professor Joseph A. Howley, whose syllabus instructs students who "have made it this far" to email him a photo of the 1980s television alien Alf (Romano). Overall, professors do not like writing syllabi, and students do not like reading them. Yet a syllabus is an expectation, sometimes treated as a mere formality and at other times as a contract, and it is expected at the start of every course (which many students feel is a throwaway class because "all you do is go over the syllabus"). But perhaps we are missing the real issue: syllabi are so dry, boring, and uncreative that students have no reason to want to read them. Enter Barry, whose syllabi are such vivid, funny, insightful, colorful works of art that she can collect them, publish them as a book, and entice people who are not even her students to pay for the joy of reading them. Perhaps instead of castigating students for failing to read the syllabus, we should consider our failure as writers to create texts that our readers are compelled to read. We teach student writers to think about considerations of audience. But when we create our syllabi—our first written communication with our students—many of us neglect to take our own writing advice to mind. After all, it is just a syllabus, right?

Syllabus is subtitled "Notes from an Accidental Professor," and it chronicles three years of "trying to figure out how to teach this practice" of "being present and seeing what's there" (4). A large part of *Syllabus*'s message is to encourage readers to put themselves in a position to be so free and creative that "mistakes"

happen, and to refrain from judging their work on a scale of "good" to "bad." When we read Barry's notes to herself, it becomes apparent that she is interested in avoiding these judgments from the instructional standpoint as well.

If readers open *Syllabus* expecting the strict formal structure of a typical syllabus, they are in for a chaotic surprise. Barry's syllabi are nearly unrecognizable as the traditional scaffolds for classes. They are not in chronological order. They are collaged and handwritten teaching notes on yellow legal pads and marbled composition books, usually scanned against a background of blue or yellow paper lined with crayon so that a quarter-inch border remains. The crayon lines are an example of one of the exercises mentioned in the text, as well as a design element that holds all these diverse pages, exercises, notes, and bits and pieces together.

Syllabus reproduces elements of a composition book in the covers and endpapers and then uses the collage techniques that appear between sections of *One Hundred Demons* and the didactic exercise structures from *What It Is*. However, it also offers a behind-the-scenes glimpse into a professor's mind as she works her way through her courses, using the experiences of her previous instructors and colleagues as guides. The pages are chaotic and full; like Barry's earlier works, they "exude a scruffiness" and are covered in doodles, text boxes, captions, drawings, patterns, photographs, and images competing for the reader's attention (Chute 3). It is hard to tell where one syllabus or class ends and another begins, which is partly the point; the process of learning about oneself and embracing creativity is not linear and ideally has no end.

In many ways, Barry created her own genre in making *Syllabus*.[4] What this book, with its deceptively simple title, *is* is actually a great discussion to have with students, especially when training them to think about types of sources and genre-based expectations, to differentiate between peer-reviewed and popular sources, and to think about the boundaries between primary and secondary sources, fiction and nonfiction. Readers must be critical *and* open-minded.[5] What a thing is, what its intended purpose and audience are, and what the conventions and expectations of its form are (and when and how to break them) are important questions to consider, and *Syllabus* is a fun and instructive text for inspiring these discussions.

A Case Study: Using *Syllabus* in the Composition Classroom at UCLA

In the fall quarter of 2015 and winter of 2016, I used Barry's *Syllabus* in four writing courses at UCLA.[6] These classes included highly motivated and skilled students in a competitive public research university environment. They were

almost all first years in their first quarter of college; culturally, racially, and socioeconomically diverse; and pursuing a range of majors from electrical engineering to ethnomusicology. In *Syllabus*, Barry states that she is interested in "what happens when students from different disciplines get together to work intensely" (10). One of the great benefits of teaching first-year writing at UCLA is that classrooms are full of students with different majors and from different backgrounds. Some of my students were the first in their families to go to college; some were international students and multilingual speakers. Barry's own class is an "expedition" for which she wants a specific "crew"—eight arts and humanities students, eight sciences students, and four "wild cards" (39). Although I do not select the students who take my courses, perhaps turning all my crew into "wild cards," my final mix nonetheless reflects the diversity Barry selects for, and allowed for a rich range of responses to the material.

My plan for teaching *Syllabus* was to use as many of Barry's exercises as possible, adapting them where needed to meet writing-specific goals. Although some of her exercises, particularly in the earlier collection *What It Is*, are specific to writing, most of the exercises in *Syllabus* are geared toward the creation of visual art.[7] However, nearly everything Barry writes about the creation of art applies to writing as well. For *Syllabus* to speak directly to a composition class, sometimes it is only a matter of asking students to cross out the word "art" and replace it with "writing." This practice, in fact, is part of what Barry encourages artist-writers to do, to keep the creative process continually progressing. Writing over the text helps students to see *Syllabus* as a mutable creation rather than a perfect, static product. It is a reminder that pieces of writing can always be revised, even after they are turned in or published, and that they can be adapted to different purposes—in our case, even appropriated by the reader. In addition, our changes to the text call attention to Barry's own changes, errors, cross-outs, and purposeful "mistakes" (such as the inverted *A*s in her name on the inside title page). As Chute notes, Barry chose to keep visible mistakes in her earlier work *What It Is*: "When she misspelled a word, her subsequent correction—blotting out or pasting over—is clear to the reader's eye" (238n29). This allows readers to feel the layering of the work, to see it in multiple stages of composition and feel the tension of the original text as well as the revisions. It introduces the idea of Freudian slips but also indicates that in some places, the changes are not either/or but rather both/and. And it reminds students that mistakes are inevitable in the act of creation—and not to pay too much attention to them along the way.

I not only wanted my students to try the same exercises that Barry's students performed, but also wanted to play with the form of the work itself as much as Barry did. Before the first day of class, I emailed the students, asking them to

buy *Syllabus* and bring it to class, since we would be doing some "crafting" with it. On the first day, I announced, "I want you to disfigure this book as much as possible during the course of the next ten weeks. Not because I don't like it, but because I want you to interact with it, think about it, do the type of activity with it that it is about." I then handed out a large bag of supplies—crayons, scissors, glitter glue, glue sticks, markers—and copies of my course syllabus printed single sided. I encouraged my students to cut up the class syllabus and reglue it into *Syllabus* in any way that made sense to them. Knowing that some would be apprehensive about covering up text in the book, I pointed out that good pages for gluing would include the inside cover, title page, and page 12 ("Theory"), which had the least text and the most free space.

Some students decorated the cover of *Syllabus*; others tentatively stapled parts of the class syllabus into their book. I encouraged them to continue as I spoke, which made going through the tedious syllabus requirements a lot more interesting. Next I instructed them to turn to page 39, where Barry lists questions that her students respond to on the first day. I had my students update Barry's class name and date to match our class, cross out questions that did not pertain to us, and add in a few of my own ("Where do you live?" and "Are there any upcoming events you want to invite your classmates to?"). Then I asked them to type up answers to these questions and bring them to the next class.

I was happy that several of Barry's class policies matched my own, such as "we do not activate any electronic devices in class." She covered many of the standard syllabus rules, but in a much funnier, blunt, and less punitive tone ("You *will* be *so* graded on your effort and time spent with pen or paintbrush," and students who are "moody!," "hungover!," "in love!," or "whatev!" will not be excused [39]). I asked my students to turn to Barry's "Classroom Rules" page (55) and vote on which rules they wanted to keep or modify. I crossed off "not talking about our work outside of class," "we don't often chat," "won't give feedback on their work," "we do not ask . . . who wrote which story," and "we never talk about the work" because discussion and peer review are important parts of composition pedagogy.

I spent a lot of time considering whether or not to assign pseudonyms to my students. Although lists of "brain names" like "Limbic System" and "Amygdala" appear in *Syllabus*, the explanation behind their use is not apparent in the book. In his interview with Barry for *Talk of the Nation*, Neal Conan discusses the theory behind assigning random names from a deck of cards or a list of parts of the brain. "Barry wants to get to know her students by their work instead of by their personalities. So instead of learning their names, she assigns them 'brain names,'" he explains. I thought assigning brain names sounded fun and liked the side effect of my students learning some

anatomical terminology. I even purchased a brain anatomy coloring book in anticipation of renaming my students. But I also worried about taking away their real names. At a large university like UCLA, composition may be a first year's smallest class and the only one where the instructor knows her or him by name. I would not want to take that away. So I opened up the issue to a class vote. Some students were really excited about having brain names. Some clearly were not. The "keep our real names" contingent won.

Deciding against using brain names was one of several creative pedagogical calls I made in teaching *Syllabus*. Another early decision regarded coloring books. In the first lesson/exercise for *Syllabus*, Barry offers one of her hallmark deceptively simple and deeply provocative rhetorical questions: "Is Creative Concentration Contagious?" (2). To help create a lab space for students to experiment with this question, form hypotheses, and test them, she encouraged students to try "coloring things in by hand as [a] study aid" at the start of class (3). She wanted to find out if the way students take in information aurally was affected by creative manual concentration, such as coloring, doodling, or drawing meticulously tight spirals (examples of which appear throughout *Syllabus*, including the front page) (fig. 1).

Barry notes that she starts classes with an idea from Dan Chaon, allowing students to select coloring book pages and candy and then encouraging them to color and munch on the treats while watching the original *Bad News Bears* at the start of class (66). With only seventy-five minutes in a class meeting, I could not justify taking class time to screen a 1976 kids' film about an underdog sandlot baseball team. But I still wanted to mimic Barry's exercise as much as possible. Students are "embarrassed to be seen coloring and this embarrassment is something I want them to wonder about," writes Barry (68). Yet she makes it clear that "what we'll be doing is anything but childish," that in tapping into practices we engaged in as children, we can access creative modes most adults have long suppressed.

Curiously, I found that just as Barry anticipated students would be embarrassed to be coloring, I was embarrassed asking them to color. So I applied the same questions Barry poses to her students to myself: What was the source of this fear? Why was it there? I was concerned that students would see a fun, childlike activity and then make assumptions about my class being easy, because of a common misconception that if a class is fun, it must not be intellectually rigorous or have high standards. If some of my students, who are mostly non-humanities majors, already feel that their STEM courses are inherently more difficult, serious, and important than my class, what would giving them coloring pages do?

But I trust Barry's methods. As a concession to the desire to make "the lesson" more evident in the coloring assignment, I decided I needed coloring

Figure 2. Citation coloring page. Drawing by Sebastian Hardy, colors by a student in English Composition 3SL at UCLA.

book pages that centered on writing-specific lessons. Using Etsy, an online marketplace for handmade items, I found the cartoonist Sebastian Hardy and commissioned six writing-specific cartoon PDFs that I could use in class as coloring book pages (fig. 2).[8] These cartoons covered some of the most common challenges I see in first-year writing, including paraphrasing and quoting, using signal phrases and citing, breaking away from high school writing formulas, and learning conventions for formal writing. I felt that physically coloring in details, such as parallel bars to remember parallel verb structure, would be more effective for students' long-term memory than reading dry grammar textbooks or hearing me repeat the rules. I was inspired by Matthew Inman, creator of *The Oatmeal*, whose hilarious grammar comics include "How to Use an Apostrophe" and "Ten Words You Need to Stop Misspelling."

I handed out a mixture of pages, crayons, and markers and gave students roughly five minutes to color. My fears about the students feeling "too mature" to color were unfounded; they dove right in. Perhaps because of the limited materials available or the freeing nature of the task, several students colored flamboyantly, allowing themselves "childish" choices rather than realistic, mimetic coloring (although most, predictably, colored inside the lines). For

example, on a picture illustrating Barry's quote about the feeling of being stuck on a hamster wheel, one student gave the cartoon figure green skin, gold slacks, and a pink-and-blue polka dot shirt and colored the hamsters bright pink (fig. 2). I also gave students the option to display their pages on the wall.[9] Unlike high school classrooms, college classrooms are usually shared, so it is unusual to display student work. I enjoyed seeing the coloring pages and referencing them later in the class when we discussed citing and integrating sources. In many ways, this was the payoff for the exercise; when students forgot how to check for parallel structure, or where to put the punctuation in a quote, they could quickly glance up at the wall. The coloring pages were popular, and later, when students led their own class discussions, several brought in coloring pages or instructed their peers to draw spirals while listening. Drawing spirals has multiple benefits. In the workshops Barry runs for the Omega Institute in New York, she asks for volunteers to read their work aloud while the rest of the students continue to draw tight spirals. No one can look at the reader, and Barry gives identical feedback to each person: "Good! Good!"[10] This forces participants to actively listen to each other's work, instead of planning what they will say about it or comparing it to their own. It circumvents the problem of students consumed by trying to "sound smart."

I assigned ten pages of *Syllabus* per class meeting, even though students could easily read through the whole book in one sitting, because I wanted to space out the concepts and have time to discuss them in a meaningful way. Whenever the students asked me to clarify or interpret for them, I turned the question back to them. I emailed a few of the questions to Barry. She encouraged students to come up with their own answers—a response perfectly in keeping with the message of *Syllabus*:

> If they had any questions about Syllabus that I couldn't answer I'd say to them "Guess." Set a timer for three minutes, draw an X on a page and just start writing down every guess answer to that question you can think of. There will probably be some pretty good answers that come about. (Barry, "Re: Questions")

The technique Barry references here appears in *Syllabus* as well. Barry's X-page exercises ask students to draw a giant *X* on their paper (which "wrecks" the page right away), envision themselves in a specific place, and respond to questions such as "What does the air smell like?" and "What's behind you?" in ten- to twenty-second bursts (80). She uses the X-page to help students generate images and ideas before progressing to longer sustained writing.

Student reaction to *Syllabus* was positive overall, after they got over their initial confusion. In our first discussions, students criticized the artwork because

they could not tell what the images were "supposed to be." Students described the inside cover and first page as "a trip" and were confused by the strange figures that resembled angels, jet packs, robots, or my favorite, "C-3PO on crack." These comments resonated when we discussed "What is a bad drawing?" on page 16, and pages 24–33, which feature timed student drawings of the prompt "Batman." Many of the figures were clearly influenced by the Hollywood versions of the character, with the iconic cowl, utility belt, bat emblem, and six-pack abs. The most realistic Batmans would typically be considered "good" drawings. But in seeing the creativity of the non-Hollywood versions, especially in comparison to the "good" ones, students began to notice the liveliness and originality in the "bad" drawings. One drawing shows Batman in profile, flying quickly through the air—which suddenly made the students realize that all the others were depicted standing (25). Because all the illustrated Batmen were drawn in the same position, my students took the pose for granted and did not even notice it as a choice, until they saw one that was different. This led to a fruitful discussion about David Foster Wallace's "This Is Water" speech and our inability to see much of our daily environment because we are immersed in it. We also discussed the writing decisions we make by default without realizing they are choices, such as the use of clichés, sayings, and gendered rhetorical patterns. In seeing all these drawings together, and in knowing Barry's students only had minutes to draw them, my students began to "forgive" the artists for their more "childish" choices. Barry's comments, written in cursive alongside these images, help drive home the point of the lesson:

> There is something beautiful in the lines drawn by people who stopped drawing a long time ago. . . . What if the way kids draw—that kind of line we call "childish"— what if that is what a line looks like when someone is having an experience by hand? *A live wire.* There is an aliveness in these drawings that can't be faked. (31)

The students in my class recognized the "alive" quality of the more childish drawings and, more importantly, could see the parallel to "alive" writing that is individual, unique, energized, and marked by the author's personality. Several students who wrote essays about *Syllabus* quoted the "live wire" and "aliveness" sections of Barry's work (23). As an instructor, I want to see "aliveness" because it is a sign of a writer who is truly identifying with the task and engaging with it in meaningful ways, rather than repeating tired arguments or what he or she thinks the professor wants to hear. In writing, that "alive" quality is often called "voice," and creating a strong voice is a very difficult skill to teach.

There are many fruitful ways to pair other texts with *Syllabus.* One could delve into Barry's references to poets and philosophers such as W. H. Auden,

Jalaluddin Rumi, Emily Dickinson, and Carl Jung.[11] I used several episodes of *This American Life*, Anne Lamott's *Bird by Bird*, and selections from Stephen King's *On Writing*. For example, in his hallmark otherworldly fashion, King compares writing to telepathy—stating how remarkable it is that he can transcend place and time to make an image appear in the reader's mind. This corresponds to Barry's interest in "how images move between people and parts of ourselves" (10). She reveals, "I was trying to understand how images travel between people, how they move through time, and if there was a way to use writing and picture making to figure out more about how images work" (49). The idea of writing as "a transit system for images," where ideas are actually "transferred to the inside of someone else," is striking and weird for students (9). It also helps them to understand why peer review is important: we cannot test how successfully we are transmitting, transferring, or telepathizing unless we check in with the recipient of the message. Writers know what they mean to say, but not what the reader actually gets. A peer reviewer's questions, and where they get stuck in a piece of writing, convey essential information to the writer.

Another example of an outside source I connected to *Syllabus* is *This American Life* episode 544, "Batman," which I assigned the same week the students were analyzing the Batman drawings by Barry's students. This podcast is about Daniel Kish, a blind man who "sees" by using a clicking "echolocation" system he developed as a child. This "Batman" challenges a dominant cultural view of what specific groups of people can or cannot do—and fits with Barry's call to action to stop judging while also letting go of the fear of being judged.

Using words written over a series of bat pictures, Barry asks, "If a kid is never allowed to play—what happens? Why? Does play have a biological function?" (49). Kish's story has one answer to these questions. His mother not only allowed her blind son to climb trees and speed wildly down the street, but also bought him a bicycle and continued to let him ride it, even after Daniel crashed multiple times, hit poles, and knocked out his teeth. In a line that several of my students brought up in class discussion, Kish observes, "Running into a pole is a drag. But never being allowed to run into a pole is a disaster." As a result of being allowed to play like a "typical" sighted kid, Kish developed abilities to *see*, as shown by MRIs where the same parts of his brain lit up as a sighted person's does when objects were placed in front of him. This is one example of how a real-world text in a completely different medium can pair with *Syllabus* to offer rich discursive interdisciplinary connections. This can help students practice examining how different texts can reflect on, expand on, and reinforce each other, instead of only thinking about them in terms of a "compare and contrast" essay.

Writing Assignments Based on *Syllabus*

Like Lamott's *Bird by Bird, Syllabus* is best used in the early stages of prewriting, to help loosen students and open their minds to possible topics, research questions, and areas of exploration. And *Syllabus* itself can also be the subject of an essay. In first-year writing, I frequently scaffold assignments so that students work on their essays earlier than they normally would—and therefore have time for play, rumination, drafting, and revision, rather than the night-before word frenzy that most of them perfected in high school. To be fair to the students and other procrastinators, myself included, deadline-induced word vomiting has its place. The adrenaline rush of the last-minute time crunch in some ways offers results similar to Barry's short timed-drawing exercises, where students have no time to be perfect and just focus on *doing*. Some students respond to time pressure positively, as it is one way to "get into the zone" or, in Barry's words, achieve that "*certain state of mind* that comes about when we gaze with open attention. When we are in the groove, we are not thinking about liking or not liking" (*Syllabus* 22). However, the majority of students experience stress and panic when procrastinating and cannot successfully write strong essays under such conditions.

I also wanted to help students access the playfulness and enjoyment of writing, to start thinking of themselves as writers who are free to create and make mistakes rather than nonwriters fixated on pursuing perfection. One of my goals is to teach students that they do not need to have a thesis set in stone when they begin writing, that they write to figure out what it is they have to say, and that writing is a way of thinking. Students frequently feel that their essays must burst forth fully formed from their heads like textual Athenas. Therefore, when they do not have all the answers at the start, they cannot begin at all. Barry also acknowledges that she had this misconception when she was younger. "When I was taking English classes in high school or discussing books in college I was given the impression that writers planned the stories, inserted the symbols, symbolic moments, and had a message," she reveals (Jenkinson 171). But she "never [had] anything in mind" when she started writing and instead let the ideas come to her in the process (171). As she notes in *Making Comics*, there is a "spontaneous core that is too easily forgotten when we believe we must know what we are drawing before we can begin" (66). The same is true for writing.

In *Syllabus*, Barry also experiments with both removing and constructing restraints, such as assigning her students to do life drawings but only within the space of an index card (22), drawing in response to prompts for sixty seconds or less, and coloring using up as much crayon as possible (87). Some of these exercises can easily be adapted for writing (for example, describing a person

or scene on an index card), and I wanted to capture the concepts of playing with materials, using up as much of a given resource as possible, and letting go of perfectionism to create something "alive."

I chose magnetic poetry as my exercise. I started class by handing out pizza pans and pie tins, instructing the students to take one as their "canvas." When I ran out of pans and tins, I encouraged the remaining students to use any magnetic surface they could find, which included whiteboards, door handles, and even trash cans. Immediately after I announced they would be writing a poem, most of the students grimaced at the thought of having to do such a hard and embarrassing task. However, one of the best aspects of magnetic poetry is that it removes the possibility of perfection, because students realize they simply cannot be perfect with a handful of random words. An added bonus of these limitations is that they nearly eliminate rhyming (which students often think poetry must have). I gave each student a small pile of magnets and instructed them not to worry about parts of speech or making sense but to put individual words together in ways that looked or sounded appealing to them. After a few minutes, I walked around the room "selling" additional words ("Who needs a verb?" "I just found 'chocolate'!"). I also encouraged students to create words of their own if needed by putting magnets on top of each other or exchanging words with their peers. Just like Barry's students' drawings, some of my students' magnetic poems were bound to be silly or childish or weird, but we would not judge any of them as "good" or "bad." Creating a Nobel Prize–worthy poem was not the point; reclaiming a childlike facility with language was. I wanted students to manipulate language physically so that they could also think about how they manipulate it figuratively.

One of the students was an active member of the military, so as a class we decided he was going to write a military poem, and we fed him words that we thought would fit. The result was surprisingly good—even though we were committed to *not* evaluating the poems in that way. I particularly loved the poems that were "alive" with unusual pairings and rich juxtapositions. This exercise often results in unexpected beauty that the writer would not have created under normal conditions. One student wrote, "Do not welcome the presidency / every which of them come to yield to majority / for freedom." He crafted his poem on the whiteboard, creating the prepositions he needed by overlapping magnets and covering letters he did not need.

This class occurred just weeks after the first Republican presidential primary debates leading up to the 2016 election, so the timing of his poem was particularly apt. It was also a great example of how "unpoetic" words like "presidency" and "majority" can nonetheless work in a poem. One of my favorite magnetic poems was interactive, used found poetry, and was composed on a trash can.

Figure 3. Magnetic poem and photograph by Zach Cooper.

The student lined up his magnets so that the word "PUSH"—embossed vertically into the trash can's shiny metal opening—became one of his words, and adapted the adage "when push comes to shove" into "from PUSH to show" (fig. 3).

Of course, magnetic poetry is a creative writing technique rather than the more traditional exercises one would expect for college prose. But I kept telling my students that there is more than one way to get at the heart of what they are trying to express in writing, and no one way is more valid than another, if it works for them. Sometimes simply getting out of their usual perspective and seeing a work through a different lens, whether through a different style of writing or a different discipline, is exactly what the writer needs. I wanted my students to feel how fresh, original, and nonclichéd language could be, and how to remember this playfulness and pleasure when working on more "practical" assignments.

For the first formal essay in the course, I offered prompts based on reader response and reading strategies for *Syllabus*, examining Barry's syllabi as a genre, performing a close reading of any two pages, and analyzing *Syllabus* from the perspective of the students' majors. Like Barry, I posed a series of open-ended questions to my students rather than telling them what they should write about. One of the more popular prompts was based on reader response:

Barry's *Syllabus* is not the easiest text to read. What reading strategies do readers use to figure it out? How does Barry teach you *how* to read her syllabi within the syllabi themselves? Does the experience of figuring out how to read *Syllabus* actually teach you some of the principles Barry is trying to teach in her classes? Talk about the experience of reading *Syllabus* with the goal of having an overall theory about *how* readers read it . . . or at least, your own reading strategies.

I also offered a prompt where students could use Barry's "Two Questions" to write about their own writing process and history as writers. Finally, I offered an "open topic" option where students could pitch ideas and write them with my approval. Only one student took this option, selecting Barry's question "What is an image?" as his starting point. All the prompts encouraged students to consider carefully both text and art, not just in *Syllabus* but in their own writing. I encouraged them to scan and insert images from *Syllabus* in their essays as figures and to experiment with discussing those images in the text.

The creative play that Barry encourages in *Syllabus* crept into my students' essays as well. Normally for the first essay assignment, students tend to write generic titles such as "Essay #1." This time, some students used playful puns and neologisms in their titles, such as "Breaking from the Syllabindings." This is important because a generic title is often the first indicator of a generic essay, whereas when students think carefully about how to christen their writing, they take more ownership of their work, and in figuring out the specific title that describes their ideas, they often clarify their main points even further.

One of the more unusual essays clearly connected with Barry's messages on a deep level. The student had not read *One Hundred Demons*' "Magic Lanterns," which describes the "aliveness" of the security blankets and stuffed animals that mean so much to young children (150). But he wrote about the same phenomenon, using Barry's ideas about image transference in the example of the two stuffed hippos he loved as a child. He started with the abstract idea, noting, "In *Syllabus*, Lynda Barry refers to an image as 'something that is more like a ghost than a picture; something which feels somehow alive, has no fixed meaning and is contained and transported'" (15). Then he applied her idea to the realm of physics. "In essence, the waves of energy transporting through frequencies are that 'ghost' Barry talks about. Moving like a phantom that cannot be seen by the eyes but having power in itself . . . energy affects us and this explains how and why images have this power to connect."

The intellectual examination of the idea of "image" as both immaterial and physical was one aspect of the paper that stood out and was clearly inspired by Barry's ruminations on the nature of images and idea transference. But the next move the essay made was even more unusual, creative, and satisfying.

The writer began to discuss the comforting smell of two stuffed hippos he had received when he was born:

> I took them with me everywhere I went until I was about five. . . . Every time I sniffed my "babies" I smelled the same odor. This aroma brought me to a calm and happy emotional state no matter how I felt at the time. . . . [Their] smell had power, not a physical image but a mental image, and could travel from the hippos to me. It consisted of tiny vibrating particles that reached my nostrils and affected me. . . . The smell was an image. (Cooper 3)

In this passage, the student makes the leap from memories associated with scent to the transference of invisible particles through the sense of smell to Barry's idea of the image. Without knowing it, he was following in the footsteps of Proust, and the study of *Syllabus* helped him make these connections. Iain McGilchrist, whom Barry cites frequently as a source of inspiration for *Syllabus*, writes extensively about how all actions require input from both hemispheres of the brain—that there is no action that is wholly "right brained" or "left brained."[12] This student's work shows how personal sentiment and even a sense of childhood magic play a role in logical reasoning and scientific knowledge. The essay contains both mature abstract reasoning and vulnerable, childlike memory. Most students are comfortable with one style of writing or the other, but this juxtaposition of them in the same essay made for rich reading that was original and *alive*.

The aspects of *Syllabus* that focused on quiet, meticulous observation without judgment were particularly applicable to one section of my composition course, which included a service-learning component. Each week my students applied their academic skills to support the work of a community partner, culminating in twenty hours of service learning by the end of the quarter. One of the challenges of teaching a service-learning or civically engaged course is that I have limited control over what happens when my students are off campus working with their designated community partners. Sometimes the children they are supposed to tutor do not show up. Sometimes it is a slow day, so they are moved to other tasks, such as manning the front desk at a youth center and checking in visitors. Sometimes there is simply downtime, when no one needs help and there is nothing to do. Of course, if one has the right mind-set, anything can be a learning opportunity, from riding to Hollywood on a crowded Metro bus to chatting in the Time Travel Mart at 826LA. "How do you stop saying 'nothing happened'?" Barry writes in *Syllabus*. This is exactly the question I pose to my students after their first days on-site. How can they collect data when things are slow? Barry offers one solution: "Pay attention, be quiet, and see what's

there" (5). Moments of boredom are important for creation, Barry stresses, but we often ruin the opportunity by heading straight for our cell phones for distraction.[13] It is difficult to just be aware, to observe without passing judgment. But by reading Barry's text, especially when she quotes Marilyn Frasca's call for "being present and seeing what's there" (4), and seeing what attention *looks* like in student life sketches, my own students have models for the type of details they can notice on-site and make meaning of moments where on the surface nothing seems to be happening.

Teaching Lynda Barry

If we follow Chute's description of Barry's *What It Is* as a "sibling text" to *One Hundred Demons*, then *Syllabus* is the baby in the family (and accordingly follows the fewest rules) (113). It is a rich and complicated text, full of possibility. For instructors who already read comics, *One Hundred Demons* is an obvious choice as a course text, as it lends itself easily to students thinking about, analyzing, and describing their own demons. No doubt this is partially why much of the literature about teaching Barry's work focuses on *One Hundred Demons*. However, writing instructors in particular, regardless of their knowledge of comics, can find inspiration in *Syllabus*, even if they do not want to tackle the challenge of assigning this hybrid text. According to Nathalie op de Beeck, "Barry's hands-on activities do have multiple applications for instructors. Her creative writing and illustration exercises . . . begin with free association and can generate active critical thinking" (170).

Jesse Cohn describes one of the common challenges instructors face when using comics in the classroom. He notes:

> Most of our students, accustomed to thinking of comics as easy reading, run their eyes quite rapidly over pages that are usually designed not to interrupt this ease. . . . While my class was eager to discuss what Lynda Barry's *One Hundred Demons*, Marjane Satrapi's *Persepolis*, and Jessica Abel's *La Perdida* had to say about women's experiences of family, sexual abuse, war, or culture shock, it was hard to get them to turn their attention to the *graphic* aspects of the novels. (44)

The assumption of comics as "easy reading" was evident in my classes as well, although it worked to my benefit in the cases of students who bragged to their roommates about having to read comics for class. However, the odd specificity of the way *Syllabus* uses cartoons and its overwhelming structure place it in a very different category from *One Hundred Demons*. *Syllabus* is so

over-the-top in its visual bombardment and in its fragmented pedagogical diary format that it makes it much easier to get students to discuss form and to look at the individual page and the graphic aspects that Cohn emphasizes. In fact, with *Syllabus*, students are so aware of the book's visual aspects that they have a hard time understanding it as a whole. One of the most common mistakes on my students' essays was treating *Syllabus* as if it itself were a single syllabus that was handed out to Barry's students, or misunderstanding the "syllabi" aspect of the collection altogether.

"I usually begin class discussion from a cultural studies standpoint, reflecting on common practices of keeping diaries, journals, yearbooks, and scrapbooks and on the practice of embellishing these books with literal and figurative residue of the past," writes op de Beeck (166). Although she is referring to *One Hundred Demons*, her approach is perhaps even more relevant for *Syllabus*, which is a diary "from an accidental professor" that incorporates real journal entries in collage format (*Syllabus* cover). "Through attention to Barry's backward-glancing, first-person narrative and the immediacy of dialogue and imagery, readers gain insight into the practice of personal recollection and the complex process of balancing verbal and visual in comics storytelling," op de Beeck continues (168).

Conclusions and Implications

Since introducing *Syllabus* in my writing classes in 2015 and 2016, I have continued to use Barry's techniques in a variety of settings to help people tackle writer's block and generate vivid, lively writing. For example, I use Barry's X-page exercises in workshops for the Kurnitz International Student Creative Writing Award, to help students who are struggling to write in a nonnative language. *Syllabu*s has also been a hit with parents: I have adapted Barry's exercises for creative writing workshops during Bruin Family Weekend.

Clearly, Barry's unique pedagogical and artistic vision can be fruitfully incorporated into the college writing classroom to enhance powers of communication and yield thoughtful analysis. Reading *Syllabus* can help liberate students from the pressures of the high-stakes model of writing hardwired into them from SAT prep courses—a step that is essential not only for their growth as writers but also for their own mental health and well-being.[14] It can be used to help students think deeply and critically about writing not as a magical gift but as a process, as well as to think about the kinds of techniques they have practiced so far—their own, the ones they learned in high school, and the ones they are learning in the college composition classroom. Part of this process

Figure 4. A "shitty first draft," by Nancy Valencia.

means letting go of the idea of perfection and embracing the messiness that is necessary in working through complex ideas over time. Writing is learning how to see and think, and to see, especially to see new ideas that other people have missed, you have to be able to play. We need politicians, scientists, and engineers who can play with ideas, and learning this skill through writing will help all our students, whatever their future careers may be. By using *Syllabus*, we can teach students to move beyond the critical voices in their heads and practice and develop their own process of writing, which can serve them for the rest of their lives.

Barry's effect on my students resulted in focused, nuanced essays that asked important questions rather than repeating a three-pronged manufactured thesis. Her effect also appeared when students began to use her techniques and apply them in different contexts. For example, I required the class to follow Lamott's instructions and write a truly "shitty first draft" about their own development as writers, without any regard for what I would think of it.[15] Knowing that they would not have an audience would change their ability to write freely, so I made it clear that I would not collect their drafts, much less read them, and that it was purely a brainstorming exercise to see if the technique worked for them. Typically, it has been difficult to get my students to write truly "shitty" drafts. The students still type, format, double-space, date, and spell-check their "shitty" drafts. They cannot let go of the need to impress their instructor, no matter how much I tell them that I will not read the drafts. But this time, in one of my *Syllabus* classes, a student wanted to share her work with the class. She held up her "shitty draft," and it clearly showed Barry's influence. It was written by hand (a method Barry advocates in *Syllabus*), and although it had coordinating ink colors and a loose outline structure, drawn at the top was a conspicuous pile

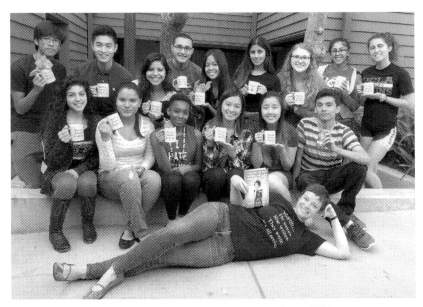

Figure 5. The Fall 2015 English Composition 3 Service Learning class at UCLA.

of feces—the "poop emoji" that has been making the internet rounds (fig. 4). The student told me that she drew the picture as a reminder that her writing was *supposed* to be "shitty." Drawing a childish picture at the top of the page was the thing she needed to give herself permission to let go of being perfect.

It may seem counterintuitive to encourage students to write "badly." But it is especially necessary for the types of anxious high achievers that I regularly work with at UCLA. One of the aspects of writing that often frustrates students is that there is no single answer or formula to achieve the results you want. There are multiple paths to strong writing, and multiple ways to help students get there. When teaching alternative techniques in class, such as clustering, freewriting, outlining, reverse outlining, and even "shitty" first drafting, I explain to my students that no single technique will work for all writers. However, I want them to experiment with a broad array of techniques to figure out which ones will work for them. To use another Stephen King analogy, many of them only have the five-paragraph essay in their "tool kit." Using *Syllabus* helps them to imagine a wild range of possibilities, and even if most of those possibilities are too far-flung for their taste, it still pushes them one step closer to *choice*—to realizing that the form of writing they use is a decision, rather than a default.

Syllabus includes group photos that Barry takes with her students at the ends of her courses, showing the impressive stacks of composition books they have filled. Inspired by this gesture, I took similar photos and shared them with the

class (fig. 5). The pictures are reminders to the students not only of the pleasure of sharing their work but also of what it means to build a writing community. Some of the goals of first-year college writing are to help students break out of the mold of high school writing, to communicate their ideas through prose for different audiences, and ultimately to discover who they are and what their voice is. Writing is a form of expression, but more importantly, it is a tool of inquiry and investigation. We write to find out what we think and know, to sort through the evidence at hand and discover what we truly believe. I want to teach students to keep their lines of inquiry open, to allow for multiplicity and complexity and to suspend judgment, and, yes, to write well enough to get through college and into a career, but more importantly, to use writing as a part of life. Writing is a process rather than a formula, and Barry's *Syllabus* is an excellent tool to help students come to this realization on their own terms.

NOTES

1. A black-and-white version of "Two Questions," reduced so that two pages of the comic fit on each page of the book, appears in *McSweeney's Quarterly Concern*, vol. 13, pp. 60–65. A significantly larger version, with illustrated borders and highlighted coloring, appears in Barry's *What It Is*, pp. 123–35.

2. For other sources of alternative writing styles for college composition, see Winston Weathers, "Grammar B," in *An Alternate Style: Options in Composition* (1980).

3. Related to the idea of students paying attention to the reactions of others when reading their textbooks in public, Anne N. Thalheimer has a wonderful technique that she used at Simon's Rock College of Bard: "The first assignment I give students with [Roberta Gregory's] *A Bitch Is Born* is to display their copy of the graphic novel in public and gauge public response" (88).

4. In searching for ideas for creating her own syllabus, Barry mentions that her friend and fellow cartoonist Ivan Brunetti published his syllabus as *Cartooning: Philosophy and Practice* (*Syllabus* 6). Yet this book is far more typically structured and "normal" than Barry's *Syllabus*.

5. I must thank the UCLA librarian Julia Glassman for driving home this point with my classes when discussing source evaluation.

6. All the student examples in this essay have been used with the students' permission. I am grateful to the students for sharing their work.

7. Although I did not use them as writing prompts, Barry includes very open-ended "Essay Questions" in *What It Is* (13). These questions include "What is an image?"; "Where are images found?"; "What is the past?," "Where is it located?," and "What is the past made of?"; "What is an experience?"; and "Where/Why do we keep bad memories?" (13–24).

8. Sebastian Hardy's Etsy shop is called the Haphazard Land and can be found at www.etsy.com/shop/TheHaphazardLand.

9. In *What It Is*, Barry shares a memory of the pride she felt when her grade school teacher selected her work to display on the class wall. Unfortunately, she also felt rejected when the teacher did not think her other pictures were fit for display.

10. Barry's praise includes the silent participants as well: "And to the people who didn't read: you kicked ass!" ("Writing the Unthinkable").

11. Barry famously reads the Coleman Barks translation of Rumi's "The Diver's Clothes Lying Empty" as a meditative exercise before writing. This can be seen on Barry's "9 Minute Timing" videos on YouTube. One can also use the classroom as an unexpected site for singing. In her July 2016 "Writing the Unthinkable" workshop for the Omega Institute, Barry alternatively sang a jingle for BIC pens, the Underpants Gnome theme from *South Park*, and "Archie, Marry Me" by Alvvays.

12. Barry assigns the introduction of McGilchrist's *The Master and His Emissary*, which is helpfully available as a free online PDF. There is also a TED Talk on McGilchrist's work that may help students grasp the concepts. However, my students struggled with McGilchrist's dense prose and concepts.

13. In a writing and drawing workshop at UCLA on October 9, 2017, Barry told the story of how she instructs students to put their phones in their bags against the classroom wall, and that although the phones will miss them and clamor for their attention, the students must remember to leave them alone.

14. Barry is well aware of the difference between the admissions arms race that today's students face and the open admissions she enjoyed at "hippie school" in the seventies: "I always say that my entrance essay for Evergreen was: index card, Elmer's glue, peace sign, lentils. Full scholarship!" ("An Evening With . . .").

15. Barry follows Lamott's advice as well. She wrote a "decoy novel" during the composition of *Cruddy* in which she "tried to write the shittiest novel [she could] on the side" ("Writing the Unthinkable").

WORKS CITED

Barry, Lynda. Comics Workshop. Center for the Arts of Performance at UCLA, Royce Hall, Los Angeles, California, October 9, 2017.

Barry, Lynda. "An Evening with Matt Groening & Lynda Barry: Love, Hate & Comics—the Friendship That Would Not Die." Center for the Arts of Performance at UCLA, the Theater at Ace Hotel, Los Angeles, California, October 8, 2017.

Barry, Lynda. Interview by Neal Conan. *Talk of the Nation*. National Public Radio, WBEZ, Chicago, May 30, 2013.

Barry, Lynda. *Making Comics*. Drawn & Quarterly, 2020.

Barry, Lynda. *One Hundred Demons*. Sasquatch Books, 2002.

Barry, Lynda. "Re: Questions from an Instructor Teaching *Syllabus* at UCLA." Received by Tara Prescott-Johnson, October 1, 2015.

Barry, Lynda. *Syllabus*. Drawn & Quarterly, 2015.

Barry, Lynda. "Two Questions." *McSweeney's Quarterly Concern*, vol. 13, 2004, pp. 60–65.

Barry, Lynda. *What It Is*. Drawn & Quarterly, 2008.

Barry, Lynda. "Writing the Unthinkable." Workshop. Omega Institute, Rhinebeck, NY, July 24–29, 2016.

Chute, Hillary L. *Graphic Women: Life Narrative and Contemporary Comics*. Columbia University Press, 2010.

Cohn, Jesse. "Mise-en-Page: A Vocabulary for Page Layouts." *Teaching the Graphic Novel*, edited by Stephen E. Tabachnick, Modern Language Association of America, 2009.

Cooper, Zachary. "Imagining Reality, Physical and Nonphysical." Essay. University of California, Los Angeles, 2015.

Glass, Ira, Alix Spiegel, and Lulu Miller. "Batman." Episode 544 of *This American Life*, January 9, 2015. https://www.thisamericanlife.org/radio-archives/episode/544/batman.

Halliday, Ayun. "Lynda Barry's Wonderfully Illustrated Syllabus & Homework Assignments from her UW-Madison Class, 'The Unthinkable Mind.'" Openculture.com, November 28, 2014. bit.ly/1yknsIU.

Jenkinson, Edward. "Will You Climb Up to the Heavens That Enclose Us Above: A Talk with Lynda Barry, 2000." *Page to Page: Retrospectives of Writers from the Seattle Review*, edited by Colleen J. McElroy, University of Washington Press, 2006.

Lamott, Anne. *Bird by Bird*. Anchor Books, 1995.

op de Beeck, Nathalie. "Autobifictionalography: Making Do in Lynda Barry's *One Hundred Demons*." *Teaching the Graphic Novel*, edited by Stephen E. Tabachnick, Modern Language Association of America, 2009.

Palmer, Amanda. "The Fraud Police." New England Institute of Art. YouTube, May 30, 2011, youtu.be/eA8XiC3m7vw.

Romano, Andrea. "A teacher hid an 'Alf' reference in the syllabus to see if students read it, and . . ." *Mashable*, September 15, 2015. https://mashable.com/2015/09/15/teacher-alf-syllabus-troll/#0WCLE7hug05k.

Thalheimer, Anne N. "Too Weenie to Deal with All of This 'Girl Stuff': Women, Comics, and the Classroom." *Teaching the Graphic Novel*, edited by Stephen E. Tabachnick, Modern Language Association of America, 2009.

COMICS
AND
AUTOBIOGRAPHY

Chapter 5

In the Orbit of the Cephalopod:
What It Is and Artistic Education

—Allan Pero

Education, Freud said, was one of the "impossible professions" (*SE*, vol. 19, 273). That is to say, education is impossible in the sense that it does not, ideally, have a fixed end (it is, at its best, a lifelong pursuit). Perhaps more important, education perforce means, yes, the joy of knowledge, but it also entails a confrontation with the anxieties and resistances that attend encountering limits—the limits of knowledge and understanding—that one is asked to contend with. As Deborah Britzman puts it, education is as much about what one does not know as it is about what one does not *want* to know (41). Lynda Barry's *What It Is* attempts to confront this very problem in the hope of answering the anxious question of writing. She explores "the formless thing which gives things form." But what is this formless thing? Following on the work of analysts like D. W. Winnicott, Marion Milner, and her own college instructor, Marilyn Frasca, Barry maps the space of what she calls the image, the psychic reality of an object that can be conjured and sustained through an unconscious intermingling of memory, play, and a yielding to formlessness. This yielding is simultaneously a means of invoking and coping with anxiety, an affect that accompanies the possibility of purpose-driven symbolization, a playful distinguishing of subjects from objects, and the creation of transitional objects. In sum, one must produce the psychic conditions—a trust in the work—in which one can create.

However, unlike Barry, Winnicott wants "to separate the idea of creation from works of art" (67). Creation is a universal condition of being alive to the emerging subject's relationship to reality. It is not that creativity and artistic creation have no connection to each other; rather, in Winnicott's theorization of creation and transitional objects, they are shown to have a paradoxical relationship. That is to say, the transitional object is experienced as having been both discovered and produced by the child at the same time; the object awaits its creation, even as the act of creation opens up the possibility of becoming "a cathected object" (Winnicott 89). This paradoxical space is the site of formlessness. But formlessness is not merely a space; it is, more properly, a space of play that opens up "the experience of a non-purposive state," which, in its unconsciousness, prompts "a ticking over of the unintegrated personality" (55). It is precisely this "ticking over" that Barry works to sustain, by recognizing the ways in which the ego sets up defenses against writing, and the ways in which anxiety functions as an enemy of the creative impulse in adults as well as children.

Images are, for Barry, not only the "stuff" of creative ideas; they are "the soul's immune system and transit system," the means by which we create, internally, the outside world for ourselves so as to orient ourselves psychically (*What It Is* 17). Barry's persistent use of collage in *What It Is*, then, like the presence of the "magic cephalopod" and the many-eyed "sea demon," works to generate the freedom of movement necessary for "writing the unthinkable" (138). (Here we encounter a further development of a figural process we encountered several years earlier in *One Hundred Demons*.) In opening the text of *What It Is*, we come upon endpapers filled with sticky notes, ideas, questions, and inspirations that offer conduits into states of play. Some speak to Barry's own history of creation, others to chance encounters that produce new insights or images, and still others to the different impasses, frustrations, and confusions that surround writing and drawing.

For example, one of the notes in the endpapers reverses a common assumption about writing: "Not having an experience to write it / But / Writing to have an experience." Barry undercuts the notion that creativity is bound up in a particular temporal narrative, one that is bound by our relationship to intertextuality—a relationship that is less canonical than it is structural ("What Is an Experience?" 27). By reversing the procedure, she draws our attention to the fact that play and creation precede and inform intertextuality; writing is thus not the pledge and seal of the value of an experience. Instead writing can be understood as another form of play, of concentration, that yields the promise of absorption, a yielding to formlessness, instead of an anxious marshaling of intellectual forces dampened by the expectation of producing

form. In this way, experience is not a narrative or historical record shaped by language. As Georges Bataille contends, experience is "a voyage to the end of the possible in man" (*Inner Experience* 7), one that generates its own authority through the negation of other values, other forms of authority; that is to say, it is a challenging of oneself. The authority it produces "expiates itself" (7). Barry's pedagogical method operates on a Winnicottian logic of cutting oneself off from the censorship of the conscious mind (what Barry calls "the top of one's mind") and being absorbed by the extremity (for Barry, "the back of the mind") that the subject, in producing the work, experiences as a moment of determination: one of formlessness's infinitude—an experience of play that is obviously very different from censorious "productivity."

Play and work are thus linked, but not by a demand for productivity. This is the lure that keeps us, as adults, from creative play; we mistake the chore of being productive—of having a purpose—with the evolution of experience itself. In Barry's view, the evolution of experience is grounded in two primary paradoxes: the first involves memory (we must remember in order to forget, and forget in order to remember); the second involves the demand of the work in a state of play (that is, in a state of worklessness). I will turn to the first paradox in due course, but for now, let us consider the implications of the second. In Maurice Blanchot's *The Space of Literature*, we encounter what he persistently refers to as "the work's demand." This demand has useful echoes in understanding Barry's own pedagogical approach. Blanchot explores in depth the work's demand not as the demand we make on ourselves to generate the work, but instead as the demand the work makes on us. The work's demand, as Barry herself repeatedly avers, is one of anxiety—the yielding of one's very being to the "most hidden moment of the experience" (*Space of Literature* 46):

Indeed, we understand it intimately, as the intimacy of the decision which is ourselves and which gives us being only when, at our risk and peril, we reject—with fire and iron and with silent refusal—being's permanence and protection. Yes, we can understand that the work is thus pure beginning, the first and last moment when being presents itself by way of the jeopardized freedom which makes us exclude it imperiously, without, however, again including it in the appearance of beings. But this exigency, which makes the work declare being in the unique moment of rupture—"those very words: *it is*," the point which the work brilliantly illuminates even while receiving its consuming burst of light—we must also comprehend and feel that this point renders the work impossible, because it never permits the arrival of the work. It is a region anterior to the beginning where nothing is made of being, in which nothing is accomplished. It is the depth of being's inertia [*désoeuvrement*]. (*Space of Literature* 46)

I have quoted this complex passage because it is necessary to untangle its rather gnomic implications for Barry's method. If, as her instructor at Green Mountain College, Marilyn Frasca (to whom *What It Is* is dedicated), put it, it is crucial for the writer to "listen to the work," then what, precisely, is one listening to? On one level, the instruction is meant as a warning to the teacher not to get in the way of the student's work by offering too many suggestions, by offering too much information. But on a more important level, listening to the work—to its demand—is a surrendering to its beginning, when what Barry calls "an image" is permitted to appear, or to speak. One surrenders the safety of thinking reason, of being ("the top of one's mind"), for the anterior—the neutral space of nothing ("the back of one's mind")—to manifest itself. In the context of Barry's work, Blanchot's use of the word *désoeuvrement* requires some unpacking. The English text offers "inertia" by way of translation, but neologisms like "worklessness" or "unworking" better capture the charged *process* by which the work appears in a moment of rupture; this rupture is born out of a purposelessness that points to the work's arrival, even as it hinders its appearance. In other words, the state of worklessness enables the writer to see the work, even if the perfection of that vision—again, revealed in a moment of rupture, the "*it is*"—cannot itself be translated back into the creative product. What I would suggest is that the word *désoeuvrement* would be, for the purposes of Barry's creative pedagogy, even better translated as "play," in the Winnicottian sense. Why? Because "the basis of playing is built," according to Winnicott, on "the whole of man's experiential existence" (64). However, as we have already seen, play is not simply a site of innocent, trivial activity. Winnicott describes it as the opening up of an "unintegrated state of the personality," one in which the search for the work of play "can come only from desultory formless functioning . . . as if in a neutral zone" (64).

This neutral zone, which combines the slow revelation of the work's demand through desultory—that is, purposeless—play, and in turn opens up a space in which the formless can function, could perhaps be encapsulated by collage. The principle of collage, which Barry often uses when "stuck" while writing or drawing, is embodied in the ambivalent figures of the cephalopod and the many-eyed sea demon, who are rather like the pineal eye, or "ocular tree," in Georges Bataille's sense of the term (*Visions* 84). Another way of putting it is to suggest that the pineal eye is itself the *gaze created by collage*, one that supersedes the limits of unidirectional, horizontal vision to produce an image.

In calling the pineal eye the gaze created by collage, I am referring to the Lacanian gaze. The neutral zone of play, in the production of collage, illustrates the split between the eye and the gaze, a split that is both virtual and material. The lack of reciprocity between them—the eye or subject cannot see from the

perspective of the gaze, that is, from the gaze of the other—produces a virtual blind spot in the eye's vision. Of course, the eye also has a material blind spot, one for which bifocality compensates but does not erase. As Lacan tells us, the gaze, occasioned by the other's desire to reveal itself, is matched by the eye's desire to see. Thus it is the fact that the gaze is unseen that provokes the subject to identify with it, "to become the punctiform object, that point of vanishing being with which the subject confuses his own failure" (*Seminar XI* 83). As Lacan insists, the gaze cannot be understood merely as another eye; the gaze, we are told, is an intervention—like Bataille's pineal eye, it intrudes on the subject seemingly as the cause of its desire. In other words, the gaze is *objet a*: the symptom. That is, one cannot see from the perspective of the gaze *except* from the perspective of the gaze; it cannot secure this perspective, the perspective of the gaze, without feeling anxiety—an anxiety akin to putting one's psychic existence in jeopardy. Collage becomes a means of managing anxiety through the worklessness of play, of engaging the neutral zone or field between the eye and the gaze.

Like collage, the pineal eye is also formed by layering. Collage is like montage in that it is a mounting, or an intertextual gluing together of different spaces, of memory, imagination, and experience, into freshening contiguities. The energized, pineal accretion of ectodermic layers (comparable, say, to a mollusk's shell) that form the pineal eye's primitive retina or light receptor can be compared in turn to the rhetorical connections between metaphor and metonymy that emphasize process over product, deferral over definition.

For example, the vertical ascent into the shifting metonymic plates made by metaphor (such an ascent implies the metaphoric substitution of one point of elevation for another) is made possible by the contiguous, repetitive nature of metonymy. In other words, as Henri Bergson writes in *Creative Evolution*, metonymy is the condition for metaphor (283). But as Winnicott is quick to remind us, formlessness is the condition of form. The process of layering suggests that, in the subject's relation to the pineal eye, metonymy is the process of fragmented, even kaleidoscopic, repetition—that is, desire—that permits the metaphoric substitution or cut to occur. The sustained repetition involved in the paraboloid ascent of the pineal eye (in other words, to see from the objectal perspective of the gaze) arguably moves the subject closer to the vertex or focus—that is, to the object of desire. For Barry, that object or form is made up of literature and art, which are themselves artifacts of the process of constructing subjectivity. If, following Winnicott, Barry uses collage in *What It Is* as a means of disrupting the policing of boundaries between subject and object, then collage itself—through the text's exploration of memory—becomes an imaginative means of reconstructing the very process whereby the subject came

into being in the first place. That is, if collage's apparently formless, fragmented appropriation of images demonstrates how the border between the playing subject and the objective world of reality is itself porous, like a cephalopod, and if, in turn, the subject constructs itself like a collage from fragments of objective reality, then Barry's pedagogical method is informed by the fact that we have forgotten the intimate process of self-determination, of differentiating oneself from the world of objects through collage. As a result, one must remember what has been forgotten to create the state of worklessness necessary to writing.

In its pedagogy, *What It Is* uses somatic repetition, the memory and focus that the body develops through repetitive, metonymic movements (like beginning class by repeatedly writing out the alphabet, or the activity of drawing spirals in the "sequel" to *What It Is,* called *Picture This,* on different orbiting scraps of paper) to produce the necessary space of safety and concentration in which what Winnicott calls "transitional objects" (that is, objects that create a neutral space of experience) can surface (12). Transitional objects are indices of what Blanchot calls "the work's demand"; they are paradoxical insofar as "the baby creates the object, but the object was there waiting to be created and to become a cathected object" (Winnicott 89). Repetition becomes crucial to the process of the production of transitional objects; repetition is itself a form of ritual, or ritualistic concentration on the doubts and anxieties that must be confronted with any creative act. The pleasure of repetition, in its triumph over the threat to the ego's fantasy of self-identity, effectively replaces the ego (with its attendant doubts and anxieties) with the constancy of guided, anticipatory repetition. For example, when Barry has her students begin their work by producing spirals, she does so precisely because the spirals in themselves have no creative purpose or goal; they embody the purposelessness of worklessness. The pleasure, calm, and concentration produced by making spirals literally circle the creative object or goal, focusing the attention of the artist without expecting or demanding the creation of a finished "product." Drawing spirals is a preparatory gesture for the creative act to emerge, opening up the possibility for improvisation and what Marion Milner, for example, describes as the "plunge into color," into a particular medium's own expressions of freedom—a freedom that one can see with one's "conscious inner eye," liberated from the fear of failure, on the one hand, and brought into conversation with the "blind experience of color," on the other (23–24). In following Milner, Barry makes safety and freedom crucial pedagogical components of her text, since many of its pragmatic exercises circle around the anxiety that formlessness can produce. The exercises confront the anxiety so as to claim the freedom to create. On the surface, anxiety is the enemy of play, the enemy of creativity; in its violence, it is the ego's attempt to reassert its dominance over formlessness, in its demand

that the activities of writing or painting "make sense" or that the results prove themselves to be aesthetically "good." But like the spiral, the transitional objects that shape the emergence of images cannot be reduced to a point. The sense of images lies elsewhere, in the anxiety generated by the worklessness of play. But as Barry's text shows us, anxiety is not simply "outside" creative play; it is a constitutive element of it. That which makes us most anxious, Barry suggests, may very well be the most valuable element of a story or image. *What It Is* thus works to embody a doing without thinking, a kind of fantasy in which both the subject and object can survive—through the process of giving form to formlessness—the opening up of the anxious pain of reality.

That said, the production of forms or images is a species of fantasy; images, fittingly enough, occur in the imaginary. What, then, are the implications for anxiety? We must confront what might seem like a counterintuitive notion: the affect of anxiety is not an unconscious one but is itself wandering, errant, requiring representation. Anxiety has an object, but it resists clear symbolization. In effect, to confront anxiety is to confront "the depth of being's inertia" (Blanchot 46). By way of explanation, we should recall that Lacan is quite pointed in his insistence that affects are not to be confused with unconscious repression: "What I said about affect is that it isn't repressed. Freud says it just as I do. It's unfastened, it drifts about. It can be found displaced, maddened, inverted, or metabolized, but it isn't repressed. What are repressed are the signifiers that moor it" (*Seminar X* 14). So what does this mean for anxiety and the creative act? In this respect, the magic cephalopod is a signifier, an image meant to guide, but it is also one that drifts about the text of *What It Is*. At some moments, for whole sequences of pages, the cephalopod—etymologically "head-foot" or "brain-foot," in effect a wandering brain—appears to be dark, silent, even forbidding; at others, she is called "Sea-Ma" and is playful, inviting, and full of encouraging questions and exercises. Why is the cephalopod a figure of ambiguity, even ambivalence? It is, I would suggest, the unmoored embodiment of anxiety, but as Lacan famously says, "anxiety is that which does not deceive" (*Seminar XI* 41). The cephalopod may be an image of anxiety, specifically an anxiety about the truths that will surface in the subject when committing herself to answering the question—which is, perhaps, *the* question—written in capital letters on the cover of *What It Is*: "DO YOU WISH YOU COULD WRITE?" But what or who poses this question? Importantly, it is not the cephalopod but another figure entirely: the monkey. (Barry famously calls her teaching self "the near-sighted monkey" and insists that each student also take on a character or "brain name") (*Syllabus* 47, 55). The magic cephalopod and the monkey are thus complementary figures. If the first embodies the anxiety accompanying the creative act, then the second has both a pedagogical and a psychoanalytic

function: the monkey is both teacher and analyst, surfacing at moments to help the student/analysand recognize the ways in which the wish to write is, even in the anxiety that grounds it, a sign of the truth of the student's desire to answer the work's demand.

Barry's pedagogical practice gives structure to anxiety. It does this not by putting words in students' mouths or images in their heads but by giving shape to anxiety through exercises that work to unmoor thinking and judgment. She is producing a space where experience, once repressed and forgotten, is slowly remembered, described, drawn, and moored to being, becoming *what is necessary for the work to appear*. Perhaps this is one of the reasons why everyone, including Barry, must assume another identity in class. If answering the work's demand is a falling away from, or yielding up of, one's being, then the anxiety prompted by that fall or yielding is predicated on a saving transformation: in becoming the object necessary to answer the call of the work, in objectifying the desire to answer that call, it is not *your* being, *your* subjectivity, that is falling away, it is the "brain name" that assumes the task. In promoting this turning away from oneself, one's identity, Barry encourages her students to sublimate the moments of imaginary identification with an object, reminding them of the ways in which they transform objects into "living" things.

For example, Barry tells us of a childhood memory of a picture of a gray kitten by her bed; occasionally she would see it blink. It was not mere ink and paper; it was ink and paper that blinked, lived, held a gaze. But the illusion produced by the sublimation of the picture could only be recognized as such retroactively, once disillusionment had set in. The picture was, of course, mere ink and paper, now divested of the "aliveness" its gaze had communicated to Barry (*What It Is* 11–12). The lesson Barry wishes to convey is that despite the disillusionment, the memory of the experience of sublimation, of the satisfaction of its creation from nothing, is itself important. If the image satisfies, it does so even if it does not make conscious sense. For Winnicott, the satisfaction the subject derives from the image comes from its assertion of a true self, an authentic self. Of course, Winnicott is not using terms like "true" and "authentic" to refer to a stable or rigid notion of subjectivity; rather, the image is a collage—of the self's potential, of its being alive to itself. It is a fantasy that gives structure to possibility, rather than standing for the structure of selfhood. As Mari Ruti describes it, "Winnicott's notion of creative living [is] a psychoanalytic answer to the phenomenological problematic of self-actualization" (139). In other words, self-actualization is not the discovery of a rigid, stable self but instead the collage of sublimations that mark, metonymically and retroactively, the self's capacity for both reimagining and having reimagined itself. In sum, Barry's use of Winnicott simultaneously acknowledges the anxiety that is nec-

essarily invoked by the desire to create, to take on the work's demand, while anchoring and giving structure to that anxiety.

In its porosity, the image not only stands for a site of resistance in distinguishing subject from object but also functions as a site of intimacy. Among the many questions Barry's text poses, one of the dominant themes revolves around the image's location: Is it inside or outside? Or is the image both inside and outside? How does it move? (*What It Is* 30). One of her approaches to the problem of creativity is to prompt us to think about how our paradoxical relationship to the image grants it a kind of life; it is alive in the way "memory is alive," "in the way the ocean is alive and able to transport us, and contain us," and "in the way thinking is not, but experiencing is, made both of memory and imagination" (*What It Is* 14). The life of the image, then, is paradoxical in the way that our relationship to it is; the image can appear, suddenly, unbidden, to vex and disturb, but can just as vexingly remain stubbornly remote and hidden.

In Barry's pedagogy, memory and thought must be distinguished from each other. If conscious thought gets in the way of memory's drift, then memory is the opposite: it is "an image which travels through time," which, upon arrival, offers itself as a possible site of sublimation (*What It Is* 33). With these insights in mind, we can now turn to the first paradox I outlined earlier: "We must remember in order to forget, and forget in order to remember." Remembering is a process, one marked by worklessness in the way that play itself is; just as memories sometimes require us to do the "remembering," they are, like images, not mastered by us—they are just as likely to appear when we least expect or want them to. The play of memory, or playing with memory, is, like images and narratives alike, not an escape from reality but a means of coping with it. Fantasy is not a resistance to reality, nor is it its binary opposite; it is a support for reality, "to stand and understand what otherwise would be intolerable" (*What It Is* 40). If memory is time-traveling image, then its relation to writing produces a temporal chiasmus of the kind described earlier—remembering in order to forget, and forgetting in order to remember. A chiasmus contains both repetition and inversion. The past, however temporarily, effaces or forgets the present, even as a present act of forgetting in turn invokes the past. The image conjured by remembering, captured in the midst of its taking shape, is intentionally a priori to the writing or drawing that will come to surround it. In its spectral anteriority, the memory image is, for the artist, a noetic moment or entelechy in the answering of the work's demand. But in effacing the present, the invocation of the past must itself be forgotten for the work to appear in the present. Yet we must be attendant to the black space—or blind spot—produced in the center of the chiasmus. It is the black hole in temporal vision; it is the source, as it were, of anxiety. And at the point of crossing lies

the chiasmus of repetition: our retroactive understanding of the process of creation is determined by the repetition of the image—first as memory, then as the work. The temporal logic of the image can only be apprehended, in a sense, after the fact of its creation. What Barry calls "follow[ing] the wandering mind" (49) illustrates the paradoxical nature of this repetition: the freedom of the memory-image dwells in the doubling of the image-as-work, which forces us to confront, in the act of writing, the temporal instability—the anxiety of what Blanchot calls "time's absence"—necessary to the creation of the work (Blanchot 30). That is to say, the artist must chiasmically inhabit the temporal nullity or neutral zone, succumb to its fascination, for the memory-image to appear of its own volition: "The time of time's absence has no present, no presence. . . . Memory still bears witness to this active force. It frees me from what otherwise would recall me; it frees me by giving me the means of calling freely upon the past, of ordering it according to my present intention. Memory is freedom of the past" (Blanchot 30). However, this freedom comes at a cost. The memory-image has no place—no presence—but stands as the paradoxical site of creativity, and the anxiety that informs it. On the one hand, the memory has no facticity, no substance, but on the other, it is forever initiatory, agential, and "it starts over, again, again, infinitely" in its opening up of the neutral zone of possibility, of writing.

In *The Visible and the Invisible*, Maurice Merleau-Ponty critiques the dualism of subject and object that typifies much phenomenological thought, preferring instead to think of self and other, self and world, as intertwined, as a chiasm. This chiasmic form of engagement complicates the privileging of vision and visibility by drawing our attention to touch and tangibility—it gives life and movement to the relation, utterly binding subject and world in startling, provocative ways. "There is," Merleau-Ponty argues, "double and crossed situating of the visible in the tangible and of the tangible in the visible; the two maps are complete, and yet they do not merge into one. The two parts are total parts and yet are not superposable" (134). The porosity of the image is an index of the chiasmic intertwining of subject and world. However, the intertwining does not produce an absolute unity or identity with the world: "On the contrary, this occurs because a sort of dehiscence opens my body in two, and because between my body looked at and my body looking, my body touched and my body touching, there is overlapping or encroachment, so that we may say that the things pass into us, as well as we into the things" (Merleau-Ponty 123).

So if the point of crossing or intertwining is a site of dehiscence, an opening to the aliveness of oneself and the world, it then also functions as a kind of blank or blind spot; in creative terms, it can be understood as Winnicott's neutral zone, but it gains currency in Barry's work by virtue of her turning to memoir.

What It Is includes a sequence in which Barry talks about her transformative encounter with Frasca. In prefacing this encounter, Barry talks about the ways in which reading, writing, and music—specifically the staged fantasies of aping and copying of art, writing, modes of dress, behavior—were needed to push her farther, to provide a space of psychic safety, to give her the structure to be able to claim the life she wanted to have. But when Barry is confronted by Frasca's question "What is an image?" (117), she is profoundly nonplussed. She admits she has no idea what the question and its implications might be, much less how to answer them. She comes to realize that the gap between visibility and tangibility, or, in other words, "between trying to decide what I thought and having something actually happen to me," is what requires her attention. She finds herself intellectualizing without feeling, or looking to Frasca for reassuring words about a work's aesthetic quality, despite the fact that Frasca is not looking for intellectualism and consistently refers to Barry's work as "good." However, Frasca is not expansive in her praise, which, as Barry confesses, "drives me crazy at the time because I wanted to know what she thought" (120). What is fascinating is what happened next. Frasca's almost analytic silence pushes Barry into the neutral zone, the chiasmic point of crossing—in sum, a space of waiting for the image to appear.

And the result? Over the next year, Barry's paintings—produced at a rate of ten per week—remained empty, blank. Barry describes it this way: "I believe it was closer to the staring game I played in the trailer when I was little, a state of mind I had forgotten about. A different kind of looking. An ability to wait" (121). She is waiting for the image to take hold of her, like "the pull-toy that pulls you, takes you from one place to another. . . . The ability to stay in motion, to be pulled by something, to follow it, and stay behind it" (121). As it turned out, the problem for Barry was twofold; first, there is the problem of being able to sustain her response to the work's demand, and second, she continues to be hectored by two questions, questions that remain a lure for anyone hoping to produce creative work: "Is this good? Does it suck?" (123). These questions pull her away for some time from the space of anxiety, the exigencies of the work's demand, into facile praise and social recognition, until the anxiety returns, but in a different form: it is not the facility itself that is the problem; it is that her occasional failures produce an interior dialogue with crippling anxiety and doubt. In psychic terms, she feels that she is being asked by two demons, each perhaps embodying one of the two questions, to sacrifice the magic cephalopod to appease them as they haunt and mock her work. As she narrates this time in her career, Barry puts the cephalopod in boxes, ties its tentacles in knots, often driving it to the corners and gutters of the pages, even as it weeps and pleads with her to remember what she has forgotten in Frasca's course (123–32). Over

several pages, Barry draws a series of panels in which stifled creativity is offering keys to her torment: in one, the magic cephalopod appears boxed, pressed against a window, the monkey meanwhile sleeping in its tentacles, while Barry is feverishly reading anything, everything, trying to find the answer (132); in another, Barry is herself boxed in the window, reading Milner's *On Not Being Able to Paint* (133); and finally the cephalopod is knocking at the window, telling her repeatedly to "Give Up!" (134). This last seems surprising, until one realizes that the answer is precisely that: to acknowledge that she does not know, that she cannot answer the demons' inquisitorial questions. In other words, obsessively thinking about these questions bars her from the unthinkable. The chiasmic intertwining, visual and tactile, with the magic cephalopod (which occurs on page 135) cannot happen unless the state of worklessness, of play, creates a space for the "aliveness" of the image to appear.

The subsequent pages of *What It Is* elaborate a phenomenology that is startlingly like Merleau-Ponty's. Barry produces a series of exercises to encourage and generate writing that ask the students to consider the ways in which their bodies, as visual and tactile beings, are engaged with, intertwined with, the world of images. As we have come to understand, images are not simply modes of visual representation; they have affective weight and mobility, producing tangible effects on the body, in feeling and memory. The act of writing (and Barry insists on using pens or pencils and paper, because they stimulate the chiasmic connections between body and mind, between formlessness and form, subject and world) (107) is grounded in repetition, in a kind of learning that is not governed by linearity, by the rigidity of an end goal, but is instead guided by constant circular motion, by spirals. This is why Barry keeps a blank pad beside her while she works; if she gets stuck, the pad is always there, open, free, and ready to receive whatever she places on it, "until [her] other pad of paper calls [her] back" (*What It Is* 190).

WORKS CITED

Barry, Lynda. *One Hundred Demons*. Sasquatch Books, 2002.

Barry, Lynda. *Picture This: The Near-Sighted Monkey Book*. Drawn & Quarterly, 2010.

Barry, Lynda. *Syllabus: Notes from an Accidental Professor*. Drawn & Quarterly, 2014.

Barry, Lynda. *What It Is: The Formless Thing Which Gives Things Form*. Drawn & Quarterly, 2008.

Bataille, Georges. *Inner Experience*. Translated by Leslie Anne Boldt-Irons, SUNY Press, 1988.

Bataille, Georges. *Visions of Excess: Selected Writings, 1927–1939*. Translated by Allan Stoekl, University of Minnesota Press, 1985.

Bergson, Henri. *Creative Evolution*. Translated by Arthur Mitchell, Dover, 1998.

Blanchot, Maurice. *The Space of Literature*. Translated by Ann Smock, University of Nebraska Press, 1989.

Britzman, Deborah. *The Very Thought of Education: Psychoanalysis and the Impossible Professions*. SUNY Press, 2009.

Lacan, Jacques. *The Seminar of Jacques Lacan, Book X: Anxiety*. Edited by Jacques-Alain Miller, translated by A. R. Price, Polity, 2015.

Lacan, Jacques. *The Seminar of Jacques Lacan, Book XI: The Four Fundamental Concepts of Psychoanalysis*. Edited by Jacques-Alain Miller, translated by Alan Sheridan, W. W. Norton, 1981.

Merleau-Ponty, Maurice. *The Visible and the Invisible*. Edited by Claude Lefort, translated by Alphonso Lingis, Northwestern University Press, 2000.

Milner, Marion. *On Not Being Able to Paint*. International Universities Press, 1957.

Ruti, Mari. "Winnicott with Lacan: Living Creatively in a Postmodern World." *Between Winnicott and Lacan: A Clinical Engagement*, edited by Lewis A. Kirshner, Routledge, 2011, pp. 133–50.

Schlick, Yaël. "What Is an Experience? Selves and Texts in the Comic Autobiographies of Alison Bechdel and Lynda Barry." *Drawing from Life: Memory and Subjectivity in Comic Art*, edited by Jane Tolmie, University Press of Mississippi, 2013, pp. 26–43.

Winnicott, D. W. *Playing and Reality*. Tavistock, 1971.

Chapter 6

Autobiography and the Empathic Imagination in *Ernie Pook's Comeek*

—Rachel Trousdale

Lynda Barry's long-running four-panel comic *Ernie Pook's Comeek* invokes the conventions of autobiography to examine the relationship between memory and empathy. The autobiographer, Barry suggests, must learn to treat others with the same care that she directs toward herself, and to treat herself with some of the skepticism she directs toward others. If we do this, we can engage in ethical life writing, which demands special acts of empathic imagination directed both at our former selves and at the people we have known. Barry's comics suggest that this sort of life writing can help us to protect the vulnerable—including our childhood selves.

But *Ernie Pook's Comeek* is not autobiography, and in a 2000 interview with Edward Jenkinson, Barry expressed puzzlement at readers who read her work as autobiographical:

> In a way I don't care if people want to see the work as autobiographical or not at this point. There seems to be some need on the part of the reader to do this. I don't really mind, but it's not true at all. Maybe it's because I write in the first person and do use real places? I guess in a way it's a compliment; the stories seem that real to people. When I wrote *Cruddy* [an illustrated novel about a serial killer] I was sure no one would think that bloody, violent, far-fetched story was autobiographical, but people do this. It sort of makes me laugh a little bit. . . .

Autobiography may get one started, but reality is stubborn and it interferes with storytelling. I like realistic imagination best.... Also there is a concern about hurting real people. I don't like that concern when I work. (Jenkinson 169–70)

The tendency of readers to read Barry's work as autobiographical probably has a number of causes. They may be influenced by the recent surge in graphic memoirs, by the autobiographical content of "wimmin's comix," by what Scott McCloud suggests is the inherently autobiographical nature of the "cartoon," which invites readerly projection (29), or, most likely, by the retrospective, nostalgic tone of much of Barry's work. Barry's description of readers' tendency to interpret her work as autobiographical suggests a hard-won tolerance; her remark that "it sort of makes me laugh a little bit" suggests how completely these people misread some of her "far-fetched" texts. Her statements that "I don't care" or even that "it's a compliment" are both hedged with "in a way," implying that in other ways, she does care, and it is not a compliment. Most important, though, Barry's final statement about why she does not enjoy writing autobiographically is that "there is a concern about hurting real people." This idea, that telling the story of our own lives has the potential to hurt others, reappears in many forms throughout her fictional work.

Ernie Pook chronicles the lives of brash, imaginative Marlys, her brother Freddie, their teenage sister Maybonne, and an assortment of their relatives and neighbors. The point of view varies, but Arna, Marlys's introspective cousin, is one of the most frequent narrators. The events Arna describes are frequently not so much stories as observations, often in the form of a realization about the hidden motivations and desires of the people around her. As Arna comes to recognize the insecurities and distresses behind Marlys's love of the spotlight or her aunt's hostility toward the children in her care, she is presented with the problem of how to respond to her relatives' hurtful behavior in light of her newfound recognition of their suffering. The comic sets a layered exercise in empathy: readers are prompted to feel both with Arna's subjects and with Arna herself.

Arna's narratives invoke tropes of autobiography in their structure, their combination of analysis and nostalgia, and their emphasis on how the incidents described illuminate the inner lives of the characters involved. Barry's deliberately scrawly drawing style, combined with Arna's glimpses into other characters' interiorities, grants primacy to psychological over physical realism, placing *Ernie Pook*'s anecdotes in a position of liminal reality, neither overt truth claim nor avowed fiction. Instead the comics examine the intersection of the literal life event and the act of interpretation, representing not so much Barry's actual experience as the process of life writing itself. Autobiography,

Barry suggests, requires an act of imaginative generosity to the past self, whose
feelings must be refelt empathically even while they are also examined skepti-
cally. If, as Nicole Stamant argues, memoir "allows for a multiplicity of subject
positions which pose a challenge to the possibility of having . . . an 'interior self,'"
Barry's deployments of autobiography allow for a multiplicity of selves across
time, each able to look back on earlier subjectivities as insider and outsider
simultaneously (5). This exercise in simultaneous empathy and distance gives
us practice in extending generosity toward others, an act that may be difficult
in the moment of experience. For all of Barry's ruthlessness in rendering some
of her characters' flaws, *Ernie Pook's Comeek* suggests that life writing can be a
vehicle through which we learn fellow feeling even for our antagonists.

While the comic repeatedly draws on autobiographical conventions, Barry
distances herself from the term "autobiography" even in texts far more directly
based on her real life than *Ernie Pook* is. In *One Hundred Demons* (2005), the
main character shares Barry's name, appearance, and basic life trajectory. In the
book's introduction, Barry muses, "Is it autobiography if parts of it are not true?
Is it fiction if parts of it are?" She calls *Demons* "autobifictionalography." This
blurring of generic lines is typical of Barry's work: for an artist who frequently
challenges categorical distinctions like gallery art versus popular art, humor
versus serious, or drawing versus collage, merely blurring the line between
autobiography and fiction (as memoirs so often do) seems almost conventional.

Unlike Barry, however, the characters in *Ernie Pook* appear to believe that
they can describe their own lives without recourse to fiction. They create a
wide variety of autobiographical texts, which they seem to intend to convey
truths about their experiences, their acquaintances, and their inner lives. The
comic strips themselves, which the characters narrate, are the most obvious of
these texts. The strips also detail the creation of other forms of life narrative: a
museum the children make containing artifacts from their lives; Arna's school
essay in which she turns a retelling of the Persephone myth into a plea to her
mother to allow her to get a dog; Marlys's many pronouncements of her own
greatness; and a microbiography of the new neighbors. Through the children's
varying biographical and autobiographical texts, and their framing within the
comics more broadly, *Ernie Pook* continually theorizes and reconceives life
writing as a way to reveal or create agency and empathy. For Barry, turning
experience into narrative becomes not just a way of making meaning out of
the ephemera and chaos of a difficult life but a way of protecting the vulner-
able: the strips repeatedly ask us to share the children's loneliness, and thus to
render them less alone.

The idea that life narrative can be a form of self-protection begins with the
children's uses of it to protect themselves from each other. Self-defense can

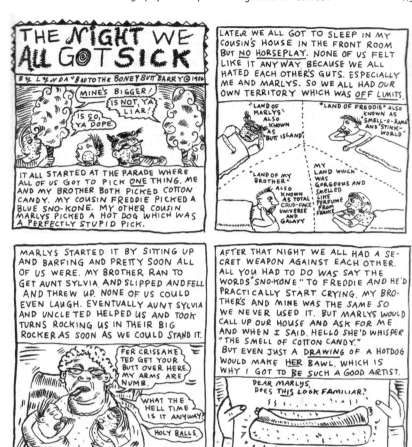

Figure 1. Barry, "The Night We All Got Sick."

take a number of forms—including, as the comic establishes early on, a good offense. From the first appearance of Marlys, Arna, Freddie, and Arnold in "The Night We All Got Sick," the characters are associated with the idea that intense memory can overpower our experience of the present. The four children use this phenomenon against each other. Arna narrates:

> It all started at the parade where all of us got to pick *one* thing. Me and my brother both picked cotton candy. My cousin Freddie picked a blue Sno-Kone. My other cousin Marlys picked a hot dog which was a perfectly stupid pick. Later we all got to sleep in my cousin's house in the front room but *no horseplay*. None of us felt like it anyway because we all hated each other's guts. Especially me and Marlys. So we all had our own territory which was *off limits*. Marlys started it by

sitting up and barfing and pretty soon all of us were. My brother ran to get Aunt
Sylvia and slipped and fell and threw up. None of us could even laugh. Eventu-
ally Aunt Sylvia and Uncle Ted helped us and took turns rocking us in their big
rocker as soon as we could stand it. After that night we all had a secret weapon
against each other. All you had to do was say the words "Sno-Kone" to Freddie
and he'd practically start crying. My brother's and mine was the same so we never
used it. But Marlys would call up our house and ask for me and when I said hello
she'd whisper "the smell of cotton candy." But even just a *drawing* of a hotdog
would make *her* bawl. Which is why I got to be such a good artist. (*Greatest of
Marlys*, 3)

The strip in which Arna, Arnold, Marlys, and Freddie first appear is about
how brief, simple representations of everyday objects can be used to invoke
overwhelming memories in controlled circumstances. The children's discovery
of this phenomenon makes them both vulnerable and empowered: the two
girls who "hate each other's guts" use their knowledge to torment each other.
But the discomfort associated with being on the receiving end of triggered
memory is clearly less than the pleasure of producing it in someone else: Arna's
delight in her ability to nauseate Marlys is much greater than the discomfort
she experiences from Marlys's ability to nauseate her.

This story plays with the way that retrospection can give us insight into
other people's interiorities. After the children get sick, they discover that they
are able to trigger physical reactions in each other through the strategic use of
abstract representations. Arna lists these representations in increasing order of
abstraction. Freddie's trigger is flagged as being purely verbal: "the words 'Sno-
Kone.'" Arna's phrasing highlights that it is the *name* of the object that prompts
nausea in Freddie, not the object itself. Arna and her brother's shared trigger is
one degree more abstract than Freddie's: not the words "cotton candy" (a verbal
representation of an object) but the words "the smell of cotton candy" (a verbal
representation of the odor of an object). Marlys's trigger is the most abstract of
all: "even just a *drawing*" (Barry's emphasis). The fact that "even just" a drawing
of a hot dog can make Marlys "bawl" suggests that abstract representations
and the objects they represent are not as different as we might believe: while
a drawing of a hot dog is clearly not the same thing as a hot dog, context has
blurred the line between abstraction and immediate physical reality.

Hillary Chute, among other critics, argues that Barry's work focuses on
trauma, and the power of words and images to produce nausea certainly comes
from the traumatic experience of violent illness. But Arna's narrative suggests
that the episode is not entirely traumatic. When Arnold (her brother) slips and
falls and throws up, she remarks, "None of us could even laugh"—a line that

suggests both how much the children are suffering from their illness (too sick to laugh is pretty sick) and the extent to which they nonetheless retain their sense of humor (they recognize that Arnold's mishap is something they might like to laugh at). While the trauma of illness is what gives the abstractions power, the memory of that missed laughter is what makes the comic worth writing, and what motivates Arna to draw her many hot dogs—first sending them to Marlys and then including one in the strip's final panel.

"The Night We All Got Sick" plays with three primary layers of memory. First, the central plot of the story: once upon a time, we all got sick at once, and it was awful. Second, the intradiegetic use of memory: we all remembered our sickness and used it to make each other sick again, which was kind of great. Third, the extradiegetic memory: Arna, looking back after an unspecified lapse of time, comes to the conclusion that learning to use Marlys's memory against her gave Arna the incentive to become a "good artist." The comic's consideration of these different stages of memory—event, visceral recall, retrospective recall—suggests that memory, narrative, empathy, and art are inextricably interwoven.

The power of this night comes from the fact that "*we all*" got sick; each child knows precisely what the other children felt. At the same time, their experiences are just individuated enough that, except for Arna and her brother, each can use the others' triggers against them without triggering their own reactions. Art, then, becomes a way to access another person's emotional responses with reference to, but without activating, one's own: shared experience does not erase the boundary between individuals but rather gives them privileged access into each other's inner lives. Each child is able to understand the others' experiences by reference to his or her own, but the line between individuals remains clear, just as each child's territory in the living room is "off-limits" to the others. The comic's retrospective tone—looking back on how Arna became "such a good artist"—thus suggests that being a good artist requires harnessing one's own visceral responses to understand and produce such responses in others. A good artist can make you vomit without vomiting herself.

The children's art becomes even more autobiographical in "Our Museum." The narrator—probably Arna, the only one of the children self-effacing enough not to emphasize her authorship—speaks in the first-person plural:

One time we got the interesting idea of starting an actual museum down in the garage. Mainly all you need to do this is tape and fascinating things. Practically *anything* can look more incredible if you tape it to a wall and stick up a sign about it. Everybody put something up that was supposed to stimulate your imagination. We could have kept going but we ran out of tape. We tried Elmer's

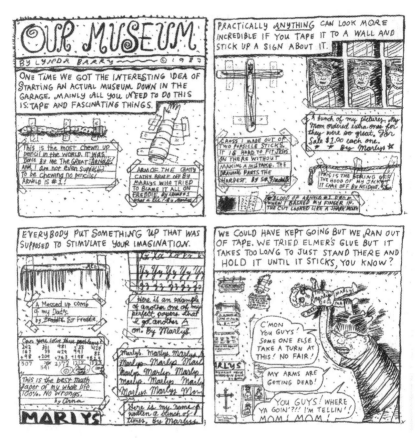

Figure 2. Barry, "Our Museum."

glue but it takes too long to just stand there and hold it until it sticks, you know?
(*Greatest of Marlys*, 38)

"Our Museum" is most obviously about what constitutes "art"—the museum's task, to "stimulate your imagination," is not educative (like a science or history museum) but imaginative. The phrase "stimulate your imagination" suggests that the children are borrowing from a discourse of high culture (perhaps the phrase is quoted from a teacher?), one that identifies the museum as a rarefied space away from ordinary life. (Barry herself, unsurprisingly, has pushed back against this cultural divide, deciding to "quit showing in galleries" when the art world pressured her to choose between identifying with "high" and "low" art [Chute 99].) But the objects the children choose to "stimulate your imagination" are explained on their labels in autobiographical terms, for example:

This is the most chewn up pencil in the world. It was done by me the great
 Arnold! and I am not even supposed to be chewing no pencils! Arnold is #1!
This is the string off the hood of my jacket it came off by accident. By Arna
Blood of Arnold #1 from when I bashed my finger in. The cut looked like a shark
 mouth.
Messed up comb of my Dad's. by ~~Freddie~~ Sir Freddie.
This is the best math paper of my whole life. 100%. No wrongs. by Arna
Here is an example of another one of my perfect papers that I got another A on.
 By Marlys.
Here is my name written a bunch of times. By Marlys (*Greatest of Marlys*, 38)

The exhibits gain some of their value from being placed on a wall with an
explanation, museum style, which, as Arna says, makes anything "look . . . more
incredible" (*Greatest of Marlys*, 38). The rest of their value comes from their
immediate, physical association with the children's lives—what Walter Benja-
min calls "aura." The museum exhibits, then, are explicitly both linked to and
separated from their makers. Arnold's "chewn" pencil and bloody Band-Aid
are of interest because his body has modified them. Freddie's contribution, his
father's comb, also gains value from having been damaged by a human body,
with the added value that it reflects the comic's many absent fathers via its
own missing teeth. Freddie's alteration of his signature from "Freddie" to "Sir
Freddie" suggests how placing this object on view gives him a sense of mastery
over his difficult situation.

Marlys's contributions are even more self-aggrandizing than the boys'—her
"perfect paper" is just a handwriting exercise in which she has repeatedly copied
the letters of the alphabet, and her name written over and over is pure self-
assertion. Arna's math test is both the most straightforward (schoolwork she
is proud of) and perhaps the most heartrending (the second problem contains
an error the teacher has inexplicably overlooked). Her jacket string, even more
than the other objects, gains value only from its contextual narrative; she has
made no marks on it at all, and it is emblematic of the many accidental dam-
ages inflicted on her and the other children.

"Our Museum" is narrated from a temporal perspective that is clearly quite
close to the activity it describes: Arna makes little retrospective commentary of
the sort that closes "The Night We All Got Sick." Instead, her larger comment is
on artistic process—that it is a nuisance to use Elmer's glue instead of tape to
stick objects to the wall. Her closing, however, once again broadens the scope of
the comic: she ends with "you know?," addressing the reader in a way that sug-
gests that the reader really *might* know what she is taking about. The experience
narrated in the comic—the difficulty of making life into art, as embodied by

Elmer's glue's dubious power to hold disparate objects together—is, she implies, so universal that we are sure to recognize it. We are also likely to recognize the other significant problem of art in the comic's closing: the final panel, showing a frustrated Marlys holding her doll against the wall and shouting to the other children to come back, suggests the difficulty of finding a sympathetic audience.

"Our Museum," then, both exposes vulnerability—Arnold's cut finger, Freddie's damaged comb, Marlys's sense of abandonment as she holds the doll against the garage wall, the ephemeral nature of human experience, and the scarcity of appreciative onlookers—and celebrates it as the "incredible" materials of art. The "museum" protects fragile, broken objects, rescuing them from their status as junk and turning them not just into things of value but into testimonies to the value of the children's lives. The objects in this context once again suggest a layered set of possible responses to experience: first, an initial, local trauma (Arnold cut his finger); second, a reframing of that trauma as something exciting or cool (Arnold is number one, the cut looked like a shark); third, an insight via that reframing into the children's need to assert to a hostile or indifferent world the meaning of their own lives. Where in "The Night We All Got Sick," memory is used against others, here it becomes a way to reframe damage (the chewed pencil, the lost string) as proof of individual value.

In "Ugliful," Barry experiments with another form of weaponized memory. As Maybonne, Marlys's older sister, recounts her mother's reminiscences, autobiography becomes an act of aggression, while biography becomes one of reclamation:

> The first thing about my mom is that she was very beautiful when she was young. In fact, gorgeous. The gorgeous twin of Ava Gardner, everybody said it. My mom has told us this 10,000 times. She was so beautiful, five guys asked her to marry them before she picked my father, the worst mistake of her life. I always wonder what I could have looked like instead, if she had picked one of them. When I was little, I looked just like her. We had those dresses that match and according to my mother, the people who saw us said we were wonderful. Then I had to get glasses which my mother hated because it spoiled my looks. This was a long time ago when my mom's eyes were perfect and my dad was still with us. "You got your father's looks. The both of you," she says to me and my sister when she gets in that one talking mood about her mistakes in life. And she tells me I had better get busy working on my charm. "Well, be grateful you don't have a weight problem," she says, then looks straight at my sister. (*Greatest of Marlys*, 71)

As in "The Night We All Got Sick," "Ugliful" contains layers of memory, presented this time via reported narration and textual collage. Maybonne reports

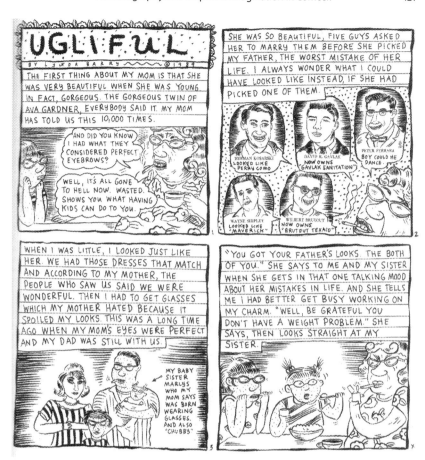

Figure 3. Barry, "Ugliful."

her mother's speech, both summarizing what she "has told us … 10,000 times" and giving the mother's precise words and actions during one emblematic example of those speeches. Similarly, the images contain several different time periods and viewpoints. The images of the family in the present day (the mother, Maybonne, and Marlys sitting together at a table while the mother laments her fate) are in Barry's characteristic drawing style. The images of the past, including the mother's former boyfriends and the younger family (father, mother, baby Marlys, young Maybonne), deviate from Barry's usual sketchy lines to suggest that they are copies of photographs. The contrast between the two calls the accuracy of different narrative perceptions into question. Where do the "present-day" pictures come from? They are narrated by Maybonne, but since she is visible in them, they do not represent what she sees; instead they

seem to combine her narrative perspective with the outside perspective of a reader. The accuracy of the panels' narrative perspective is thus rendered unclear (is this how Maybonne sees her mother, her sister, and herself? Or is this how they "really" are?), while the perspective of the past selves gains the (dubious) objectivity of photography: the mother, now ugly, "really" was beautiful when her children were young.

The layered narration and opposed approaches to autobiographical truth claims in "Ugliful" help Barry compare two fundamentally different ways that narratives can approach their readers. The mother uses the story of her past beauty to attack her children (baby Marlys is "chubby"; her own current unat-tractiveness "shows you what having kids can do to you" [*Greatest of Marlys*, 71]). Maybonne's narrative voice makes no such comment; although she transmits her mother's cruel remarks, she makes no overtly negative statements of her own. Instead, unlike her mother, Maybonne lets the images she gives us speak for themselves. Where the mother cannot trust her children to look at the texts in front of them (the photograph of her beautiful past self; her current grotesque appearance) and deduce what she wants them to (that the change is their fault), Maybonne can trust the reader to recognize the mother's hostility and the damage that it does to her daughters. Autobiographical truth claims, the comic suggests, cannot be established through the kind of documentary evidence that the mother is using; photographic evidence is in this case no evidence at all, because it gives us no access to the interiorities of its subjects.

Maybonne's narrative, by contrast, asks us to enter the mind of Marlys, who is atypically silent in these panels. We see her twice, once as the baby whom Maybonne reports her mother describing as "born wearing glasses. And also 'chubby,'" held in the arms of her now-absent father, and once as a child, caught in mid-spoonful by her mother's jab about her "weight problem" (*Greatest of Marlys*, 71). (The comic does not represent her as fat, and certainly not as fatter than Maybonne or her mother.) The final panel contains little motion lines indicating that she has moved abruptly in reaction to her mother's words, and Barry's distinctive cross-hatching is interrupted to create a bright spot around her: the visual focus of the final panel is not on its reported narrator (the mother, lighting a cigarette in the right-hand foreground) or its actual narra-tor (Maybonne, resting her chin on her hands on the left) but on the startled younger child. Maybonne's narrative and the visual focus of the last panel cause the comic's final subject to be the one character who says nothing at all.

The mother's motive for narrating her story is clearly to hurt her younger daughter. Maybonne's is more complex; she says nothing to comfort her sister directly, but her narration of the story presents her sister as an object of empathy, in direct contrast to the mother's presentation of Marlys as a target. While the

mother attempts to enlist Maybonne in her attack on Marlys by suggesting that there was a time when "I looked just like her" and "the people who saw us said we were wonderful" (*Greatest of Marlys*, 71), Maybonne resists this invitation to gang up on her sister and instead invites the reader—absent from the room but, in the comic's layout, implicitly occupying the fourth side of the kitchen table—to join her in sympathy with the child.

While Jared Gardner argues that, even more than "traditional prose autobi-ography," graphic memoir "opens wounds of the past, and produces moments that forge a temporary (and problematic) collapse of autobiographer and subject" (18), this comic suggests the possibility that we can enter several very different subjectivities simultaneously. The subtle cues by which the comic brings us into Marlys's and Maybonne's consciousnesses (a few tiny lines) do not seem to suggest a "collapse" of autobiographer and subject. Rather, they illustrate the difficulty of entering the subjectivities of any besides our own, because such extensions of sympathy require sustained, precise, disinterested observation of people who are unlike ourselves.

The sides in this comic are clearly drawn, and the mother's cruelty is inex-cusable, but Maybonne's lack of comment on her mother's speech still makes it possible to enter the mother's perspective. We can imagine, looking at the difference between her youthful, beautiful self and her present-day scowl, wrinkled arms, pursed lips, and devil-horn hair, that her intervening life has been difficult. Her fantasies of other lives with her other suitors may seem unappealing (who really wants to marry the owner of "Gavlak Sanitation"?), but their very unattractiveness suggests the degree of dissatisfaction she now feels with her choices and their results. Maybonne's narrative, then, differs from her mother's in its refusal to make absolute judgments. She does not demonize her mother—although her mother may demonize herself.

Although Maybonne is the narrator of the comic, we learn the least about her. The closest she comes to commenting on her mother's story is a slight flinch in the last panel, where a few lines indicate that her left hand has moved in response to her mother's attacks on Marlys. Rather than telling us exactly what she is feeling, Maybonne instead gives us the opportunity to recognize and enter into it: empathy with Marlys. The comic's layered narration—reading through Maybonne's speech to her mother's—teaches us to turn our empathic imaginations in the other direction: reading through Maybonne's emotions to Marlys's. Where the mother's life narrative is deliberately hurtful to her children, Maybonne's—using the same words and stories as her mother's—is deliberately evocative of fellow feeling, teaching the reader to recognize both the pain of the mother's attack and the quite different pain of Maybonne's helpless love for her sister.

Figure 4. Barry, "About the Author."

Autobiographical gestures in *Ernie Pook's Comeek* continually play with how art uses memory to construct, direct, and limit empathy. The characters frequently use memory as a way to attack each other, and the more empathically perceptive the use of memory, the more effective the weapon. From the perspective outside the comics panel, however, these hostile uses of memory somewhat paradoxically suggest the possibility that we can use empathic memory to care for each other and for our past selves.

While the characters for the most part do not consider their texts hybrids of truth and fiction, Barry flags the comics' hybrid nature all but explicitly. In the "About the Author" note to *The Greatest of Marlys* (2000), she appears to direct the reader away from treating *Ernie Pook* as autobiographical:

About the Author: I'm a dog loving person, born in 1956. I've always liked to draw and write, and one day in 1986 I made the comic strip called "The Night We All Got Sick" where I saw Marlys for the first time. She's had a huge influence on me ever since. Although my own childhood was very different from hers, she's helped me make some sense of things that I never had words for before. She became the imaginary friend I'd always wanted. I hope you enjoy this collection of her stories.

I'm so happy to have so many of them all in one place at last. Lynda Barry (*Greatest of Marlys*, 220)

Barry may raise the topic of autobiography in part to respond to readers who interpret her texts as autobiographical. But this discussion of the line between fiction and autobiography also sheds light on the comic's treatment of how the narrative framing of memory can become an act of empathy—for others and for the past self—and of self-defense. Barry describes Marlys's childhood as "very different" from her own and calls her an "imaginary friend," which seems like a way to distance her own life narrative from her characters'. But her initial self-description, "a dog loving person," identifies her with Arna. Arna's love of dogs is thoroughly detailed in a series of strips collected toward the end of the volume; the placement of this note, on the book's final page, means that readers cannot miss the connection. As anyone familiar with Barry's life will instantly recognize, she has given the characters elements of her own childhood: angry, distant mothers; mixed Filipino and white ancestry; a working-class neighborhood; an extended family that lives sometimes together, sometimes apart, with adults who abruptly abandon their children; physical and sexual abuse; and, of course, her own fascinations (dogs, bugs).[1] The paragraph tells us that the text is not autobiographical, then also tells us that it is. Unlike most "About the Author" notes, it is written in the first person and signed like a letter, thereby marking the auto-component of this one unambiguously biographical statement.

In this context of fluid and slippery truth claims, the phrase "imaginary friend" highlights both that the characters are made up and that they gain a kind of autonomy from their creator, taking on the narration of the strips and telling their own lives directly to the readers. As a result, they can become "friends"—independent beings with agency and interiorities, who engage in empathic exchanges. This, the note suggests, may be one of the greatest payoffs of Barry's artistic fusions of memory and empathy: it gives us a chance to view our own lives as a friend would, combining fellow feeling and critical distance.

Lynda Barry's layered narratives demonstrate the double-edged possibilities of autobiography as healing and as mode of attack. As they walk us through the process of moving from visceral, immersive memory to narrativized memory, they provide an ethical model of life writing not just as reclamation of the past self but as a way to understand the subjectivities of the people around us. Autobiography, for all its apparent focus on the individual, turns out, in these comics, to be a way to understand not just the self but the other.

NOTES

1. For a biographical essay on Barry, see Kirtley 15–47.

WORKS CITED

Barry, Lynda. *The Greatest of Marlys*. Sasquatch Books, 2000.

Barry, Lynda. *One Hundred Demons*. Sasquatch Books, 2002.

Benjamin, Walter. "The Work of Art in the Age of Mechanical Reproduction." *Illuminations*, translated by Harry Zohn, edited by Hannah Arendt, Schocken Books, 2007, pp. 217–52.

Chute, Hillary. *Graphic Women: Life Narrative and Contemporary Comics*. Columbia University Press, 2010.

Gardner, Jared. "Autobiography's Biography, 1972–2007." *Biography*, vol. 31, no. 1, 2008, pp. 1–26.

Jenkinson, Edward. "Will You Climb Up to the Heavens That Enclose Us Above: A Talk with Lynda Barry." *Page to Page: Retrospectives of Writers from the Seattle Review*, edited by Colleen J. McElroy, University of Washington Press, 2006, pp. 167–77.

Kirtley, Susan. *Lynda Barry: Girlhood through the Looking Glass*. University Press of Mississippi, 2012.

McCloud, Scott. *Understanding Comics: The Invisible Art*. Harper Perennial, 1993.

Stamant, Nicole. *Serial Memoir: Archiving American Lives*. Palgrave Macmillan, 2014.

CRUDDY

Chapter 7

"Dear Anyone Who Finds This": *Cruddy* as Diary Fiction

—Susan Kirtley

In Lynda Barry's bleakly humorous novel *Cruddy*, the protagonist Roberta Rohbeson directly and unflinchingly addresses her readers from the outset in the prefatory pages: "Dear Anyone Who Finds This," the narration begins, "Do not blame the drugs." And thus commences this mind-bending, genre-crossing novel, a book that Ellen Berry describes as a mixture of "true confession, teens-gone-wild, and other sensational tabloid styles; the road trip crime spree and the quest for buried treasure; the frontier tall tale; and, above all, low-budget 'creature feature' horror films from *The Horror of the Blood Monsters* to the *Amazing Colossal Man*" (406). *Cruddy: An Illustrated Novel* is certainly not for the faint of heart. While critics primarily examine *Cruddy* as a horror novel, the book also contains elements of numerous literary forms, including the bildungsroman and *Künstlerroman*. In fact, although scholars have thus far not discussed this approach, Barry cleverly uses strategies of diary fiction to generate suspense, forcing the reader to participate actively in creating "closure" and imagining the ultimate outcome for Roberta. This essay explores the techniques of diary fiction as used in *Cruddy*, and studies the ways in which these strategies serve to engender a thrilling anticipation in readers, in addition to demanding active involvement from the audience.

Fashioning a Diary: Process, Form, and Reception

Cruddy was originally published by Simon and Schuster in September 1999 and surprised many critics and readers, who were primarily familiar with Barry's comic strips. The book marks a departure of sorts for a creator usually associated with her cult-favorite comic strip *Ernie Pook's Comeek*, but the narrative had actually been developing for several years. Throughout her career, Barry had quietly been writing essays, articles, and other prose-based works for a variety of publications. The beginnings of *Cruddy* are apparent in the dark turns in *Ernie Pook's Comeek* and in the discord of Barry's novel *The Good Times Are Killing Me*, which was originally published by Real Comet Press in 1988 and was adapted into an award-winning play the year after. *The Good Times Are Killing Me* was, as Barry explained to Mervyn Rothstein, a "feel-bad comedy" about two teenage best friends, Edna Arkins and Bonna Willis, who bond over a shared love of music but are ultimately pulled apart by racism in the 1960s. Brian Miller noted of the connection between *Cruddy* and *The Good Times Are Killing Me* that "the seeds of such violence are suggested in Barry's more benign first novel . . . where family turmoil leaves only emotional scars," and in *The Good Times Are Killing Me* there is only a scuffle and a slap as tangible evidence of the drama roiling beneath the surface. But *Cruddy* departs from these more realistic settings, depicting an extraordinarily violent landscape and gothic tale of murder and betrayal.

However, the trajectory of the story and between the books can be traced through Barry's publication history. It is clear that Barry still had the heroine Edna on her mind after the release of *The Good Times Are Killing Me*, as evidenced by the recurring prose fiction page she penned for *Mother Jones* magazine from February 1989 to June 1991 titled "1619 East Crowley," in which she chronicled Edna's story after the book's ending. These brief pieces were unusual in structure, featuring only eight to twelve paragraphs and an added illustration with embellishments around the text. The feature continued Edna's story but also introduced one of the main characters from *Cruddy*, Vicky Talluso, in the piece "Getting Saved" from May 1989. As the narration shifted, so did the language and tone, with the story "Blue Cross" from February–March 1989 featuring a mention of a "cruddy beige house on this cruddy dirt street" (68). In an interview with Benny Shaboy, Barry explained, "At first I thought it was Edna Arkins, the character who was in my first little novel, *The Good Times Are Killing Me*. But it wasn't her, it turned out." Barry was not continuing Edna's journey but rather had started a new, darker one with her heroine Roberta Rohbeson.

Despite these early glimpses of Roberta's narrative in her "1619 East Crowley" stories, Barry faced difficulties setting the story down. In particular, early in the process, Barry struggled with the book's darkness: "I think there was some part of me that knew I wanted to write a book another part of me would be shocked about. You know how violent *Cruddy* is. It took a long time for some part of me to convince the other part of me to do it" (Shaboy interview). It was not until Barry allowed herself to let go of bright, light colors and revel in the "ugly colors" that she was able to write *Cruddy*. Once Barry "discovered the multitude of mud and blood and fly colors . . . it was pretty fun," and the writing began to take shape (Shaboy interview).

Delving into color and image would prove to be the momentum Barry needed to jump-start the narrative. Initially Barry had tried to draft in the "traditional" way, on the computer, but she discovered that "writing it on the computer didn't work at all" (Shaboy interview). Barry remembered:

> The first draft really took shape when I found that I needed to slow way down and distract myself at the same time so I used a paintbrush and Tuscan red watercolor and painted the manuscript on legal paper, trying to concentrate on the calligraphic aspect of writing rather than trying to craft beautiful sentences. I figured as long as the sentences looked beautiful, the rest would take care of itself. That draft was seven hundred pages long. I used a hairdryer when I got to the end of each page so I could stack them without smearing. I can do some pretty nice handwriting now. I tried to write it a word at a time like it was being dictated. *Cruddy* was the result. (Shaboy interview)

Barry painted the entire manuscript with a paintbrush and then took the story of Roberta and, according to a personal interview, "typed it up on a manual typewriter and then typed that manuscript again." For Barry, even typing the draft manually on a typewriter (which most would agree is an arduous process at best) entailed a challenging twist. Barry clarified in the interview:

> It's not like I just type it on a regular piece of paper, because I can't do that. I type it on a big index card that I have to actually glue onto a piece of legal paper, each page, because there's something about having it physically. I have to do something with it physically and glue it, so the manuscripts are crazy looking.

Finally, Barry knew she had gotten to a good stopping point and then went back to the draft, adding and expanding the work. During this process, Barry kept legal paper nearby to record any additional thoughts that might occur to

her, and as she was working on *Cruddy*, her next book, *One Hundred Demons* (published in 2002 by Sasquatch Books), also began to emerge.

The focus, though, of this laborious composition process was on *Cruddy*, and the result of the retyping process was a "bloated and unusual" draft that at the time did not make much sense. As part of the process, however, Barry took another pass at retyping the entire manuscript, and the narrative began to take shape. After this third draft, Barry turned to the computer. Finally, after typing the fourth draft into the computer, Barry noted, "*Cruddy*, it pretty much fell perfectly into place," with the exception of one chapter that was eventually cut (personal interview, 2006). *Cruddy*, then, is the result of an enormously physical, strenuous process. Barry argued that "doing it that way is the way that works best for me," but many others find her process daunting. When she suggests to aspiring writers that they try recopying drafts, Barry is "amazed at how unwilling people are to copy something over." Yet it seems clear that it takes extreme dedication to the image and the narrative to devote such energy to the process.

In *Cruddy*, Barry creates a sinister new world and a completely broken heroine, providing a darker reflection on the themes of girlhood hinted at in her other works. Some readers were surprised by this dark turn, but most critics and fans applauded Barry's longest work to date. When Joe Garden asked Barry whether *Cruddy* indicated a "conscious desire to explore the darker material hinted at in your strip" in a 1999 interview for *The Onion*, Barry replied, "It was about as conscious as a pinball game. I just tried to keep the ball in play, keep the story going, and try not to freak out about the dark parts being too much for my editor to handle. I live in constant fear of being fired or dropped for that dark part of my work I can't control." Yet Barry insists that *Cruddy* is no darker than children's classics such as *Grimms' Fairy Tales*, a work she cites as a strong influence.

Barry explained that the book drew on these dark fairy tales, taking place in an alternative reality—a place removed from the world we live in, a place where terrible things happen. Barry told Paige La Grone, "Actually it was harder to not write *Cruddy* than to write it. To me the darkness and violence are more like the useful sort found in the original unsanitized versions of Grimms' fairy tales and *A Thousand and One Nights*, both of which were important books for me as a child." Dwelling in a safe and secure actual world allowed Barry to access a place of horrific violence and fear but remain centered. Distancing herself from the events allowed Barry to see the humor of the story, and critics like Benjamin Weissman felt that the book was "seriously funny" and that "Barry's humor is relentless and blunt, and incorporates violence as elegantly as a Cormac McCarthy Western" (55). The illustrations also drew attention from

critics. Brian Miller commented on the "crude, disturbing black-and-white daubing style unlike the jittery drawings of Barry's cartoon work" and further observed that the "wonderful frontis- and endspiece maps recall the adventure novels of childhood." Weissman similarly lauded the power of the images:

> Cruddy is packed with Barry's dark, gloomy drawings, which often seem like images glimpsed through a keyhole. They are equal parts spontaneous, gothic and raw—not a single belabored picture. Without the constraints of tight little comic-strip boxes, Barry is able to broaden her loose signature style (she draws the best monkeys in the world) into something more detailed and cinematic, like film stills from a bleak crime drama. (55)

Critics thus commented on the novel as something of an "adventure novel" and a "bleak crime drama," but in fact, much of the tension of the text derives from its unique use of the strategies of diary fiction.

Recording Lies and Lives: Strategies of Diary Fiction

Cruddy tells the story of Roberta Rohbeson through first-person narration and is initially framed as a diary, as evidenced by the opening address: "Dear Anyone Who Finds This." The structure is an unusual example of diary fiction, however, in that it moves back and forth in time, from Roberta's near past as a sixteen-year-old recording her "cruddy" life story to her more distant past as an eleven-year-old accompanying her murderous father on a sadistic road trip as he seeks to reclaim money he feels is owed to him. On the journey, the pair leave a trail of destruction, with Roberta eventually killing her father before being found wandering in the desert. Roberta is eventually returned to her evil mother and irritating sister, and the near past relates Roberta's meeting with new friends, including Vicky Talluso, and her attempt to lead them to the stolen money, stashed away by her father years ago. The expedition fails, and the conclusion implies that Roberta has committed suicide.

While this riotous narrative bears little resemblance to most girls' diaries, Barry's choice to emulate a diary through fiction links the text to a form often associated with women, particularly adolescent women. In "Engendered Autobiographies: The Diary as a Feminine Form," Rebecca Hogan notes, "The diary, which valorizes the detail in both the realms of ornament and everyday, can also be seen as feminine" (96). This "feminine" form represents Roberta's narrative as gendered from the onset and connects the work to a tradition of secret keeping, for, as Sara K. Day indicates, "Though young women's personal diaries

have been published and read by large audiences for centuries, suggesting that this private medium has frequently been understood as being anything but, the diary in contemporary America exists as a symbol of privacy and secret keeping" (45). Roberta creates what Day refers to as "narrative intimacy" with her imagined reader through this highly confessional, frequently gendered form.

However, although *Cruddy*'s opening pages strongly suggest that the narrative will follow a faux diary structure, we find chapter numbers and no dates listed. Therefore the text seems to borrow some conventions of diary fiction while ignoring others. When studying *Cruddy* as diary fiction, it is helpful to consider definitions of the "diary novel" and the "strategies of diary fiction" to illuminate how these terms relate to *Cruddy*. In *The Diary Novel*, Lorna Martens argues that a diary novel "is a fictional prose narrative written from day to day by a single first-person narrator who does not address himself to a fictive addressee or recipient" (4); but "the diary novel, like any genre, has blurred edges" (6), and the question of whether there is a "fictive addressee" is controversial. In his article "The Diary Novel: Notes for the Definition of a Sub-genre," Gerald Prince contends that the most important "characteristic of a diary novel is the narrative mode," while in *Form and Function in the Diary Novel*, Trevor Field defines the diary novel as "fiction predominantly written in the form of a diary; or else, in an unwieldy but at least comprehensive definition, as a fiction of which a dominant part purports to be an ongoing record of past and present events, as noted by the main character" (8). Field's definition, then, would appear to encompass *Cruddy*. However, the most helpful scholarship on diary fiction in this regard comes from H. Porter Abbott's *Diary Fiction: Writing as Action*. Abbott notes, "All diary novels are diary fiction, but not all works of diary fiction are diary novels" (15). Rather than focusing on a rigid definition of a diary novel and speculating on whether individual books fit the genre, Abbott notes that many texts employ "strategies" or techniques associated with diaries, in particular the "mimetic, thematic, and temporal—in which one can isolate functions served by the distinctive characteristics of diary structure itself. The *actual* functions to which a diary can be put in fiction are nearly infinite" (37). And it is the strategies borrowed from diaries—imitation or mimesis, theme or plot, and temporality and time—that create suspense and participation in *Cruddy*.

Imitation and the Intimate Artifact

Martens contends that "the diary novel is a *mimetic form*, that is, a form that the system of fiction has borrowed from the system of letters in general" (24), and Field notes that "the diary novel is a story whose meaning is conveyed or even affected by its resemblance to a diary; the resultant work is not some-

thing that is a diary and/or a novel, even though it partakes of the qualities of each" (1). As indicated previously, from the start, *Cruddy* positions itself as a diary artifact through the dedication and direct address and signature from the author presented in the opening pages. By speaking directly to "anyone who finds this," the narrator draws the reader into the fiction that this text is a found object, evidence of an author and her journey as detailed in its pages. The direct address also cautions the reader not to "blame the drugs or Vicky Talluso," explaining that it was "my idea to kill myself." Furthermore, "If you are holding this book right now it means that everything came out just the way I wanted it to. I got my happily ever after." The opening is endorsed with Roberta's scrawling, cursive signature and the dates 1955–1971. The facing page features a dark, accurately sized handprint with one digit cut short—reflecting Roberta's shortened finger, as later recounted in the text. The dedication and handprint all frame *Cruddy* as a relic of Roberta's life writings, calling on the mimetic qualities of diary fiction.

Abbott maintains that "the damaged manuscript" conceit recalls actual diaries, for in some of these fictions, "the diary is erased, torn, scorched, tearstained, or in some other way marked by the pressure of the events. The physical document itself expresses precariousness" (31). *Cruddy* plays on the porous boundary between real and unreal, creating a reading experience that blurs the lines of truth and fiction and intensifies horror and anticipation. Will Roberta perish, as indicated in the dedication? Does the fact that the reader is, indeed, holding the text mean the conclusion has already been decided?

Cruddy also features what appear to be hand-drawn maps on the book's opening and closing pages, further lending to the feeling that the text is a discovered relic. The maps indicate the key locations reported in the text, including the seemingly real "Dunbar Avenue" and "Diggy's Drive In," as well as "the Make-Out Garage" and "Saggy Underwear Man's House." A key includes symbols for "All the Places Where We Got High," "Places Where There Was Blood," and "Dead People We Left Behind." The final map includes a cross, indicating "The Money Is Here." The drawings accurately reflect the events of the narrative and bestow yet another level of authenticity on the text. They also appear to be sketched by hand, further developing the illusion that the book is an intimate diary completed by Roberta. In fact, all the drawings have a rough quality suggestive of the young narrator's hand.

The conclusion features yet another particularly powerful imitation of the real in the form of a postscript, seemingly from Roberta's sister Julie. In the final paragraphs, Roberta explains her plan to

sneak out and meet Vicky by Diggy's Dumpster. And then tomorrow night, after the concert she promised she will come with me to the train tracks. And she

promised she will give me the little push I need. . . . And so if you are reading this, if you are holding this book in your hands right now it means my plan worked completely, I am gone. I am gone. I got my happy ending. (304–5)

Roberta then encourages her reader to follow her description and take the money before dedicating the book to her sister. Just below these final words from Roberta is an annotation in a handwritten scrawl, ostensibly from Julie, that reads, "*Fuck* you Roberta!!! I *hate* you Roberta!!! *Where are you*??" (305). The calligraphy of this glossing of the text is decidedly childlike and markedly different from the typeset font of the majority of the text, striking an abrupt contrast. In fact, when I first read the book, I initially thought that someone had damaged the text, and I had to scrutinize the handwriting to determine that it was actually a part of the book and not the work of a vandal. Once again, this embellishment adds to the sensation that *Cruddy* is an authentic diary and thus subject to the scrawled commentary of a pained Julie looking for her sister. Furthermore, the text of the note itself lends veracity to the conclusion that Roberta has disappeared and successfully committed suicide.

The tone of the language further mimics the real in the voice of the narrator. Chapter 2 opens with the meditation:

Once upon a cruddy time on a cruddy street on the side of a cruddy hill . . . where a cruddy girl is sitting on a cruddy bed across from her cruddy sister who I WILL KILL IF YOU TOUCH THIS, JULIE, AND IF YOU DO I SWEAR TO GOD I WILL KILL YOU, NO MERCY, NO TAKE-BACKS-PRIVATE PROPERTY, THIS MEANS YOU, JULIE, YOU! The cruddy girl named Roberta was writing the cruddy book of her cruddy life and the name of the book was called Cruddy. (3)

Barry has often been cited for her ability to render the world of childhood accurately, and the repetition of "cruddy" echoes the vocabulary of a miserable adolescent, while the abrupt shift to a capitalized address to the sister intimates a real-life connection and a warning that will come full circle with Julie's words closing the text. All these techniques—the direct address to the readers, the damaged and hand-embellished manuscript, and the teenage voice—simulate the diary of a young adult, blurring the lines of truth and fiction and adding a discernible tension to the text.

Isolation and the Inner Life

The diary, concerned with the innermost thoughts and feelings of a single individual, offers an intimate portrait of the narrator, and the writing often

serves as a way of making sense of the self and exploring feelings of isolation or loneliness. Abbott argues that the one "salient characteristic" of diary fiction "is the way, generally, it modifies the theme of solitude" (45), given that for "the lonely individual, mentally barricaded behind a rampart of pages even if not physically locked away, the journal does become the most intimate part of existence" (148). Although surrounded by people as a teenager, Roberta frequently comments on her status as a loner. Her only true friends are Cookie, her dog that was killed by her mother; and "Little Debbie," her favorite knife. Roberta suggests that "there are also drifter creatures, attached to nothing, carried places by the current, and at night some of them will glow when disturbed" (223). Roberta is such a drifter, carried along by forces beyond her control. Struggling to stay alive, Roberta describes herself as "about as detailed as a shadow" (17) and expresses her desire to be left alone, untouched: "Normally I do not like for people to touch me, I have a weird problem with it, a doggish problem. When people touch me I want to bite them" (69). This fiction, then, becomes a safe space where Roberta can be alone and untouched, and painfully honest about her life story, using the diary mode to confess her intimate secrets.

In this confessional diary mode, Roberta as narrator uses the writing process as a reflection of selfhood, a mirror in which she can shape her fractured identity. Thomas Mallon, speaking of real-life nonfiction diarists, notes, "A breed apart from the diarists who write simply to collect the days or preserve impressions of foreign places are those who set out in their books to discover who they really are" (75), and this concept can also be applied to the fictional diarist. Field comments on the link between diaries and reflections of self: "Whatever the level of seriousness, however, we can see that from the very earliest examples, writers of diary fiction have been intuitively aware of the vital link between the intimate journal and imagery of mirrors" (154). In fact, the first line of *Cruddy* opens with an ominous reference to mirrors: "When we first moved here, the mother took the blue-mirror cross that hung over her bed in our old house and nailed a nail for it in the new bedroom of me and my sister. Truthfully it is a cross I have never liked" (1). This "blue-mirror cross" that commences the narrative frightens Roberta, who wonders, "But when the thing that is scaring you is already Jesus, who are you supposed to pray to?" (1). The reflective surface of the mirror placed in the intimate sanctuary of her room, coupled with the image of crucifixion, terrifies Roberta, evoking the anxiety reproduced in the text itself, which acts as a likeness of the narrator through the repetition of the intimate details of her gruesome travels and terrible selves.

As she engages in the composition of her text as mirror, Roberta frequently studies her reflection and attempts to bring together the many parts she has played into a cohesive whole through the creation of the text. Abbott asserts, "Such an act of writing/reading is simultaneously to say Who I am and to ask

Who am I? The self disclosed *behind* the text is the *project* of the text" (49), and Roberta performs this process throughout the book, asking again and again, "Who am I?" Ultimately Roberta finds herself through writing, creating an identity as an author, but first she must write her way through her stories and selves.

For Roberta, fashioning these identities is not innocent or fun but deadly serious. To survive (until such time as she chooses), Roberta learns to manipulate the various roles society has created for her, and to create various reflections of self, creating roles and names based on exaggerating the stereotypes projected onto her by others. For example, while accompanying her father on a spectacularly gruesome road trip, Roberta becomes his son, Clyde, a "mirrored" image of the father. Roberta records the creation bluntly:

> He told me how to do it. Be this type of idiot. And he was proud when I first pulled it off. In Moorehead, North Dakota, he took me into a Salvation Army. The clothes the mother threw into the car for me were mostly dresses and he didn't want me in dresses. The lady at the counter felt so sorry for us she didn't even charge us.
> "Clyde," said the father as we rolled out of that town, "You are a treasure." (60)

Roberta later becomes Eegore, an idiot child, a part created by the father to scam others. She also takes on the characters of the "Mystery Child," after the murderous rampage that leaves her alone in the desert, and "Michelle," while living with a Christian woman before her mother claims her. Roberta recalls, "Things were going pretty good until the mother showed up and blabbed about my true identity" (142). As a teenager, she resumes her identity as Roberta and then takes on another self, Hillbilly Woman, an identity that exists only in the sixteen-year-old's narrative and is bestowed on her by her new friends. Though the name Roberta was given to her by her parents, the author eventually reclaims it. Several of Roberta's closest allies accept this name and her identity as a leader, including her younger sister Julie, her friend Vicky Talluso, and her potential boyfriend "the Stick."

But it isn't until she inhabits these other selves that she returns to reclaim and ultimately destroy Roberta. Although *Cruddy*'s Roberta eventually chooses her own name and identity, she realizes that, given her instability and her past, she cannot survive, and she decides to take power over her own existence, perishing physically but living on through her words. The many characters in *Cruddy* give the central narrator names they feel most appropriate, conferring on her various identities that reflect their needs and desires, and she, in turn, takes on these roles, making multifarious selves her own, but Roberta as author is her first and final identity. For Roberta, the self as author is the identity that

endures beyond mere survival, transcending and bringing together her many voices and names. Roberta narrates:

> And now the story can be told. And must be told. In this book the truth will finally be revealed about the horrible murders and then the author must die. And people may be sad about that and wishing there were more books by the author, Roberta Rohbeson, but sadly, it will be too late. There will be only one Dewey decimal system number for her. Sadly only one. And if they ever find her body, and if she could have a final request, that number is what she would like engraved on her gravestone. (13–14).

Roberta develops these multiple identities to cope with outside pressures and attempts to bring them together in her book/diary, but in the end she can only achieve a sense of unity by sacrificing her physical self and leaving the book as the only evidence of corporeal identity. Her single book and her name as author will endure; her final wish is that she will live on through the Dewey decimal number assigned to the text. A Dewey decimal number, while somewhat anonymous, is also unambiguous and transcendent. This number, unassailable, endures and offers proof of Roberta, defining her and making her whole.

Temporality and the Teen Antihero

Cruddy presents a somewhat unusual interpretation of diary fiction in that most iterations focus on the immediate past and the present (telling the story), whereas *Cruddy* moves deftly between the far past (eleven-year-old Roberta's road trip with the father), the immediate past (sixteen-year-old Roberta's journey with her new friends), the present (the narrator's current situation), and the implied future (the writer's possible death). The structure borrows from diary fiction yet complicates it, creating suspense in the gaps and spaces between the manifold, competing temporalities and the polyglossic nature of Roberta's many voices. Martens contends that "an author may wish to establish complex parallelisms or present a special kind of psychological development by emphasizing both past and present time" (6), and in this especially complicated layering of timelines, Barry is able to echo Roberta's struggle for stability among her many selves and stories as she seeks to find connections across the lacunae in the narrative.

Cruddy slowly relates the events of five years earlier, alternating that far(ther)-past narrative with the immediate past, wherein Roberta makes new friends and eventually tries to take them to the site where her father's money is hidden. The

two narratives unravel gradually, ratcheting up the tension as the events of five years earlier grow darker with each episode. Abbott argues, "Diary structure in fiction can be used in the service of opposite temporal objectives, suspense or timelessness" (36), and *Cruddy* exploits these possibilities by gradually unveiling the gruesome mystery of the past and revealing, bit by bit, the truth of Roberta's selves and past, even as the reader sees the protagonist navigating the immediate past as a teenager on the cusp of adulthood. This technique generates a fearful anticipation and a sense of timelessness, as the reader senses this is something of a story out of time, but a deep sense of urgency also connects the pieces of the narrative and drives it toward the conclusion. Abbott further explains, "The author of the fictional reflexive diary loves to play off the surprise of an emergent plot against the conventional expectation of discontinuity in diaries" (44). In a more typically organized novel, plots generally follow a conventional structure, but *Cruddy* takes discontinuity to an extreme, mimicking the tension and anxiety central to the themes of disruption, isolation, and survival in an uncertain world as represented in the work.

In *Cruddy* the reader is forced to make connections between the years, creating something akin to what Scott McCloud calls "closure" in a comic. McCloud suggests that "comics panels fracture both time and space, offering a jagged, staccato rhythm of unconnected moments. But closure allows us to connect these moments and mentally construct a continuous, unified reality" (67). Barry, well versed in the comics form, exploits a similar strategy with her text-based novel, but instead of using the lines and boxes of panels to demarcate gaps to be filled, she develops diverse temporal story lines to generate holes and absences through progressive sequences that are never fully reconciled.

In addition to the narratives of the far past and the immediate past, we have the "present," or the narrator directly relating the tale to the unknown but addressed reader, or "Anyone Who Finds This." This voice breaks through the fourth wall to address the reader and her current situation openly, as in this early example from the novel:

> Cruddy. The famous book by the famous author Roberta Rohbeson who can't even CONCENTRATE TO WRITE this because her little sister will NOT shut up she will NOT shut up SHE WILL NOT SHUT UP and Roberta is about to BASH her little sister's HEAD IN IF SHE DOES NOT SHUT UP AND—Now it is later. (3)

This excerpt demonstrates the immediacy of the author's situatedness. Though the voice attempts a serious tone, she is interrupted by her sister and her home life, taking the narrator out of the writing process with threats of violence emphasized by the capitalization. Yet the calmer voice returns with the time-

bending phrase "Now it is later," signaling that the author has transcended the chaos of the immediate past to resume the sober task of composition. This intricate dance between narrating the past as well as the present condition enhances the exigency of the connection with the reader, implying a connection between the narrator's present and the audience of the "found" text. The act of composition in all its exigency becomes for Roberta what Abbott terms "a part of the action" (43). The locatedness of creation is an important element of diary fiction and is frequently referenced in texts that use such methods. Moreover, Field argues of diary fiction that "one thing which all such references have in common, whether they are couched in note form or elaborate description, is the allusion to the act of writing in current time" (92). Furthermore, Abbott claims:

> The principal advantage of diary fiction on this score is the *immediacy of the writing itself*, however variable its distance from the action (the recorded events, some of which may be far back in time). . . . Nonretrospective procedure, with its potential for heightening our awareness of the process of writing and with the possibilities it affords of allowing an alteration of the narrator's point of view *over the course of the narration*, can convert the narration itself into a kind of action. (29)

Accordingly, Roberta's frequent references to composing and her attempts to articulate her story reveal her working through her various selves, including Roberta, Clyde, Eegore, the Mystery Child, Michelle, and Hillbilly Woman, before finding a unified self as the present-tense author of the text. The process of creation, of inscribing the events as they happen, becomes the most important achievement of the text and Roberta's final triumph.

One might ask, however, whether Roberta the author truly finds success if she does, indeed, commit suicide with the help of her friend Vicky. The opening and closing pages manipulate paratext to blur the lines of fact and fiction (as does diary fiction) to point to an undetermined future. Yet I would argue that in that indeterminacy lies freedom. Referencing the faux diary/memoir *Lemonodasos*, George Kallinis comments that the narrator "forms an idea of his death through writing; in other words, writing helps him to create an idea of reality" (61), and this theory also applies to *Cruddy*. Perhaps this reality through ambiguity allows the reader to create closure for the heroine. Perhaps Roberta kills herself, but since we, as readers, are consuming her text, we grant her the unitary self and voice she lacked in her life. Or perhaps the reader is more optimistic, imagining Roberta sneaking away and starting a new life, unencumbered by the past. In fact, one key theme of the text is the idea of "dazzle camouflage," a notion Roberta learned from her father. She explains, "It was the Navy that figured out you could paint something with confusions so

horror-bright that the eyeballs would get upset to where they refused to see" (17). Perhaps these techniques are examples of "dazzle camouflage," distracting and confusing the reader while Roberta makes her escape. Regardless, in *Cruddy* Lynda Barry has skillfully employed the systems of diary fiction to fashion an exhilarating, anxious literary journey that forces the reader to participate in the making of meaning, establishing closure by imagining the outcome for the ostensible author of this fiction, Roberta Rohbeson.

WORKS CITED

Abbott, H. Porter. *Diary Fiction: Writing as Action.* Cornell University Press, 1984.

Barry, Lynda. "1619 East Crowley." *Mother Jones*, February/March 1989–May/June 1991.

Barry, Lynda. *Cruddy: An Illustrated Novel.* Scribner's, 2000.

Barry, Lynda. *The Good Times Are Killing Me.* Harper Perennial, 1988.

Barry, Lynda. Interview by Benny Shaboy. *Studio Notes #27: The Journal for Working Artists,* 1999–2000, http://www.marlysmagazine.com/interviews/barry.htm.

Barry, Lynda. Interview by Joe Garden. AV Club, December 8, 1999. https://www.avclub.com/content/node/24257 (accessed March 2008).

Barry, Lynda. Interview by Paige La Grone. *Mean Magazine*, vol. 6, 1999. https://www.marlysmagazine.com/interviews/mean.htm (accessed January 2008).

Barry, Lynda. *One Hundred Demons.* Sasquatch Books, 2002.

Barry, Lynda. Personal interview, July 19, 2006.

Berry, Ellen E. "Becoming-Girl/Becoming-Fly/Becoming-Imperceptible: Gothic Posthumanism in Lynda Barry's *Cruddy: An Illustrated Novel.*" *A Companion to American Gothic*, edited by Charles L. Crow, John Wiley & Sons, 2014, pp. 405–17.

Day, Sara K. *Reading Like a Girl: Narrative Intimacy in Contemporary American Young Adult Literature.* University Press of Mississippi, 2013.

Field, Trevor. *Form and Function in the Diary Novel.* Barnes & Noble, 1989.

Hogan, Rebecca. "Engendered Autobiographies: The Diary as Feminine Form." *Autobiography and Questions of Gender*, edited by Shirley Neuman, Frank Cass, 1991, pp. 95–107.

Kallinis, George. "*Lemonodasos*: Diary Novel or Diary Fiction?" *Journal of Modern Greek Studies*, vol. 15, no. 1, 1997, pp. 55–66.

Kirtley, Susan. *Girlhood through the Looking Glass: Lynda Barry.* University Press of Mississippi, 2013.

Mallon, Thomas. *A Book of One's Own: People and Their Diaries.* Ticknor & Fields, 1984.

Martens, Lorna. *The Diary Novel.* Cambridge University Press, 1985.

McCloud, Scott. *Understanding Comics.* Kitchen Sink Press, 1994.

Miller, Brian. "This Girl's Life: Lynda Barry's Bizarre Brand of Bleakness." *Seattle Weekly*, October 6, 1999.

Prince, Gerald. "The Diary Novel: Notes for the Definition of a Sub-genre." *Neophilogus*, vol. 59, no. 4, 1975, pp. 477–81.

Rothstein, Mervyn. "From Cartoons to a Play about Racism in the 60's." *New York Times*, August 14, 1991, p. C11.

Weissman, Benjamin. "Graphic Stories." *LA Weekly*, December 17, 1999, p. 55.

chapter 8

Confusions So Horror-Bright:
Class and Gender in Lynda Barry's *Cruddy*

—Rachel Luria

Lynda Barry's illustrated novel *Cruddy* is written as the journal of Roberta Rohbeson, a sixteen-year-old girl. Readers know from the book's first words that Roberta's story is not a happy one. Beside what appears to be a bloody, disfigured handprint is Roberta's note to the reader:

> Do not blame the drugs. It was not the fault of the drugs. I planned this way before the drugs were ever in my life. And do not blame Vicky Talluso. It was my idea to kill myself. All she did was give me a little push. If you are holding this book right now it means that everything came out just the way I wanted it to. I got my happily ever after.

What follows this note is Roberta's narration of two periods in her life: her travels with her murdering con man of a father when she was eleven, and her brief and fateful friendship with the troubled Vicky Talluso five years later. Though readers know from the first page that Roberta will die by the story's end, one cannot help but root for such an insightful and often witty young person who has seen and suffered so much. Barry is right to give voice to the desire to look for someone to blame for Roberta's death. But if we are not to blame the drugs or Vicky, then where does blame lie? For Barry, the blame lies with a system that exploits and devours the young, the poor, the laborers. The

gruesome story of Roberta Rohbeson and her father's bloody, murderous trip in search of wealth and revenge across a nightmarish American landscape reads, at first, like a sensational story of satisfying thrills and bloody plot twists. The book presents itself as a shocking, pulpy horror novel, but in a move the book calls "dazzle camouflage," the grotesque surface hides a powerful critique of capitalism and the American dream.

The corrupting power of this system that transforms men into monsters is aptly illustrated in a scene late in the novel. Nearing the end of their bloody journey through a nightmare version of America, Roberta and her father are driving to Vegas with his latest mark, Pammy, whom he has drugged and who is now unconscious. By this point in the novel, Roberta has witnessed numerous horrors and battled monsters more terrifying than the vampires in her beloved horror movies. The greatest of these is her own father, who has lied, tortured, and murdered in pursuit of his supposedly stolen inheritance. The father, as Roberta calls him, and Roberta, or Clyde, as he calls her, have just left the hellish Knocking Hammer, an old slaughterhouse run by the corrupt pederast sheriff and murderous Pammy. The father plans to marry and then kill Pammy so that he can take over the Knocking Hammer himself and return to the family business of meatpacking.

Roberta has barely survived her time at the Knocking Hammer and is enjoying a rare moment of peace behind the wheel of the car (though a child, she is driving—given responsibility well beyond her years, as she often is). Interrupting the calm and beauty of the white alkali flats is Roberta's sudden recognition of the land: "*The Horror of the Blood Monsters. It Came From Outer Space. Them! The Blob. The Mummy. The Amazing Colossal Man.* I was in the valley of the monsters. I was in the middle of the location where so many of the world's greatest movies were filmed" (247). Roberta realizes she is at the site where her beloved B-movie horrors are filmed. In the movies, the landscape turned ordinary people into monsters: "The radiation has caused a change. He starts growing. His body becomes huge and he can't stop wanting to destroy everything, he hurls a bus full of people over his head. They all die. The furious emotions of the Amazing Colossal Man are real" (247). A similar transformation marks the furious emotions of the father, a man who became a monster long before he ever drove through this haunting, poisonous landscape. It was not radiation that transformed him, or any of the monsters in *Cruddy*; it was money and greed. It was the toxic system in which we all live.

In this moment, the book is both self-consciously playing with genre and making an argument against a culture that destroys and devours its most vulnerable people. Just as Roberta found herself and her story set against the

fictional landscape of the movies, readers too will find their own stories in the fictional landscape of the novel. Its descriptions and the illustrations are monstrous and terrifying, but if one looks beyond the sensationalism, one finds a far too common story.

Though the story and pictures of *Cruddy* are a "fun-house mirror . . . gruesome, distorted, terrifying" portrait of America, they illustrate an unpleasant truth (Kirtley 85). The horrors of the novel, the "dazzle camouflage," are not simply an entertaining distraction but, in fact, the only means through which one can see the truth of the existence of an exploited underclass. It is often only through exaggeration—a fun-house mirror—that one can see one's actual reflection.

The world that *Cruddy* reflects is the world of modern capitalism. As Marx defines it, capitalism is a system in which there are only two classes: the proletarians, or those who labor, and the bourgeoisie, or those who profit off the labor of the proletarians. Though these two classes are at odds with each other, as the exploited and the exploiter always are, they are both the products of an ever-expanding world that is driven by lust for profit and the search for new markets that can feed that lust. Though Marx acknowledges that the bourgeoisie is "itself the product of a long course of development, of a series of revolutions in the modes of production and of exchange," he argues that it now controls and maintains a system in which there is "no other bond between man and man than naked self-interest, than callous 'cash payment.' . . . It has resolved personal worth into exchange value, and in place of the number-less indefeasible chartered freedoms, has set up that single, unconscionable freedom—Free Trade" (10–11). This, then, is a world where no value exists but cash value. Capitalism has "drowned the most heavenly ecstasies of religious fervor, of chivalrous enthusiasm, of philistine sentimentalism, in the icy water of egotistical calculation" (11). Where once one might choose a profession for its intrinsic value—the way it may serve and better the lives of all—now capitalism "has converted the physician, the lawyer, the priest, the poet, the man of science into its paid wage-laborers" (11). Even the family unit has been corrupted by this system and those who control it: "The bourgeoisie has torn away from the family its sentimental veil, and has reduced the family relation to a mere money relation" (11). *Cruddy* takes this even further by making the family a source of genuine peril. For the father, Roberta is a means to an end—recovering his inheritance—and he is more than willing to sacrifice her safety to achieve his goal. Even her own mother sacrifices Roberta's safety for her own comfort. Where many children are told to fear strangers, Roberta learns to fear her own family most of all.

The world of *Cruddy* is the most horrifying, though perhaps logical, evolution of this culture, in which there are no values but those that can be quanti-

fied with a cash value, no individual identity, only faceless masses of workers and those who exploit them, and in which all trusted institutions have been corrupted. The reader's introduction to this world is an unsettling description of a crucifix in which "the Jesus of it seems haunted" and a terrified Roberta, who says, "Some nights looking at him scares me so bad I can hardly move and I start doing a prayer for protection. But when the thing that is scaring you is already Jesus, who are you supposed to pray to?" (1). This is a question that will haunt the rest of the narrative, and it seems the answer is no one but yourself. Clearly, this is a world in which once-trusted institutions like the church have been "drowned" and are now suspect, frightening, and, in fact, the ones who do the drowning. Only a few pages after we are introduced to the "haunted" Jesus, we learn that the influential "string-puller" Ardus

> came home from work and told [his wife] he might have buried the little boy
> that was lost, the boy the town was turning itself inside out about. He told
> Marie there was a pretty good chance he buried the Leonards boy alive in
> concrete while he was pouring the foundation for the new church. He said that
> by the time he noticed there was nothing he could do. The boy was gone. So
> he just kept pouring. He told Marie he was just hoping the whole thing would
> somehow blow over. (27)

This incident is just the first of many graphic examples in which the poor, and especially poor children, are swallowed and destroyed by the machinery of progress—in this case, literal machinery. A church is no longer a safe, sacred space but a site of callous consumption in which the boy's fate is inevitable, his life deemed of less value than the cost of digging him out. This is a world in which children are of so little value that a "string-puller" might reasonably hope his loss would "blow over."

Though Ardus's wife does alert the police after his confession, readers already know that his hope is, in fact, reasonable. Readers have been told that their neighborhood, East Crawford, is "a road of trash people" (6). The lives of these people literalize the alienating, dehumanizing process Marx describes when he details the effects of industrialization. He writes, "Owing to the extensive use of machinery and to division of labor, the work of the proletarians has lost all individual character, and, consequently, all charm for the workman. He becomes an appendage of the machine" (16). In Roberta's world, this is literally true. Where she lives, there are

> a lot of trees behind the house, mostly scrub maple and pine, and a lot of nasty
> smells that come from the garbage ravine and more nasty smells that come from

the mud in front of the house and all day there is the sound of the loudspeaker calling in the lumberyard for Mike. . . . And I have watched out my window to see which one is Mike, which one of the forklifts inserting the smashed-flat Dracula teeth under stacked loads of wood is Mike, but every time they call for Mike a different guy goes inside. Maybe they are all Mike. (6)

The local lumberyard that employs most of the town's residents has dehumanized workers to the point that they seem to all share a single identity. Only Roberta, watching from her window, seems to notice any difference between these men and to hold out any hope that some individuality might still exist in this terrifying world of "string-pullers" and "garbage people."

This hope is dashed on the night Roberta's mother shoves her into the back seat of her father's car, and she finds herself an unwilling passenger on and witness to her father's bloody odyssey through the American West. Roberta's father, or "the father," as she calls him—making him both a man and an institution—is both a product of the capitalist system and its most violent protector.

No single character embodies the horrors of capitalism and the cruelty of the bourgeoisie more than the father. His personal history is a distorted mirror of the history of capitalism. Just as the bourgeoisie came to replace the lords and aristocrats of the feudal system, the father replaces Old Dad. Just as free trade came to replace the inheritance system of the nobility, so too was Rohbeson's Slaughter and Custom House, the family business, usurped by large corporations. Roberta describes the family and their business as being "famous for five counties" (24). She says, "Rohbeson's methods were strictly Old World. Everything done by hand. The rounding, knocking, bleeding, gutting, skinning, splitting, dressing, aging, curing, pickling, packing, bone and hoof boiling, all of it done right on-site" (24). And whether part of the Old World or New, the processing of flesh for consumption is an apt metaphor for the role of the elite—a role the father was born to play. But the father is a complex character, just as capitalism is a complex system. He is a member of the elite who will consume the working class, but he is also a victim of that elite class. Just as the toxic landscape of those horror movies created monsters, so too did the toxic landscape of capitalism create the monstrous father. The father's own cruelty and rage may be the result of abuse he suffered at the hands of his own father. This abuse may have led to his sense of entitlement, which then led to his relentless pursuit of an inheritance he was denied. He does not inherit the family business, as Old Dad sells it out from under him. As the father says, "Chicago and all. We couldn't compete. That's progress" (37). And it is that kind of progress that strips the father of his legacy and is the catalyst for his rampage and ruthless quest.

The father is on the road, trying to track down suitcases of money, money Old Dad hid from him. And though he cuts a bloody swath across the country, killing anyone who stands in his way, wounding and nearly killing his own daughter—a daughter whose identity he refuses to acknowledge, renaming her Clyde and telling everyone she is a boy—it is this very quest that proves to be his undoing. Marx argues that "not only has the bourgeoisie forged the weapons that bring death to itself; it has also called into existence the men who are to wield those weapons—the modern working class—the proletarians" (15). Like the bourgeoisie, the father has "called into existence" the person who will bring about his end: his daughter Roberta, to whom he literally gives the weapons of his own destruction (a set of deadly sharp knives, one of which Roberta names "Little Debbie") and whom he pushes and torments until she has no choice but to kill for her own survival.

In the world of *Cruddy*, however, the death of the father is not the end of the story and does not offer the key to Roberta's salvation. Though Marx predicts a united, classless society in the wake of capitalism's destruction, *Cruddy* does not. It does not suggest a bright future in which all are united and work together. Though we may find a glimmer of hope in the narrative, which I discuss hereafter, the overwhelming picture that it paints is of endless destruction, a series of erasures in which the most vulnerable in this world systematically disappear from the story and, therefore, history. Even Roberta, the story's narrator, disappears, her exact fate unknown.

To prepare the reader for such a potentially bleak ending, the story illustrates again and again the myriad ways that a capitalist system consumes people and turns them into waste. Roberta soon learns that it is not only the people of East Crawford who are "garbage people" but all laborers, who, in the words of Marx, "live only so long as they find work, and who find work only so long as their labor increases capital. These laborers, who must sell themselves piecemeal, are a commodity, like every other article of commerce, and are consequently exposed to all the fluctuations of the market" (15). When the working classes are no longer necessary, they are eliminated. We see this repeatedly graphically described and illustrated in *Cruddy*. In *Cruddy*, the working class, the young, and particularly young, working-class girls of color are consumed, digested, and, quite literally, disposed of as waste.

Take, for example, the "Fanta children" found at the Knocking Hammer. These children, who are known only collectively—their individuality stripped from them—are no more than disposable products. Their very designation, Fanta, is a corporate product. They are migrant children who watch as their only caretaker, the grandma-ma, literally cleans up the mess the father has left behind—rotting human remains. When one of these children falls into

the canal, Pammy makes a brief rescue effort but ultimately treats the child's death with callous disregard. Roberta hears crying and wailing, but it is coming from outside, not from Pammy or the sheriff. When describing the death of the child, Pammy is cold, unmoved: "She blew a jet of smoke out of her mouth and then turned and gestured to the doorway. 'The grandma-ma would like a ride to the orchard. She wants to be the one to notify'" (185). Not long after, the grandma-ma and the Fanta children are gone, leaving behind nothing but "trash and torn tarps." No one sees them leave; they just disappear.

Though these migrant workers are especially dehumanized—not even given the individuality of names—they are only some of many who are dehumanized and disposed of. In this world, any child can become surplus, a burden; even, or perhaps especially, Roberta is in danger of becoming a "spooker" child. As she says, "Spooker was another word for mongoloid. As far as the sheriff could tell, I was one. Pammy thought so too" (189). The designation "spooker," like "Fanta," exaggerates and reveals the place that children, especially children deemed to be defective, hold in this society. They are spooks, ghosts, doomed to work in "by-product processing" if they are to live at all.

It is not only poor children who may be doomed to the fate of the "spooker," as Roberta learns when she befriends Vicky Talluso. Through Vicky, she meets the Turtle, the Great Wesley, and the Stick—middle-class teenagers who are not immune to the dehumanizing effects of capitalism, identified by titles rather than names. The Turtle, in particular, illustrates the cost of a world that values only the ability to produce or reproduce wealth. As a child of wealthy parents, he is a product of the bourgeoisie. But as one who suffers from mental illness, rendering him—in the eyes of the world he inhabits—damaged, useless, and therefore disposable, he is also their victim. Like the Fanta children, the Turtle and his companion the Great Wesley disappear into a canal. Roberta witnesses his fall and says, "It seems strange to me now when I think of how convinced I was that he would need [his shoes]. How convinced I was that I would see them both again. But they were never found. Not by us. Not by anybody. There is a part of me hoping that maybe they made it. Made it to wherever people like us finally go" (300). Though they came from different social classes, Roberta recognizes that they are the same, identifying with them as "people like us." She recognizes that the Turtle's youth and mental illness make him disposable; his family's wealth does not protect him.

In the world of *Cruddy*, neither class nor gender provides any sort of protection. Though the novel is framed within the voices of two girls, Roberta and Julie, this is not the story of the particular peril girls face. Within the novel, boys are in as much danger as girls. In fact, Roberta is often most vulnerable when she is disguised as Clyde. The Turtle and the Great Wesley are not any safer, though

they are boys. In fact, only hours after their disappearance, Roberta witnesses yet again the death of a disposable "garbage person": Vicky's brother, known as the Stick. He too is damaged, a "bleeder," and he takes his own life, slicing his wrists; and then, though she was there, Roberta "cannot say if he jumped or he fell. It seemed like he did neither. To [her] it seemed as if he took a calm step into thin air" (304). The Stick dies at the hospital, getting the only "happy ending" Roberta and the novel seem to be able to imagine. But that raises an important question: does the novel actually share Roberta's nihilism?

A wealth of evidence certainly suggests that the novel does argue for such a bleak view of the world. Within it, churches do not simply neglect children; they grind them into their very foundations. Officers of the law commit murder and molest children. School provides no respite. The family proves to be Roberta's greatest enemy. Her own father tries to kill her, and her own mother forces Roberta into the harrowing journey that nearly kills her. Reading this story through a Marxist lens, however, may offer us a glimmer of hope. The world is a system, which can be changed or dismantled—though, perhaps, not in the way Marx envisions. If the cruelty found in the story were simply the natural product of human nature, then there would truly be no hope.

One might argue that the character of the mother would suggest that it is human nature and not the result of systematic oppression and antagonism between the classes. She, after all, is not a laborer like the Fanta children. Neither is she a member of the elite class, never having been an heir to any family fortune. As a nurse, and not a doctor—educated but still not at the top of the medical hierarchy—she would seem to exist in a space somewhere between the proletariat and the bourgeoisie. But this is a space Marx describes. He anticipates the way existing in such a space shapes behavior and instills in its occupants a desire to, at the least, preserve their position there. Not only has this system "torn away from the family its sentimental veil," he argues, but it creates a desire in the lower middle classes—people like the mother—to "save from extinction their existence as fractions of the middle class. They are therefore not revolutionary, but conservative" (11, 19).

We see from the beginning the mother's position in this lower-middle-class space and her desire to protect it. Though she lives among "garbage people," she has higher aspirations. She decorates the home in the trappings of the middle class: "There is the mother's TV and the mother's chair and the mother's lamp. All new. All fancy. Presents to her from the grateful people at her hospital. The mother is a nurse at Veterans" (8). Note the distinction of "the mother's TV," and so on. These are her possessions, not her children's. She has created a hierarchy among them, placing herself at the top. She is also more than willing to sacrifice her children for her own comfort, sending Roberta to greet

the lecherous landlord, and ultimately it is the mother who shoves Roberta "into the backseat of [the father's car] and [tells her] not to show [her] face" (28). Readers can infer from the chapters that follow that the mother did this because she was hoping Roberta would then be able to lead her, the mother, to the father's fortune. This callous self-preservation and quest for wealth, in Marxist terms, is not a personal failing but the inevitable result of capitalism.

The story offers us a brief glimpse of a version of middle-class capitalism that seems happy, that seems to suggest the possibility that one can both live in comfort and serve, not exploit, those in need. This is the world of the Las Vegas Christian Homes, where Roberta is briefly sheltered after her ordeal. Roberta says of this time:

> During my time in the Las Vegas Christian Homes when I was the mystery child who suffered from shock and amnesia, I had a decent life. I had the name of Michelle, the Christians called me Michelle and I enjoyed life as Michelle. I enjoyed making sock monkeys for the Christian Missionaries International Sock Monkey Drive, sock monkeys for disadvantaged children around the world. I enjoyed the Jesus they prayed to, a very different-looking Jesus from the one I was used to. His eyes weren't shocked-rolled high and his mouth didn't hang open in agony and no blood was dripping down his face, or from his slash wound or from his various nailed locations. The Christian Homes Jesus was a very comfortable-looking Jesus. A strolling Jesus, in very clean clothes. A clean Jesus for clean, strolling people. (141–42)

What this passage reveals, however, is just how vast the gulf between classes is, and the impossibility of someone like Roberta ever finding permanent residence in a class other than her own. Roberta cannot even be herself to exist in this world; she must rename herself Michelle. Michelle's world and Roberta's are so different that they are ruled by different gods. Where Roberta's Jesus is haunted, Michelle's is comfortable, strolling, and clean. It is not long before the agent of capitalism, her mother, emerges from the shadows to retrieve her. Once again, the protections of the church, even a church that promises a clean, comfortable god and attempts to help "disadvantaged children," are shown to be impotent. Only Roberta herself offers true protection for disadvantaged children: "Inside of Trina [the sock monkey], wrapped in layers of twenty-dollar bills and raw cotton, [the knife] Little Debbie waited" (142). In Roberta's world, money and violence are the only protection.

These details, then, would seem to support a reading of *Cruddy* as simply illustrating the mechanics of capitalism described by Marx and offering what slim hope can be found in the idea that we inhabit a system that can be

dismantled. But Barry is engaging Marxism in conversation, affirming many of his assertions while complicating others. Marx argues that "in bourgeois society … the past dominates the present; in Communist society, the present dominates the past" (24). Through *Cruddy*, Barry seems to agree that in our current society the past dominates the present. But she seems less optimistic that a new world would break that pattern. Despite powerful depictions of her characters as products of their world, she complicates the problem by naturalizing some of their behavior, labeling Roberta and the father "meat people" and "knife people." She writes:

> The father was right, I am a knife person. Knife-loving blood circulates within me. There is a symbol for infinity, a line that describes a sideways figure eight. X marks the spot in the center. X marks the spot of recirculation. That is where you should plunge the knife to stop the blood of time past from infecting the blood of time future. I held [the knife Little Debbie]. It would be so easy. Slicing up from the wrist toward the inside of the elbow. (230)

When Barry envisions a new world, it arrives not through a change in systems alone but in a change in blood, which, of course, is impossible. One cannot change one's blood any more than one can interrupt infinity, not even with a knife. The only way out is through death, the only power the power to choose the time and nature of that death.

Fanta children fall into canals and are forgotten; "spooker" children are doomed to work in "by-product processing"; teens like the Great Wesley and the Turtle also fall into canals and are never seen again; even Roberta, who had survived so many assaults, so much horror, is eventually swallowed by her own narrative and disappears—getting the only happy ending she can imagine, a death of her own design. However, even here, Barry complicates matters. The novel resists a simplistic reading that would valorize suicide. Roberta and her friends would seem to die, but in fact they disappear. We do not know precisely what happens to them. Perhaps they die, or perhaps they live on somewhere else, under some new identity. Roberta has been Clyde and Michelle; who is to say for sure that she has not assumed yet one more identity? Barry ends Roberta's story not with the finality of a period but with an uncertain and perhaps hopeful question mark. The novel's final sentence is Julie's tormented question "I hate you Roberta!!! Where are you??" (305).

This is a fairly tenuous glimmer of hope, as the question suggests that not only has Roberta not been home in some time, but Julie is now suffering in her absence. We know from earlier scenes that Julie, despite her violent assault on Roberta, is terrified of being left alone in the house. In fact, she is so desperate

at the thought that she flies into a rage and throws a knife at Roberta. To which Roberta responds in her thoughts, "Julie. Do you know what the father would have said? He would have said you were a natural" (129). This suggests that Julie is doomed to repeat the same cycle of violence that swallowed Roberta—that there really is no hope. But the very existence of Roberta's narrative, and Julie's entry into it, offers a further glimmer of hope.

Though Marx argues that one cannot defeat the system with its own machinery, Roberta seems to challenge that. By telling her own story, she has harnessed the tools of the system to gain some control, to unify all her identities and have agency. As Susan Kirtley writes, "Roberta creates for herself a 'Roberta as author' in control of the telling of her life story and, ultimately, in control of her own life, including when that life will end. . . . This book, this story, is the conclusion of Roberta's fairytale and her means of achieving immortality" (89).

By telling Roberta's seemingly unique story, Barry tells the story of everyone, but especially the young, caught in the machinery of our capitalist society. We live their lives through Roberta. In "Rethinking Ugliness," Meghan M. Sweeney writes: "While many books describe the messiness and awkwardness of adolescence, Barry's work seems to 'dive down' deeper than most. Through darkly perceptive illustrations, an unusual sense of humor, and simple, yet striking prose, Barry enacts adolescence on the page. Lynda Barry's books are never comfortable, but neither is being an adolescent" (23). This book is not only Roberta's story, not only the story of adolescence, but America's as well: the American dream is but a fairy tale in which the only agency that the poor, the young, and the vulnerable have lies in deciding how they exit the story.

WORKS CITED

Barry, Lynda. *Cruddy: An Illustrated Novel.* Simon & Schuster, 1999.

Kirtley, Susan E. *Lynda Barry: Girlhood through the Looking Glass.* University Press of Mississippi, 2012.

Marx, Karl, and Friedrich Engels. *Manifesto of the Communist Party.* International Publishers, 1948.

Sweeney, Meghan M. "Rethinking Ugliness: Lynda Barry in the Classroom." *ALAN Review,* vol. 37, no. 3, January 2010. https://doi.org/10.21061/alan.v37i3.a.3.

RESEARCH-CREATION

Figure 1. Claire Villacorta, *Running Dry: Requiem for the Rockets*, excerpt from comic-in-progress *High Fives and Neil Young for the Road*, 2012.

Chapter 9

Me and Lynda Barry: An Autoethnographic and Artistic Response

—Elaine Claire Villacorta

Dear Lynda Barry,

Honestly, I haven't actually thought about you in years. You had been a crucial influence on my comic strips all this time. But I won't deny it—you did influence earlier strips about my own growing pains that I'd committed to paper, pencil, and ink, both finished and unfinished. In fact, I *loved* your work. Still do. Your comics took me to an "elsewhere" that embraced the emotional awkwardness of going through adolescence while poking fun at the prevailing curiosities in the area of play. You inspired the big panels, the text-heavy top panels, and the way personal narratives lend themselves to such a visual medium, with the kind of flow that doesn't necessitate a climax but isn't anticlimactic, either. It may have something to do with a lack of a punch line. A zinester friend of mine who went to college in the United States attended your lecture and went home with this piece of (paraphrased) wisdom: *You do not write a story to make a point; you write because it's beside the point.* I remind myself to adhere to this as a way of letting myself go.

"Writing the Unthinkable" was the first thing that brought me back to you in 2011, at a time when I needed to let something out. *High Fives and Neil Young for the Road* was born out of that aesthetic experience of writing and drawing as a way of grieving over my dog's tragic fate. Along the way, I had found a connection between "Writing the Unthinkable" and John Dewey's *Having*

an Experience, and I wrote a paper about it. I submitted the abridged version to a journal. With the unabridged version, I produced an outtakes zine that documented my entire image-writing process to jump-start my comics-in-progress about a sickly mutt named Siops who resonated with Neil Young's music. Both works still took on the name of *High Fives*. It also became more about the process of the comic strip than the strips alone.

Anyway, it's high time that I acknowledged your overall influence on my developing and underdeveloped body of work in the area of independent comics.

I remember the time I read—and reread—*What It Is* before going through the "Writing the Unthinkable" exercises. It brought back those feels of drawing as a kid and how it seemed like the most natural thing in the world. When I was six, I folded white sheets of paper and stapled them. On each half sheet, I drew Hello Kitty and Hello Mimmy, my all-time favorite twin cats from Japan. I came up with countless on-the-spot narratives and speech bubbles. I don't quite remember what they were about, but I'm fairly certain that there were no punch lines. My colored set of Pentel N50 bullet tip markers were on fire, and it didn't matter whether the ink bled on the back. Or maybe it did, and I just never really drew these pictures back-to-back. I made a lot of these one-shot "books" and gave them away to some of my classmates in the first grade. Other kids started requesting their own book too. It never occurred to me that these were actually *fanzines*—as a first grader, I had yet to discover that liberating world of self-publishing in the distant future. But I loved making them and giving them away, without a trace of an archive.

What I would give to feel this awesome, all over again.

It's hard to recapture that moment, no matter how I tried, even with my own writing. I just had to keep going and allow myself to feel the highs and lows of my creative process. I found drawing, on the other hand, to be a relaxing activity. Perhaps it had to do more with having lower expectations of myself. There was something cathartic about sketching and inking because I was not too concerned about something that came from my mind's eye. In fact, I had no particular vision for it; I just drew within my capabilities and allowed for things to just, you know, *flow*.

Here came a process wherein I had to relax as I was writing, for a change. This was huge for me, especially when I was feeling stumped about how I

wanted to remember my dog. I went through the warm-up phase of "Writing the Unthinkable" by doing the exercises, as I understood them from your book, before committing to my own images. I set the timers, then *boom*. It certainly was an interesting "unthinkable" journey, from riding in my mother's blue VW Passat to quiet time with my former best friend's mother at a beach resort (Villacorta, *High Fives* 18–25). When I finally got started on the initial stages of *High Fives*, I used Siops as my dog image. I set the timers once again. After the exercises, it occurred to me that I needed more stories that would bring me closer to the music that Siops resonated with—particularly *Everybody Knows This Is Nowhere*, the seminal 1969 album that Neil Young released with Crazy Horse as his backing band. It was a befitting rock and roll soundtrack to tell Siops's tale. All seven songs from the album became images, and I definitely had a lot to work with.

Admittedly, writing the songs as images did leave me with the blues. That was probably me processing my dog's death. Grieving accounted for only half the process. It was also a bit much to have Dewey in my head when theorizing the experience. I dealt with the product of my image-writing frenzy a week later, and I felt infinitely better. I extracted the choice bits of prose, did some tweaking, and used the words for my first comic strip. When I started drawing, I was breathing life on the paper with every stroke of the pen, soaking up the moment with that incredible feeling of aliveness (Villacorta, "High Fives" 93).

Looking back, I may have spiraled faster than I should have. However, it was only recently, in one of your remote learning YouTube videos for your Images 2020 class, where I actually watched you zoom in on the spiral and move the pen in a much slower, meditative pace. As you spiraled out, you talked through each relaxation point in a soothing manner. Still, whatever I did, whether it was true to your method or not, all went into my outtakes zine.

———

I had actually seen your name referenced in zines. Back in 2001, I read an interview you did with *Bitch* magazine, which started off as a feminist pop culture zine. I didn't exactly take to your comics right away, though. But when I wanted to write and draw stories about youth, I revisited the interview, reread the excerpted comics, and decided that I wanted more. So I ordered your books. This experience also reflects the shared audience of both readers of zines and independent comics. The editors of *Bitch* manage to tap into the sensibilities of their readership because they, too, share them.

Since you are not accessible to me, I decided to write you a letter and imagine the ways in which we could collaborate or converse. This letter takes on

a visual autoethnography. I recall some of your words and comics from your interviews and books. I respond to them by revisiting and reflecting on my old comic strips, some of which have been published independently, while others remain half-finished, uninked, and even undrawn. Sometimes I will just respond. This is also my way of exploring my transition from making print zines to *High Fives*. It's an assemblage of sorts—a way of repurposing the zine.

While letter writing lends itself well to my imaginary collaboration with you, it is also a nod to Flaudette May V. Datuin's approach to the open letter as an interruption of the flow of the academic mode, challenging traditional art history's linear historiographic structure. In *Home Body Memory*, Datuin engages in a fictional dialogue with the nineteenth-century artist Paz Paterno in the form of a letter (180). She uses the concept of *usapang babae* (Tagalog for "woman talk"), which she describes as emerging from "a particularly Filipina, middle-class inflection of a feminine elsewhere" (179). She elaborates: "*Usapang Babae* is a form of communication which takes place in the spirit of communion, and community, not on grounds of false harmony, but on encounter, negotiation, and perpetual auto-critique" (179).

The fictional dialogue is her way of re/presenting women's history "by establishing an imaginary link amongst women across generations and geographies" (180). Addressing the letter to Paz Paterno allows Datuin to be both conversational and confessional. Thoughts flow "through and around," and there is room for being inquisitive and speculative. There is also room for a subject position, which allows for her own confession of her personal struggles in her field of work, as art historian and critic, as she relates her own experiences in symposia on women's art to the bigger picture.

While I myself am not seeking a feminist discourse, I am initiating a fictional dialogue with a Filipina American woman cartoonist who is geographically elsewhere and about twenty or so years my senior. In that sense, it is as good as an intergenerational "conversation."

Identity

You are one multiplicitous woman.

It was the stuff about girlhood and growing up that got me absolutely hooked, particularly *The Greatest of Marlys*. The emotional stirring and turmoil of youth in the private worlds of Marlys, her sister Maybonne, and cousin Arna, the unique yet spot-on oft-humorous depictions of the awkwardness of coming-of-age in both weird ways and normal ways, minus the sappiness, and *très* cool without being self-consciously so—these were the kind of stories I'd been looking for,

perhaps all my life, without actively seeking them. I mean, how could I, when most of your books were anything but accessible here in Manila? To me, they read like stories of youth from the past, coming from what I presume to be your generation. The nostalgic feel is beside the point, although it's inevitably there. But more importantly, these stories evoke that feeling of what it is—or what it was—to be alive. And, of course, that feeling of aliveness would extend to the creative process itself, hence "Writing the Unthinkable."

Your sense of paneling and art style were both flamboyant and accessible. At that time in my life when I wanted to make autobiographical comics, I felt duly encouraged. I think the Filipina identification also helped, as in the case of *One Hundred Demons*, but honestly, it wasn't the be-all and end-all of your having become my favorite cartoonist of the moment. You summoned your autobifictionalographic monsters in that book and went as far as naming them in words closest to home (i.e., *aswang, kuto,* or the "head lice" you likened to your worst white boyfriend). Of course, the biggest difference here is that you are writing and drawing from the perspective of a (quarter-) Pinay in America, while I am a Pinay in my own hometown. And you may not even look Pinay at all, with your extremely fair, freckled skin and bright, albeit natural, red hair; but the way both your Ilonggo grandmother and half-white mother figure prominently and have added that cultural spice to your Western upbringing gives your maternal roots away.

And as much as I would have loved to add a more localized flavor to my own comics back then, I would never have been able to pull it off as brilliantly as you. And to think that you have long penetrated an American audience with such examples in your thirty-year career as an active cartoonist, syndicated practically on her own terms.

You are so many things at once: a self-proclaimed peminist (Filipina American feminist) and more (Jesús 7); situated within Gloria Anzaldúa's discourse on "mestiza consciousness," wherein "the new mestiza" is pluralistic, a juggler of cultures, and one who tolerates contradictions and ambiguity as a way of coping and turns them into something else (6); worthy of a place in contemporary Asian American women's writing, most notably in the area of mother-daughter themes, where gender identity and conflict are analyzed, and the retelling of childhood stories (and, in your case, Filipino folktales through your quirky *lola* and mother) paves the way to self-discovery as well as a re/acquaintance with history; the embodiment of the spirit of "New Comics," or comics created by independent artists; a vanguard feminist or "wimmin's" cartoonist whose significance doesn't just end with the autobiographical narrative, a genre that intrinsically defies stereotyping—you also veered away from its self-serious tendencies (3).

I referenced these multiplicities from Melinda Luisa de Jesús's essay "Of Mothers and Monsters." You're most likely familiar with it, because she interviewed you. Her domain of exploration has pretty much been laid out. But I would like to build on that, particularly on your involvement with independent comics and your contributions as a "wimmin's" cartoonist and your plunge into the art world.

I think Jesús was onto something when she brought up the pluralism of Anzaldúa's "mestiza consciousness." You are a juggler of cultures, and you can spin heavy-handed things around into something humorous and contemplatively awesome, but she was particularly hearkening to the content-based stuff of *One Hundred Demons*. The art that you do is pretty much a given, and I don't need to analyze the representations of gender and identity in your work. But I've picked up on a connection between the pluralistic and the multiplicitous.

You are truly an artist, a cartoonist and painter rolled into one, since you practically create your comics exclusively with a paintbrush. The paintbrush has been so crucial to your everyday art practice that you couldn't even type your novel, *Cruddy*, even if you tried—instead you handwrote it in its entirety by brush. Those lined yellow sheets of pad paper are your canvases, made precious by every published page, rendered even more precious as one-of-a-kind prints sold at Etsy (and previously on eBay), since you would rather sell your work online than exhibit in a gallery. You once said: "I like to keep prices for my original art very low! because I think it's sad that only rich people can afford art, and I don't believe they use a lot of the art they buy. Also, I HATE GALLERIES! I hate the whole art scene. All of it feels like an intensive care unit to me. And it makes art have to be this THING that feels unnatural instead of it being the MOST natural thing in the world" (Barry in Schappell 57).

You may have had around five retrospectives since, and even as you cracked jokes about "selling out," I still feel this overwhelming sense of Pinay pride knowing that you represent an independent medium close to my heart. It's okay, Lynda: at least more people can see your work now. I've always believed that you've continuously straddled the independent and the mainstream in your lifetime as a cartoonist, and unapologetically so.

While you are practically an institution now, more so with the MacArthur "genius" grant and the Reuben Award, you unintentionally model the artist who never bothered with self-branding in this branded world. And because of that, you are so real to me. Besides, it seems rather pointless to have a website when people look at their social media feeds anyway. I've been following you on IG, and while @thenearsightedmonkey is you, I love how you also make it about your students' comics and zines, because you truly believe that they have it in them. I see @thenearsightedmonkey as a subversive way of taking

back the gallery by making it more about sharing their work, thereby placing the heart in art, which I find rare these days in a world that shifted online, for the most part, because of the pandemic.

You are a renowned storyteller, but while I was about to say that you are gifted, I recalled an interview where you said you didn't believe in gifts: "You know, to me it's not a gift at all. It's the direct result of playing around with images. Practicing a state of mind with a physical activity. I don't have a mysterious attitude about any of it. It seems pretty natural. It's sort of like not playing hopscotch until you are at the hopscotch place. Thinking isn't what makes a story. It is what makes an alibi, but not a story" (Barry in Schappell 57). You actually saved me from overthinking my processes too much—from being haunted by alibis that would hover like clouds that would turn dark if they remained unnurtured ideas. And most especially when I was "not playing hopscotch" where I should be. I vowed that I would do everything only "at the hopscotch place." This is also how I eventually dealt with drawing, zine making, and my master's thesis.

You are multiplicitous because you are complex, and out of many cartoonists I could herald as inspirations, you are the most dynamic by far. The fact that I looked you up again after so many years of staying away and allowing your comics to gather dust in storage boxes only means that you have the ability to cast a vibrant renewal for creativity within me. The closure of a long-term relationship made me associate your work—something I truly loved with all my heart—with the pain of having to let go of a romantic partnership that trickled into various aspects of my life . . . most of all, my creative life.

My aesthetic experiences were becoming all about music now, about getting to know albums and discographies, because there was a lot to discover out there, old and new, knowing that the ex wouldn't touch that stuff. A couple of friends turned me on to Neil Young, and I was hooked. He seemed to have the answers to what I was going through and assured me that "it's only castles burning / find someone who's turning / and you will come around." I found so much comfort in that and knew that I wasn't alone in this, that I could only push my creative goals further, whatever they were, in due time. The other thing that struck me, he posed as a question: "Can you finally make arrangements with yourself / when you're old enough to repay / but young enough to sell?" Having entered the graduate studies program in art theory and criticism when I was close to my mid-thirties, I am still trying to figure out where I fit in between the two. I'm getting carried away with references to Neil Young's *After the Gold Rush* LP when what really connects me to you, by way of creative process, is *Everybody Knows This Is Nowhere.* When my dog, Siops, died because we had to put him to sleep for attacking the housekeeper, I thought he deserved an epic poem on account of being the most extraordinarily sick dog that I have ever taken care

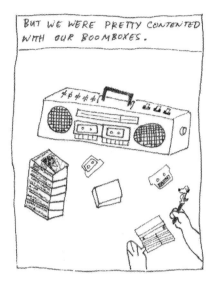

Figure 2a. Claire Villacorta, excerpt from "Do You Remember What the Music Meant?" In *Monochrome Fiesta*, 2004, n.p.

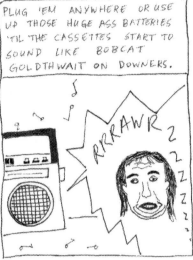

Figure 2b. Claire Villacorta, excerpt from "Do You Remember What the Music Meant?" In *Monochrome Fiesta*, 2004, n.p.

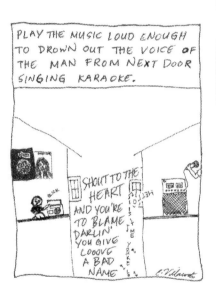

Figure 2c. Claire Villacorta, excerpt from "Do You Remember What the Music Meant?" In *Monochrome Fiesta*, 2004, n.p.

of. But it took me forever to even get started on that one. Had I not subjected myself to your "Writing the Unthinkable" exercises, Siops's story would still be an idea. And instead of a poem, I decided to make a comic strip. That brought me back to you all the more, because here I am, writing to you and trying to make sense of how you were crucial in influencing my work.

Do you ever wonder what is music?
Who invented it and what for and all that?
And why hearing a certain song can make a
whole entire time of your life suddenly just
rise up and stick in your brain?

Figure 3. Lynda Barry, *The Good Times Are Killing Me*, 1998, n.p.

Music and Dance

To this day, I'm not sure which of your comics about music inspired my first completed panels for *The Girl*, titled "Do You Remember What the Music Meant?" As it is, you had drawn quite a number of them on the experience of listening to music alone, from christening the magic demon in *One Hundred Demons*, where you begin your tale with a preteen summer recollection of the Lovin' Spoonful's "Do You Believe in Magic?" to Maybonne blasting the Silvertone stereo in the privacy of her bedroom forbiddingly loud enough for her aunt to kick up a stink in *The Greatest of Marlys*. It's possible that both examples had subliminally seeped into my comic, since mine also references a song title (if not the actual song by Pretty Girls Make Graves) with the two words, "Do You . . ." common in the beginning, and *The Girl* ends the story with a boom box blast in the direction of the neighbor's house to drown out his karaoke singing. My memory of the referenced Bon Jovi song just had to take the form of misheard lyrics.

It also occurred to me that the opening lines from your book *The Good Times Are Killing Me* may have had something to do with that.

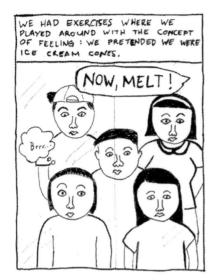
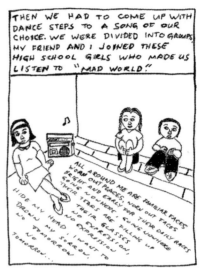

Figure 4. Claire Villacorta, untitled, 2005.

It seemed like the entire page on the right inspired an answer within, though am still unsure of how this particular text was directly responsible for my comic. Still, it conveyed the feeling of being alive: the recollection of things new and exciting, which seems to be confined only to a certain time and place. And yes, it could be something as simple as listening to a song that awakens the senses. Like magic waiting to happen. I suppose there was a magic demon lurking in this work that predated *One Hundred Demons*.

I had not seen another comic strip about music through to completion, but I did start on one as a jumping-off point to how I had discovered one of my favorite bands during my childhood at, of all places, a summer acting workshop. I began with the opening text but had only committed to drawing the last two panels of workshop activities:

PANEL #1 (unfinished): Mom signed me up for a summer acting workshop in her theater group. I got placed with the younger kids coz I fell under the age range (I was 9).

PANEL #2 (unfinished): When Mom found out that all we ever did was run around in this small room, she used her clout to move me up with the older kids.

I believe there was more to this beyond the fourth panel that I did not commit to paper—the choreography that the high school girls came up with and made us younger girls do. It entailed a lot of hand tapping to the high-pitched

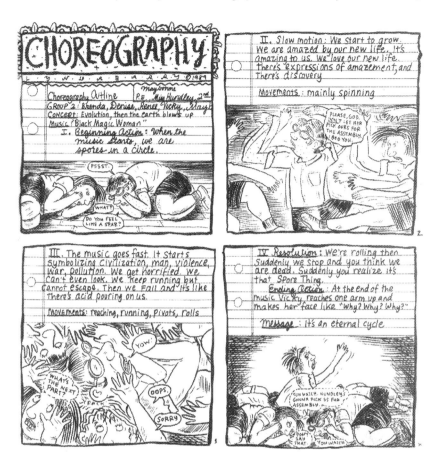

Figure 5. Lynda Barry, "Choreography." In *The Greatest of Marlys*, 2000, n.p.

percussion that introduced the song before its more melodic aspects and the singing both kicked in at the same time.

While I usually rifled through my older brother's tapes, or sought out my male cousin who was a disc jockey at a radio station that offered the latest in good music, I never dreamed I would find unintentional big sisters with a penchant for New Wave who would introduce me to Tears for Fears before they became really famous. This was the darker, more psychological and poetic side of New Wave: melancholy mixed with the kind of upbeat tempo that made you want to dance all the growing pains of adolescence away. Even the band's name was a psychological reference, a phrase taken from an Arthur Janov book about primal therapy.

These girls were closer to my brother's age and probably went to the same kind of mobile parties that I was too young to go to. I had envied my brother

for that kind of access to music and dancing on account of age alone. Being around the older girls, however, felt different. For a moment there, they were like role models. They exuded confidence, and my awkward self felt too shy to reach out to them and gush over what this awesome piece of music was about.

We only really came together because of their choreography. Beyond that, I was on my own in my musical journey. They shared Tears for Fears with me, and eventually I made them mine. I had entertained the idea of exploring that aspect of music fandom, but I hadn't articulated it at the time the way I did at the instant of this writing. I wasn't just a Tears for Fears fan; I was obsessed, to the point that the kids at school would tell me to stop talking about them and Top 40 music altogether. I think having extended the storytelling to the high school girls and crediting them for introducing me to my favorite band would have made for a better comic strip, but my original idea was to just taper off the tale at the choreography.

Honestly, I had to laugh when I saw how you handled choreography, because it was just sheer genius. It could have given me ideas on how to execute the hand-tapping motions to the tune of "Mad World," but I was too stumped to even try. The wooden floor was a given, because the acting workshop took place in big, almost empty rooms with white walls. There were hardly any chairs; we all sat on the floor, looking up and listening to our acting coach, who was the only one with a chair. My creative dilemma was how to maximize the space and draw the hand-tapping motions. I would also have envisioned a wider, clearer space, to show off the white on the walls and the distance between me and the older girls. I was never really good at packing it in, in that horror vacui kind of way that you are so accustomed to doing.

What adds to the brilliance of your panel-to-panel execution is that your comic has an added aesthetic dimension that is neither physically seen nor heard but experienced by the imagination, fueled by my prior knowledge of Santana's "Black Magic Woman." It's basically a comic strip set to music, but feeling the motions of "Choreography" requires an aesthetic experience rooted in familiarity. The initial choreographic movements of Maybonne and her group during PE acting as "spores in a circle" are as slow to midtempo as the opening strains of the song, and then it speeds up two-thirds into the song when it suddenly transitions and the percussive flow keeps apace (although percussion supposedly does the leading in songs, in general). The song does not slow down anymore; it ends at that fast pace and almost abruptly, but not too abruptly. A single, slightly long drawn note signals the song's closure, maintaining the high brought about by the transition. The concluding panel describes it as a "music victory"; Maybonne's classmate emerges from the fallen

circle with one arm up in the air and a weary expression on her face, which looks anything but victorious, as spore cycles last an eternity.

It's been years since I had any recollection of "Choreography," and it now comes off as epiphanic. I'm now confronted with the aesthetic dimension of my comic-strips-in-progress for *High Fives and Neil Young for the Road*—yes, music is pivotal in my creative process, but rather than treat each song from *Everybody Knows This Is Nowhere* as a "sound" track to its corresponding comic strip, panel by panel, I would rather regard them as images to inspire storytelling. (Okay, this is beginning to sound like you, Lynda.) The songs breathe life into the stories and strips about Siops the dog, rather than the stories being formed accordingly with the cadence of music in mind, although the possibility of the latter happening would be either accidental, unintentional, or just purely coincidental. I am opening myself up to the element of surprise because I have yet to return to the drawing table.

Something, however, needs to be done to bridge the aesthetic experience of my comics and the familiarity aspect; while *Everybody Knows* is a seminal album, not everyone would really know all the songs, save for the singles, Cinnamon Girl" or "Down by the River." These songs are not exactly "Black Magic Woman," either, even if they fall under the genre of classic rock. Neil Young himself is an acquired taste. How I share this acquired taste by the execution of my comic strip is something I have to grapple with continuously.

In due time, however, I was able to dig up stories of my own without prior references. They didn't have anything to do with music, either. I remember coming up with a few stories about hanging out with these two sisters whose father was not just any general but the former dictator's fiercely loyal right-hand man during martial law. We went to school together. It was a small school that followed the Montessori way of teaching, which meant learning at one's own pace, but with a productive day-to-day work list. We were placed together in a classroom of mixed ages and grade levels. When I was in the fifth grade, I had about eight other classmates. The general's elder daughter, whom I decided to name Ayan in my comic, was the only sixth grader in the entire school. I wasn't able to give any context in the comic alluding to our Montessori education because, quite frankly, I hadn't thought about doing that. I was more after isolated stories, but having come from a Montessori upbringing would have added to the quirkiness of the situation. For instance, the school principal had actually encouraged the older students to learn about sex and sexuality because their bodies were changing, and perhaps because some of them were already menstruating but were not quite open to talking about it. She left some required reading with the teachers for the sixth and seventh graders. Ayan

Figure 6. Claire Villacorta, "Am I Normal?" In *Komikera*, vol. 3, 2005.

apparently called first dibs on one of the books, which looked more like young adult literature than a guidebook.

I had initially storyboarded and drawn standard panels for this one. When the artists behind *Komikera* were collecting submissions for a girl-authored comics anthology, I restructured it and pared it down to a single page. *The Girl* had made its debut at Komikon 2005 via the *Komikera* anthology, but after "Do You Remember What the Music Meant?," "Am I Normal" would be the last comic strip that would see print.

Lynda Barry

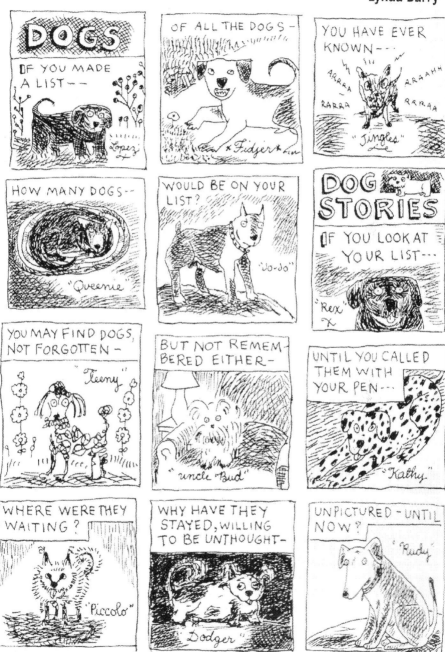

Figure 7. Lynda Barry, "Dogs," *Bark*, July–August 2007, p. 91.

I would not know this yet, but my inclination to start a pet zine would replace my interest in *The Girl*.

Dogs

I read *Bark* magazine because it was the only space for dog culture I knew that published creative nonfiction about extraordinary dogs, pet spaces, and pet psychology, as well as interesting tidbits on health and nutrition. It was pretty hip, too. I wanted to get into the motions of pet writing beyond the cheesy affirmations of dog ownership and pet parenting. My dog, Siops, was very sick, and I was trying to source out inspiration from good writing about pets afflicted with serious conditions.

When *Bark* featured your comic about dogs, I was completely awestruck and moved by your prose and overall treatment of your work. It was almost as if you were telling a story, albeit a general tale, about the dogs we remember or hadn't thought about in a while. What struck me the most about this comic was the idea other dogs—particularly dogs we have encountered from the past—are still with us when we make new furry friends. Perhaps it was because it coincided with the time when I had taken a rambunctious puppy into my care but had to bid adieu to a couple of old dogs. It hadn't occurred to me that it was actually a teaser for your book *What It Is*, as a way of introducing the word "dog" as an image and to jump-start more of your "Writing the Unthinkable" exercises. But even without the proper context of the image-places where these dogs are conjured on, it stands on its own merit.

I knew you had featured dogs in your previous work. I was entertained by your Beat poodle, Fred Milton, who declared his love for a mutt. It reminded me so much of how the aforementioned rambunctious pup Kenji (to whom I bid farewell a couple of days after his fourteenth birthday, just weeks before lockdown) had a thing for purebred dogs, particularly male shih tzus. With *Bark*, I felt your love for all canine-kind.

While *The Good Times Are Killing Me* was, in some ways, a musically charged work, I was also attracted to Edna's reflections on her neighborhood. The prose called to mind Sandra Cisneros's *The House on Mango Street*, where the storytelling captured an innocence in the observations of the narrator, but the images brought forth by the words were loaded with class and racial implications.

I wanted to try my hand at writing about my own neighborhood and make it into a comic strip. It was 2005, and I was obsessed with walking my dogs. My father had hired a dog trainer to see whether Siops the dog's behavior issues could be remedied. The training was also extended to his brother, Chigs, and

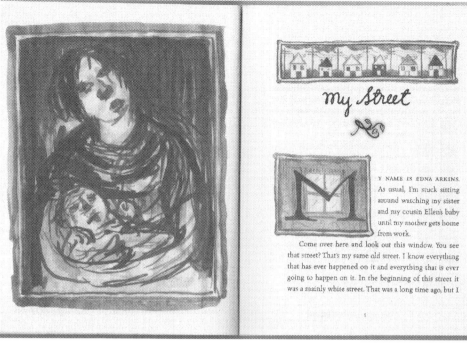

Figure 8. Lynda Barry, "My Street." In *The Good Times Are Killing Me*, 1998, p. 1.

Kenji. This whole experience made me more involved with my pets, and for a while, he helped me walk my dogs.

I storyboarded a tight strip that alternated panels of pure text with panels of pure comic art consisting of cropped images pertaining to descriptions of the neighborhood dogs and the dog-walking experience. I was not able to finalize or even ink it, since it was only half-finished. The text had come to me first, as it did in most of my processes. I called the piece "My Street," not to copy (not that it was the most unique title anyway) but because that was what I wanted to focus on, as a prelude to my own neighborhood, which I had planned to elaborate on.

My Street

When I started bringing my dogs out to my street for late afternoon walks, I familiarized myself with the neighborhood. I figured out who stayed where, who actually kept dogs in their homes, and how practically all the houses (except mine) didn't have front yards.

Our house is sandwiched between dog owners, so left and right, we'd get an earful of restless yaps and toppled-over dishes—though not as dramatic and fre-

quent as I make it sound. I find out that the peeps who live next door to the left are backyard breeders, and Yorkshire terriers are their trade. I'd seen at least one Yorkie being walked. It's also home to a lovely golden retriever, who hasn't made as many appearances in almost half a year since I first laid eyes on it (that was actually the last time I saw it). However, I still hear this really deep bark amidst the high-pitched ones. By then, I'd traded in my afternoons for early morning walks a short car ride away to a better dog-walking location.

The house on my right has a couple of dogs. One of them gets to roam outside, while the other seems contented with just sticking its butt out through the gate. The outdoorsy type, a white male dog with big brown spots, mostly sits right outside the gate but crosses the street to "high five" a car wheel or an equally piss-worthy post. On a hot day, he stays under one of those cars parked across his home, since that's the only side of the street where the cars are allowed to park—otherwise they'll get towed. Why his master leaves Spotty out there to fend for himself is a mystery. I wonder when he finds the time to eat.

A few houses down from Spotty's, a black bitch covers a lot more ground than Spotty himself. She used to have a partner in crime, and they'd hook up with a brown dog from the street perpendicular to ours, and together they'd roam around the village as a pack. They knew how to return home, unharmed by moving cars and bikes. The gang is no more, it seems, but recently she was a mother to two white pups who could easily slip in and out of the house from underneath the gate. She taught them to be streetwise, and the three of them became the new gang. One time, I spotted them walking toward the opposite side of the road, farther from their home, and turning left to the next street, which happens to be a main road. I was both amazed and worried—what if someone mistook them for strays? I saw them again in the days after that risqué attempt at family time.

Sometimes, when color coding prevents me from taking the car out and the dog trainer shows up early, we walk Chigs and Siops around the neighborhood. We pass the aforementioned houses. Spotty is sitting outside his house, as usual. He sometimes stands, looks wistfully at the dogs. If he dares to motion forward, we shoot our index fingers out at him (short of busting a Scott Pilgrim move) and tell him "NO," and he actually listens, or rather comprehends the gesture. Likewise with those white pups, who are even fiercer. They'll just back off and continue to bark. On the street parallel to ours, there's a medium-sized white dog with a black spot around one of its eyes. Seems friendly in that Odie kind of way—y'know, wants to follow us, but we can't risk contact, so we point and command, and the dog makes a 180-degree turn and runs back to where he came from.

We've encountered scarier, territorial dogs in the past. There was this street corner dog who would appear from behind parked cars to check out my dogs

and attempt to follow them. We'd stare him down or pick up a stone and throw it at his direction. That would stop him. It's been two months since we've seen that dog, and while he may have met his fate as a stray, it's kind of a relief not to have to deal with him, like, ever.

I realized that I hadn't gone as far with my "street" accounts as I had initially planned. I eventually wanted to touch on the politics of dog walking in Manila—how certain neighborhoods were not "gated," unsuitable for walking dogs, and how neighbors allowed their dogs to stray, confident that they would come home later. Then there was the issue of dog eaters lurking within proximity of my own neighborhood. These dog eaters came from a poorer neighborhood that was separated from ours by a concrete wall. While we all knew that beyond that wall was uncharted territory, those who emerged from it flocked toward our area as they pleased.

Since I had described most of the dogs next door, both left and right—and even outside—perhaps they could have deserved their own panels as the dog stars of "My Street," much like the dogs on the street where Marlys lives. But I did not envision my story that way, since mine was a story in motion.

Autocritique

I tried to be as free-flowing in our imaginary collab as possible, but I felt more pauses in the act of remembering. Some of the memories that had inspired my work with *The Girl* comic strips came back to me while I was typing; these were experiences that I hadn't thought about in years. I hadn't even accounted for them in the making of those early comic strips about my adolescence.

I also wasn't sure what to expect from this imaginary collab as well, other than ideas that didn't come out. I hoped that I wasn't too caught up in the could-have-beens of my early processes. What did come out was that I had already taken interest in projects involving my pets—even those in comic strip form. But like everything else, they were temporarily shelved.

Revisiting Datuin's *usapang babae* approach, I was drawn to the idea of an intergenerational dialogue rooted in both fantasy and imagination. Datuin, however, weaved a discursive tapestry of Filipina craft and artistry, jumping back and forth in art historical timelines by troubling both feminism and the feminine. She would always return to her "elsewhere"—the letter to the nineteenth-century artist—with burning questions about community and empowerment, which, more than anything, served as gaps in the art discourse of that given time.

I'm wondering where that leaves us here, today, in my "elsewhere" with you. If I claim that I don't know where to situate myself in the Filipina struggle for recognition in the field of art, or that it's a nonissue for me, I would only be a disappointment for Datuin, especially if I veer toward the latter statement (188). After all, generations of struggle didn't just happen only for the likes of me to seemingly fail to acknowledge Filipina predecessors who "banged on pots and pans" as a gesture of community and support against subjugation and oppression (186). But what if I still need a lifetime to figure that one out through an intricate web of art history? Honestly, I'd rather leave that task to someone more qualified, let alone genuinely interested. Also, who predicted a generation that would breed someone like me who adamantly resists going through the motions of creating art as an institutional practice? And that affinity, by way of community, may not be present where I am right now—in Manila, under a prolonged lockdown—but perhaps spread out all over the country, and the rest of the world? I may not be able to physically hear the sound of pots and pans banging, but it may require another kind of sharpening of the senses that makes recognition of others like me possible.

And you weren't even born in the Philippines. Your successes and struggles as an American cartoonist are even more context based, and it would be unwise to pin your experiences as harking from the motherland. In which case, you have more than one, even if you have shared fond memories of eating *lumpia* and chicken *adobo*. Still, *usapang babae* made this letter possible, especially when it was produced in the spirit of "perpetual autocritique," where ideas surrounding communion and community have branched out since, in terms of shared spaces that bring women closer, no matter how globally scattered we are. We are coming from some other "elsewhere," one where geography totally separates us, and yet IG gives your presence its currency. I've "liked" your posts to cheer you and your students on, but I chose to write to you in a print medium that may actually call your attention.

But what brings me to you is definitely more than just our Filipina connection. You make drawing pure again. And we will always keep meeting at the zine, for as long as your students continue making them in class.

Unthinkably yours,

Claire

WORKS CITED

Barry, Lynda. The Near-Sighted Monkey. https://www.instagram.com/thenearsighted monkey.

Barry, Lynda. *What It Is*. Drawn & Quarterly, 2008.

Datuin, Flaudette May V. *Home Body Memory: Filipina Artists in the Visual Arts, 19th Century to the Present*. University of the Philippines Press, 2002.

De Jesús, Melinda. "Of Monsters and Mothers: Filipina American Identity and Maternal Legacies in Lynda J. Barry's *One Hundred Demons*." *Meridians: Feminism, Race, Transnationalism*, vol. 5, no. 1, 2004, pp. 1–26.

Dewey, John. *Art as Experience*. 1934.

Schappell, Elissa. "A Conversation with Lynda Barry." *Tin House*, vol. 8, no. 1, 2006, pp. 50–57.

Villacorta, Claire. 2013. *High Fives and Neil Young for the Road (an Out-takes Zine)*. Print zine.

Villacorta, Elaine Claire. "High Fives and Neil Young for the Road: Lynda Barry's 'Writing the Unthinkable' as an Aesthetic Experience." *International Journal of the Image*, vol. 4, 2014, pp. 83–96.

Young, Neil. "Don't Let It Bring You Down." *After the Gold Rush*. Reprise, 1970.

Young, Neil. "Tell Me Why." *After the Gold Rush*. Reprise, 1970.

Young, Neil. "Running Dry: Requiem for the Rockets." (As Neil Young and Crazy Horse.) *Everybody Knows This Is Nowhere*. Reprise, 1969.

chapter 10

Big Ideas: Ursula Murray Husted

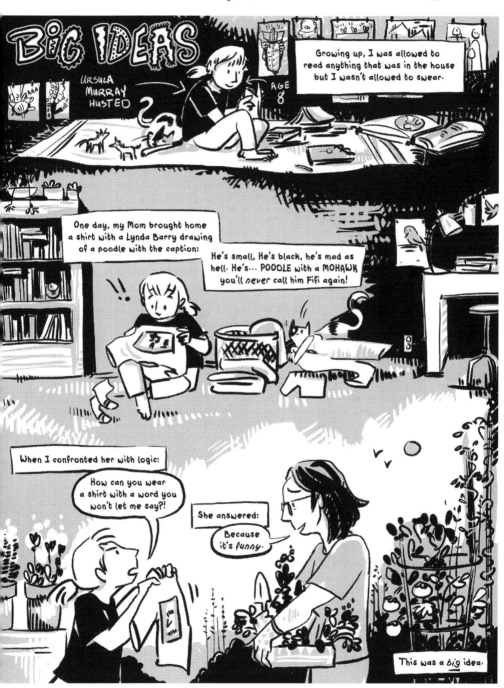

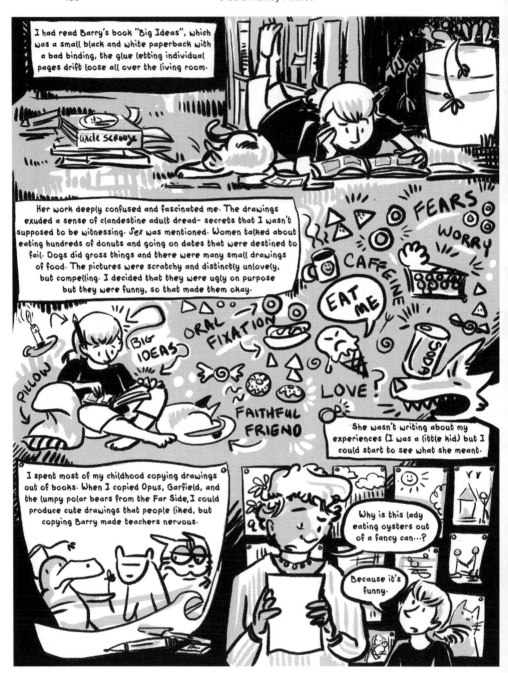

I had read Barry's book "Big Ideas", which was a small black and white paperback with a bad binding, the glue letting individual pages drift loose all over the living room.

Her work deeply confused and fascinated me. The drawings exuded a sense of clandestine adult dread- secrets that I wasn't supposed to be witnessing. Sex was mentioned. Women talked about eating hundreds of donuts and going on dates that were destined to fail. Dogs did gross things and there were many small drawings of food. The pictures were scratchy and distinctly unlovely, but compelling. I decided that they were ugly on purpose but they were funny, so that made them okay.

FEARS

WORRY

CAFFEINE

EAT ME

ORAL FIXATION

BIG IDEAS

PILLOW

FAITHFUL FRIEND

SODA

LOVE!

She wasn't writing about my experiences (I was a little kid) but I could start to see what she meant.

I spent most of my childhood copying drawings out of books. When I copied Opus, Garfield, and the lumpy polar bears from the Far Side, I could produce cute drawings that people liked, but copying Barry made teachers nervous.

Why is this lady eating oysters out of a fancy can...?

Because it's funny.

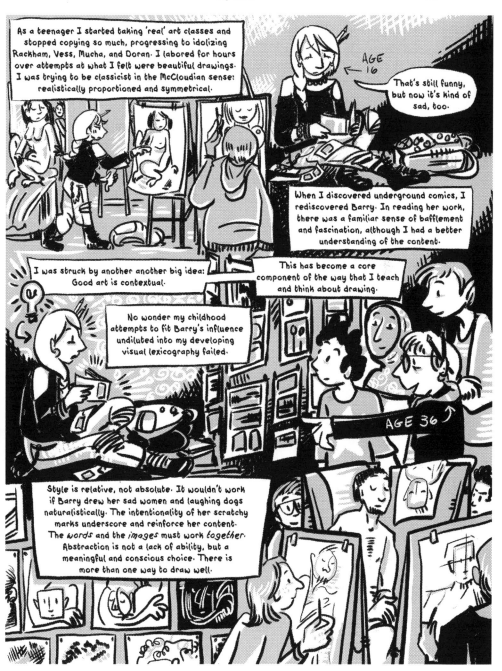

As a teenager I started taking 'real' art classes and stopped copying so much, progressing to idolizing Rackham, Vess, Mucha, and Doran. I labored for hours over attempts at what I felt were beautiful drawings. I was trying to be classicist in the McCloudian sense: realistically proportioned and symmetrical.

AGE 16

That's still funny, but now it's kind of sad, too.

When I discovered underground comics, I rediscovered Barry. In reading her work, there was a familiar sense of bafflement and fascination, although I had a better understanding of the content.

I was struck by another another big idea: Good art is contextual.

This has become a core component of the way that I teach and think about drawing.

No wonder my childhood attempts to fit Barry's influence undiluted into my developing visual lexicography failed.

AGE 36

Style is relative, not absolute. It wouldn't work if Barry drew her sad women and laughing dogs naturalistically. The intentionality of her scratchy marks underscore and reinforce her content. The words and the images must work together. Abstraction is not a lack of ability, but a meaningful and conscious choice. There is more than one way to draw well.

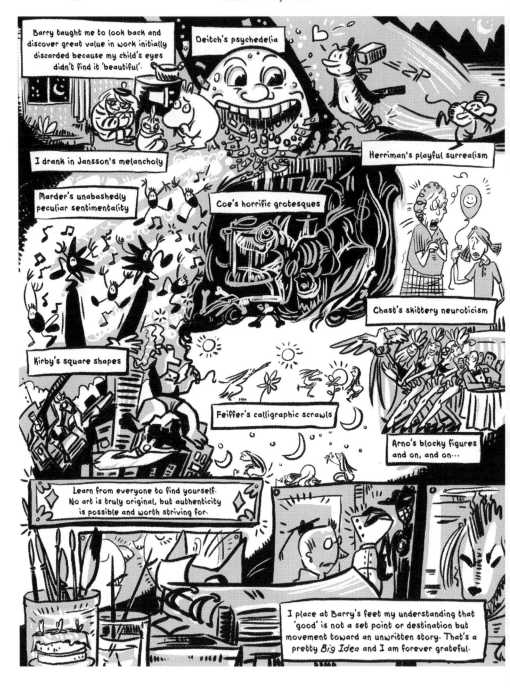

Afterword

My Kid Could Do That: Lynda Barry and Subversive Writing for Everyone

—Glenn Willmott

Lynda Barry's work, especially the book *One Hundred Demons*, has generated likely the greatest range of scholarly approaches of any comics artist, from a number of detailed formalist analyses to diverse studies of sociological and cultural content. In these last few words, I would like to step back from all those sorts of readings and sidestep both form and content as destinations for my discussion. What could be left? I want to look at Barry's commitment to comics as the communication neither of form nor of content but of a *practice*— specifically, a reading and writing practice. While this commitment explicitly motivates *One Hundred Demons*, it is more lavishly unfolded in Barry's later *What It Is* and *Picture This*, the works I will focus on here.

The cover of *What It Is* swarms with pictures and text. The question "What is an image?" appears at its center, flanking a serpentine creature with a monkey face that rises from the head of a monkey seated on a mat, perhaps in meditation, while other creatures and forms press in around them. Between the question and the merely indicative answer of the book's title are words that seem to respond to both: a cursive "the formless thing which gives things form," a checkbox checked for "inside," a checkbox checked for "outside," and, pasted across a shadowy, blob-like creature, a cutup with the words "The way in ... and out." The swarm of odd, colorful creatures, vegetal forms, and organic patterns seem also to respond to the question as an overflowing wonder cabinet of pos-

sible answers. While the question thus has a great deal of mystery associated with it, it is also emphatically practical rather than mystical. The largest text on the page other than the title and author's name, which follows "What is an image?," reads: "DO YOU WISH YOU COULD WRITE?"

What does it mean that Barry understands the stuff of comics as the image, whether that is the image of a thing, a being, a letter, a number, or a geometric shape or doodle? We learn that for her, the image is not the quite same as the basic unit of comics that Scott McCloud calls an icon, which is "any image used to represent a person, place, thing or idea" (27). For McCloud, cartoon icons are both semiotic (they can be decoded into conventional meanings) and imaginary (they can represent new ideas that are creative "extensions" of our inner selves) (40–41). Now, some people like to mock McCloud for his imaginative psychological theories about comics, but in this regard, Barry is just as creative—and just as intriguing. For Barry, the image is certainly not an inert, graphic sign to be decoded, and it frequently resists such decoding. Indeed, the image is hardly even a sign, hardly representational at all. Rather, in *What It Is*, the image is represented as a volatile dynamic *process* of sensing, feeling, remembering, and thinking; it is even a ghostly or shadowy kind of living thing.

For example, on a page headed by a cutup reading "the story of transportation" and by a multi-eyed, kerchief-wearing creature holding a pencil and a microphone asking "What is an image?," Barry provides several responses. In the first panel, above three imaginary creatures floating in a boat named "HELLO," is printed in caps: "AT THE CENTER OF EVERYTHING WE CALL 'THE ARTS,' AND CHILDREN CALL 'PLAY,' IS SOMETHING WHICH SEEMS SOMEHOW ALIVE." The next panels alternate cursive with printed caps. Above a live and a dead bird: "It's NOT ALIVE IN the WAY YOU AND I are alive, BUT IT'S certainly not dead." Then, beside a cephalopod in seaweed, "IT'S alive in the way our memory is alive." Then the multi-eyed creature reappears, plunged upside down with pencil, a bird on her head with upside-down emitting question marks: "Alive IN the WAY the Ocean is Alive AND ABLE to TRANSPORT US AND contain us." The last panel shows the kerchief-wearing author with pencil drawing by night in lamplight: "Alive IN THE WAY THINKING is NOT, but EXPERIENCING IS, made OF BOTH memory and IMAGINATION, This is THE THING we mean by 'AN Image'" (14).

All those images of unconventional, manifestly hand-drawn creatures resist decoding, resist signifying, and have instead a kind of autonomous agency, melding ideas with feelings and story situations we find ourselves having to invent to account for them. Images are alive, Barry repeatedly insists, and they swallow writer and reader alike into their living, just as we contribute part of our own lives to them. Images are "the Mysterious force by which we are lived,"

she affirms in *Picture This*; "the Image world is not Part of OUR mind—OUR
MIND IS PART OF The Image World" (218). But if they are alive, how can
images live both inside us (in our minds) and outside us (on the page)? Barry
seems to suggest, as does McCloud, that images are extensions of our bodies
and selves, like phantom limbs, except not merely our own selves—as in the
case of projection or simple expression—but our own and others' selves and
their own image-selves at the same time. In *What It Is*, she insistently represents
the image world as a kind of ceaseless, personal, and collective living process or
action that takes place between the external world and our inner worlds (15).

As it happens, Ezra Pound describes images in just this way. Pound wished
that Westerners would learn from Asian writing, whose ideographic charac-
ters and character roots, he believed, were based on actions rather than things
(*Chinese Written Character* 9). Imagism, the poetic principle he prescribed to
an ailing literary culture, was based on the "image" not as a sign to be decoded
but as a writing and reading process, meant to communicate a virtuous action
of the senses, not to represent an object or idea. Pound wanted "to give people
new eyes, not to make them see some new particular thing" (*Gaudier-Brzeska*
85). The poetic image enacts this process because it embodies "the precise
instant when a thing outward and objective transforms itself, or darts into a
thing inward and subjective," or the same process in reverse (89). This is the
same process that Barry finds in the image (*What It Is* 15). And her kinship
with Pound's imagism does not end there.

Adapting verses from the Persian poet Rumi, Barry suggests that the mate-
rial, graphic image is merely the outward shell of a larger, more mysterious
semiphysical process (*What It Is* 143). The image is like an empty diving suit
(and she pictures herself wearing one) that anyone may put on, in a process of
writing and reading that is like diving into a strange, living ocean of the self and
others. In that ocean, the image is a doorway to a variety of memories, feelings,
thoughts, and other images that record one's embodiment in the world at large.
Here that image may be as strange as a multi-eyed slug or cephalopod, or as
mundane as curler instructions or an automobile (144). As an example, Barry
asks us to picture a car we have owned and all the associations that it evokes.
An image will not mean just anything: it is constrained by culture, time, place,
individual experience, and imagination. But it is as fluid and variable, as inde-
terminate and personal, as the way any one of us would read one of her pages.
As Pound says, images do not have "a fixed value, like numbers in arithmetic,
like 1, 2, and 7. The imagiste's images have a variable significance, like the signs
a, b, and x in algebra. . . . The image is not an idea. . . . It is what I can, and must
perforce, call a VORTEX, from which, and through which, ideas are constantly
rushing" (*Gaudier-Brzeska* 84, 92). The image of an automobile is that kind of

vortex here, not an idea. Barry cares less about the car than what—as if magically, on its own—it calls up in herself and others. Beyond what it calls up, then, she wants to communicate the process of evocation itself, the living action of the image that is almost magical and leads in unpredictable directions.

But though Barry is, like Pound, an imagist—building her art from images that are layered mental and emotional complexes, and which activate new processes of thinking and feeling in the writer and reader—she does not share Pound's own aims. Pound wanted the image to provide a common language for the modern world, to expose the "ideas in action" of our global time, and allow us to imagine new and more just forms of them. His goals were emphatically political. Barry's goals are less overtly those of political critique or change, and in *What It Is* and *Picture This*, her emphasis is on personal and inward healing. Images are "THE SOUL'S IMMUNE SYSTEM AND TRANSIT SYSTEM," she writes in *What It Is* (17). One must put aside the desire to draw or write for a public, for an audience, and do it for oneself and for the moment, a restoration of one's full imaginative, emotional, and intellectual capacities that amounts to a kind of spiritual and psychological therapy. It may only be gluing cotton balls to chicken outlines that revives one's spirits on a winter's day (*Picture This* 32). Or it may be a deeper survival technique: confronted by death and loss, feeling like Dante lost and aimless in dark woods, Barry finds herself doodling monastically robed monkeys to help find her way out (208). But the chicken reminds us of something, which takes me to my last and most important point about Barry's comics. Her cotton-ball chicken page is not just a story but a set of instructions, a how-to guide. It is one of the many do-it-yourself projects and fill-in-the-blank tasks in what is essentially an activity book. This speaks to the point about communicating a comics practice, not just an experience of form or content, with which I began. But the cotton-ball chicken and the unashamedly homey scraps of paper and other stuff used everywhere in these books also point to the low-budget or no-budget side of this. Barry's comics want us not only to "write" them ourselves, as unpredictable imagist activities, but in so doing to bypass the whole commercial structure of comics and art in modern media. Don't be wholly enthralled by the culture of consumer entertainment and spectatorship, she seems to be saying: take art over for yourself.

There are two kinds of modern text, says Roland Barthes, those that are merely readable and those that are writable. The modern culture of literature, says Barthes, maintains a "pitiless divorce ... between the producer of the text and its user, between the owner and its customer, between its author and its reader. This [passive] reader is thereby plunged into a kind of idleness.... Instead of functioning himself, instead of gaining access to the magic of the signifier, to the pleasure of writing, he is left with no more than the poor freedom either

to accept or reject the text" (S/Z 4). But why is the writable important? Because its goal is to engage readers in writing a text for themselves while reading it, "to make the reader no longer a consumer, but a producer of the text." I can find no better way to describe what Barry is striving for in her comics, and indeed in her performances and other paratext for her comics. This practice of a writable imagism, which Barry finds rooted in shameless childhood capacities and pursuits, and Barthes finds rooted in play, struggles to escape the commodity form of writing and, more profoundly, to subvert an impoverished ideology of maturity in consumerist forms of desire and wealth. This makes her one of the most interesting inheritors of modernism, and subversive inventors of what comics can do, of any artist today. Yes, your kid could do that, but could you?

WORKS CITED

Barry, Lynda. *Picture This*. Montreal: Drawn & Quarterly, 2010.

Barry, Lynda. *What Is This*. Montreal: Drawn & Quarterly, 2008.

Barthes, Roland. *S/Z*. Trans. Richard Miller. New York: Hill and Wang, 1974.

McCloud, Scott. *Understanding Comics: The Invisible Art*. New York: Harper Perennial, 1994.

Pound, Ezra. *Gaudier-Brzeska: A Memoir*. New York: New Directions, 1970.

Pound, Ezra, ed. *The Chinese Written Character as a Medium for Poetry*, by Ernest Fenollosa, City Lights, 2001.

Contributors

Frederick Luis Aldama, also known as Professor Latinx, is the Jacob and Frances Sanger Mossiker Chair in the Humanities and affiliate faculty in radio-TV-film at the University of Texas, Austin, as well as adjunct professor and Distinguished University Professor at the Ohio State University. He is author of over forty-eight books and has received the International Latino Book Award and an Eisner Award for *Latinx Superheroes in Mainstream Comics*. He is editor or coeditor of nine academic press book series, including Biographix with University Press of Mississippi. He is the creator of the first documentary on the history of Latinx superheroes and the founder and director of UT's Latinx Pop Lab. His Spanish translation and animation film adaptation of his children's book *The Adventures of Chupacabra Charlie* (2020) will be published in the fall of 2021. He is also editor of *Graphic Indigeneity: Comics in the Americas and Australasia* and *Jeff Smith Conversations*, both published by University Press of Mississippi.

Melissa Burgess earned her doctorate in English from Saint Louis University in 2017. Her dissertation focused on contemporary women's autobiographies, namely, the works of Lynda Barry, Dorothy Allison, and Joan Wickersham. She has served as the coordinator of academic support at Saint Louis University since 2016.

Susan Kirtley is professor of English, director of composition, and director of comics studies at Portland State University. She is winner of the 2013 Eisner Award for Best Educational/Academic Work for her book *Lynda Barry: Girlhood through the Looking Glass* and coeditor (with Antero Garcia and Peter E. Carlson) of *With Great Power Comes Great Pedagogy: Teaching, Learning, and Comics*, both published by University Press of Mississippi.

Rachel Luria is an associate professor at Florida Atlantic University's Wilkes Honors College. In June 2018, she was the artist-in-residence in Everglades, where she composed original fables inspired by the wilderness of the Florida Everglades. Her nonfiction was named a Notable Essay of 2015 by the editors of Best American Essays, and her work has appeared in *Arts and Letters, CRAFT,* the *Normal School, Phoebe, Dash Literary Journal,* and others.

Ursula Murray Husted holds a BFA from Marshall University, MFA from the Minnesota College of Art and Design, and PhD from the University of Minnesota. *A Cat Story,* her graphic novel for kids about cats, friendship, and art history, was published in fall 2020 by the Quill Tree and Harper Alley imprints of HarperCollins. She is currently working full-time on her next graphic novel from HarperCollins. Set in 1480s Florence, *Botticelli's Apprentice* tells the story of a young girl who is secretly teaching herself to paint while looking after Sandro Botticelli's chickens. It is about persisting, finding your voice, and a very stupid dog.

Mark O'Connor, an associate professor of English at Slippery Rock University, directs the creative writing program and advises the literary magazine *SLAB*. He has a PhD from the University of Houston in creative writing and literature, where he edited *Gulf Coast*. The recipient of a Pennsylvania Council on the Arts fellowship for creative nonfiction, his work has been published in *Creative Nonfiction, Massachusetts Review, Karamu,* and elsewhere. His article on *Little Nemo in Slumberland* will be published in the anthology *Avian Aesthetics* (Lexington Books, 2022).

Allan Pero is associate professor of English and writing studies at the University of Western Ontario. He is also editor in chief of *English Studies in Canada*. He is coeditor of and contributor to *The Many Facades of Edith Sitwell* (2017). He is the author of two dozen articles and chapters. His most recent publications include articles on Wyndham Lewis, Katherine Mansfield, Virginia Woolf, Blanchot and Lacan, Lacan and the posthuman, Ford Madox Ford, and Brigid Brophy. He is currently working on *An Encyclopedia of Cultural Theory* for the University of Toronto Press, and on a book-length project on camp and modernism.

Davida Pines is an associate professor of rhetoric and rhetoric department chair in the College of General Studies at Boston University. In addition to courses in first-year writing and research, she teaches nonfiction comics in BU's Kilachand Honors College and will offer comics theory as part of BU's College of Fine Arts new visual narrative MFA. Her first book, *The Marriage Paradox: Modernist Novels and the Cultural Imperative to Marry,* was published

by the University Press of Florida. In addition to her work on Lynda Barry, she has published essays on Art Spiegelman's *In the Shadow of No Towers*, Alissa Torres and Sungyoon Choi's *American Widow*, and Roz Chast's *Can't We Talk about Something More Pleasant*.

Tara Lynn Prescott-Johnson is a continuing lecturer and faculty in residence at the University of California, Los Angeles. She is the author of *Poetic Salvage: Reading Mina Loy*, editor of *Neil Gaiman in the 21st Century*, and coeditor of *Gender and the Superhero Narrative* and *Feminism in the Worlds of Neil Gaiman*.

Jane Tolmie is associate professor in gender studies, English, and cultural studies at Queen's University in Kingston, Ontario. She is a poet, feminist activist, and editor of *Drawing from Life: Memory and Subjectivity in Comic Art*, published by University Press of Mississippi, and coeditor of *Laments for the Lost in Medieval Literature*.

Rachel Trousdale is an associate professor of English at Framingham State University. Her scholarly work includes *Nabokov, Rushdie, and the Transnational Imagination*; *Humor in Modern American Poetry*; and *Humor, Empathy, and Community in Twentieth-Century American Poetry*. She also writes poetry. More information is available at www.racheltrousdale.com.

Elaine Claire Villacorta is a Manila-based zine producer. Her imaginary collaboration with Lynda Barry has been brewing in her head since graduate school and has taken on various incarnations—the most recent one being an epistolary quaranzine thesis on art production and institutional critique. She completed her MA in art theory and criticism at the University of the Philippines (Diliman, Quezon City) and plans to pursue further studies in art therapy.

Glenn Willmott is professor of English and cultural studies at Queen's University, Canada. He studies both avant-garde and popular literature and arts since the nineteenth-century fin de siècle, especially from political-economic or ecocritical perspectives. His most recent books are *Modern Animalism: Habitats of Scarcity and Wealth in Comics and Literature* (University of Toronto Press, 2012) and *Reading for Wonder: Ecology, Ethics, Enchantment* (Palgrave Macmillan, 2018).

Index

Printed in the United States
by Baker & Taylor Publisher Services